Stained Glass
From
Medieval Times
To The Present

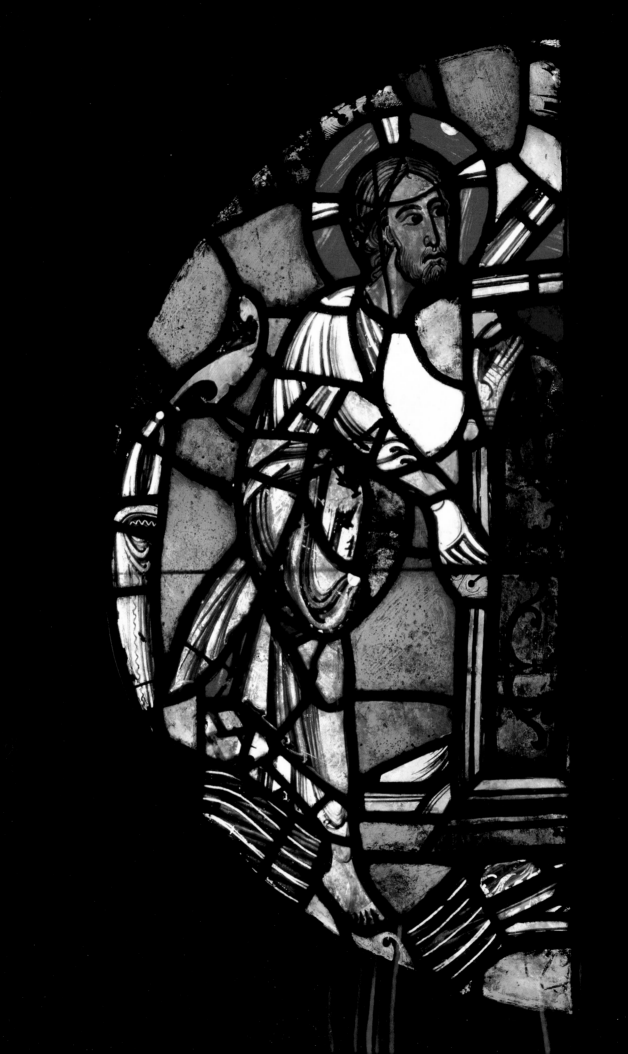

STAINED GLASS FROM MEDIEVAL TIMES TO THE PRESENT

Treasures to Be Seen in New York

Text by James L. Sturm ■ Photographs by James Chotas

E. P. DUTTON, INC. ■ NEW YORK

(FRONTISPIECE) The Metropolitan Museum of Art, Fifth Avenue and 82nd Street, Manhattan. *God, Depicted as Christ, His Incarnation, Closes the Doors of Noah's Ark,* from the Cathedral of Poitiers. c. 1190. W. 15″. Most of the glass at Poitiers was destroyed long ago, but this rare fragment with its subtle blues and complex reds survives to testify to the beauty of early French glass.

First Published, 1982,
in the United States by E. P. Dutton, Inc.,
2 Park Avenue, New York, N.Y. 10016

Library of Congress Catalog Card Number: 79-53345
ISBN: 0-525-20935-2 (cloth)
ISBN: 0-525-47627-X (DP)

Published simultaneously in Canada by
Clarke, Irwin & Company, Limited, Toronto and Vancouver

Designed by Nancy Etheredge

Printed and bound by Dai Nippon Printing Co., Ltd., Tokyo, Japan.

10 9 8 7 6 5 4 3 2 1

First Edition

JAMES L. STURM is Associate Professor of History in the City University of New York, College of Staten Island. He became aware of the neglected glass art of America through his research into and writing on the economic and social history of nineteenth-century America. In addition to his scholarly interest in stained glass he has also had a career as a glass artist in San Francisco.

JAMES CHOTAS worked at New American Library and Bantam Books and has gone on to establish himself as a free-lance writer/editor/photographer, contributing to many national and regional magazines, newspapers, books, and a variety of fine arts publications and catalogues. It was his involvement in photographing art and architecture that led him to stained glass, and making color photographs of stained glass has become a specialty of his. Most recently, Mr. Chotas has undertaken an architectural study of the monasteries of Greece's Mount Athos. A dedicated colorist he has begun to delve into the fascinating and unpredictable world of infrared photography.

Contents

Preface

There have been two great ages in stained glass. One was in the Middle Ages. The other began in the nineteenth century and has continued, after an interruption in recent decades, into our own time. During the revival of glass, which began in the nineteenth century, New York became the richest city in the world and eventually the cultural capital of Western civilization. As an art closely tied to architecture, stained glass naturally flourished in a metropolis that was growing rapidly and building extravagantly. At the beginning of the last century most of the city's glass was imported from Europe, which was then the center of the glassmaker's art, as of all the other arts. Along with the Rembrandts and the Vermeers, the Van Dykes and the Monets, the Roman sculptures and the Baroque porcelains, New York magnates brought back from Europe fine stained glass from the Middle Ages and Renaissance and commissioned work by the best artists in the European revival of stained glass. After the Civil War American artists became accomplished at imitating the Europeans and then went on to innovate for themselves. By the 1880s there was a two-way flow of ideas and glass across the Atlantic.

The inventors of the American opalescent style of glassmaking, Louis Comfort Tiffany and John La Farge, were New York artists, and their careers flourished in the city as they provided windows for dozens of public and private buildings. As they gained national and then international reputations, New York became a world center of stained-glass art.

When the opalescent era waned, the city remained a center of the craft, producing neomedieval windows that were installed all over North America. During this era as during the preceding one the wealth of New York patrons and competition within the artistic community in New York encouraged a high level of creativity and craftsmanship. So many good windows were designed for the buildings of New York that the city remains, despite the ravages of time and changing taste, a treasure house of stained glass. Some of the great studios have closed, but in their place independent artists have benefited from the current flowering of stained glass as a personal and intimate art form, and today the city is renewing its splendid affair with glass, color, and light.

New York's
Medieval and
Renaissance
Glass

The place to begin the discovery of New York's stained glass is The Cloisters museum at the north end of Manhattan Island. There one sees a splendid collection of medieval glass, arranged to show the development of the styles and techniques that have never ceased to play a vital role in the craft. Museums usually put medieval glass in exhibition cases lit by artificial lights, but The Cloisters collection has been installed in the windows of the museum, high above the Hudson River at Fort Tryon Park. Such ancient windows were designed for sunlight, and only by seeing the old glass come alive in its natural setting can one understand the role that medieval stained glass has played in the art and imagination of Western civilization.

The handsome windows of The Cloisters deserve attention for their own sake, but they also receive rather detailed discussion in the following pages because the medieval styles and techniques they exemplify provided the starting point for the revival of glass in the last century. Although many new developments are embodied in New York's thousands of stained-glass windows, those windows make more sense aesthetically and technically after one has seen The Cloisters collection.

Stained glass emerged as a flourishing art in the twelfth century, at about the same time the first Gothic

cathedrals were built. The Gothic style had just emerged out of Romanesque architecture, and abundant evidence of that transformation exists in the masonry of surviving medieval buildings. Colored windows were used in Romanesque structures, but glass is much more fragile than stone, and the history of the glassmaker's art is little known before the Gothic era. There are only a handful of windows extant from before 1137 when Abbot Suger began rebuilding the abbey church of St. Denis outside Paris in the new Gothic style. Were the great windows of Gothic cathedrals created for stained glass, or was the glass created for the great windows? The question is probably too simpleminded to be answered—certainly historians are not prepared to do so now, but from the murky prehistory of stained glass a few facts do emerge. One of them is that early windows were considered treasures from the day of their inception. Into them went enormous amounts of labor and costly materials. Some craftsmen even claimed that they needed sapphires to grind up for blue glass, and indeed there is a connection between the art of medieval glassmaking and jewelry. Although jewel dust was almost surely never used as a pigment, and, in any case, would not have colored glass, techniques for creating imitation jewels were adapted for making stained glass. Some medieval glass jewels consist

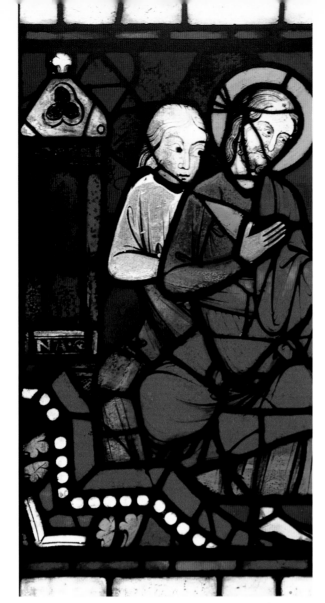
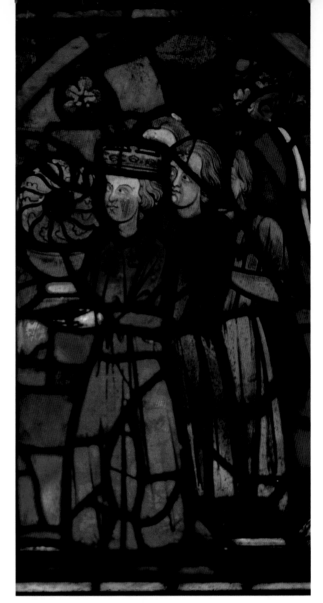

1 and 2. The Cloisters, Fort Tryon Park, Manhattan. Scenes from windows originally in the Cathedral of Tours. c. 1250. W. of each panel approx. 13″. The red glass in these windows resembles microlayered ruby glass, which has never been excelled for its fiery radiance and which in large windows summons the image of "sages standing in God's holy fire."

of microscopic layers of clear and colored glass. The multiple layers set up a play of light within the glass and produce a gemlike radiance. Similar layers are often found when ruby-red glass from early Gothic windows is examined under a microscope. The layers are not even and they merge and divide.

In addition to the layers, clear streaks run through the entire thickness of the glass, producing color gradations from a predominant deep red to orange to clear. These streaks (like the microscopic layers) seem to be the result of artifice and they are visible not only in red glass but in other colors as well. Thus both blue and red glass from the early Gothic era was crafted to produce variegated radiance, which was further enhanced by surface irregularities, bubbles, grit, and other more or less accidental "imperfections." Surface deterioration and accumulated dirt further diffuse light and give a unique glow to old windows.

The techniques for turning colored glass into pictorial windows were apparently established by the twelfth century and in many respects have survived unchanged to this day. The colored glass was cut up with a hot iron and assembled like a mosaic, a separate piece of glass being placed for each change of color. Complicated shapes, even if all of one color, might have been too difficult to cut from one piece of glass (or involved too much waste of the precious material), so they were usually assembled from several smaller pieces. When all the pieces had been cut and their shapes further finished with a notched tool (grozing iron) that chewed away irregular edges on the glass, then all the glass was fitted into lead strips that had an H-shaped cross section. The weak lead armature was reinforced with iron saddle bars placed here and there across the window. The lead became part of the design, thicker leads being used to outline a figure or to strengthen the appearance of a line.

Some details such as human features or folds of robes were painted on with a brownish-black enamel composed of ground glass, iron filings, and various liquefying agents. This enamel was fused to the glass by being fired in a kiln before the final assembly of the window. Sometimes the enamel details were delicately executed but the general technique had a robust quality that harmonized with the boldness of the lead lines and the strongly colored glass. When the window was installed, the enamel, like the leads, appeared as a very dark brown or black silhouette against the glowing colored glass. Unless one wishes to describe dark-brown paint as a color, all the color in early windows was in the glass itself.

To see a fine example of early medieval glass go to the Early Gothic Hall at The Cloisters. There, set in windows overlooking the river, are four panels, dated around 1250, from the Cathedral of Tours. Both the blues and reds have the streaky shimmer of good medieval glass. Although the glass is richly colored, it is also transparent. In the summer one can see the shiny leaves of the tree outside fluttering in the wind, catching the sun, and reflecting it through the ancient glass.

The colors in the glass come from metallic oxides, which were dissolved in the vitreous mass while still in the smelting pot. Cobalt for blue, copper scales for green, and so on. *Pot metal* is the general term for transparent glass colored while still molten and thus imbued with pigment throughout its body. The curious term probably comes from the fact that the process involves adding oxides of metal to pots of molten glass. In the Tours panels the colors one sees are very close to their appearance on the day the glass was new. Colors in glass seldom fade, although pigment in almost everything else does. Of all our losses to time, none has been more substantial than the colors in ancient art. We have misconceived the original aesthetic of Greek sculpture, for example, because we do not see it painted in full colors. The Parthenon was not a chaste white edifice but a polychrome spectacle. The muted tones of old tapestries are not the tones originally woven into them. The colors of Leonardo, Rembrandt, Michelangelo have all faded. But the stained-glass windows of the Middle Ages, patched and repaired as they are, bring us into direct contact with the imagination of another age, with the brilliant colors that delighted medieval mankind.

The four panels from Tours were originally in at least two different windows, and the scenes within the panels were at some time altered so the story they depict is not clear. The religious and, occasionally, secular tales recounted in stained glass were of course of great importance to an illiterate society. Even for people who could read, the "storied window" constituted an admirable addition to the scarce supply of historical and devotional literature. Happily for our own age, we need not have a full understanding or sympathy for the subject matter in a stained-glass window in order to enjoy it. Good stained glass has a strong impact on one's vision, and the power of the color and light in scrambled, rearranged windows can still transfix the beholder. One can also see in the figures of windows like these from Tours the evocations of character and feeling that we associate with the Western tradition of humanism. Despite the difficulty of depicting nuances of human feeling in the awkward medium of glass, the precious material was labored over by cutters and enamel painters until figures like the maiden in figure 2, her hand raised in an expressive gesture, emerged in these windows to halt one's gaze.

Only recently were the specific subject matter and origin of these windows discovered. Two of the panels concern the Crown of Thorns, a Thorn from which was purchased by Louis IX from the Byzantine Emperor. Only because he was desperate for cash was the emperor willing to part with such a precious relic, and the right-hand panel in figure 2 celebrates its acquisition by France. Louis appears here bearing the whole crown, which looks like a green doughnut. In the accompanying panel (not illustrated) a bishop seems to be exhibiting blue air, but his hands, scholars now assume, once also held the Crown of Thorns. Something happened to the piece of glass that originally was framed by the bishop's hands. Possibly a workman's ladder slipped, or a boy threw a rock (who knows what happened to the fragile glass), and it was replaced with a piece of plain blue glass. The glazier who spread the lead flanges to insert the new glass may have been ordered simply to put in something quickly, something to keep out the rain or the glaring sunlight. The repair was likely to have been especially careless if it took place during one of the eras when stained glass was not in favor. Whatever the circumstances, the missing Crown of Thorns was never replaced. The stopgap piece of blue has sufficed ever since because the beauty of the window's glass and the charming figures were enough to delight the viewer's eye.

The Tours panels are not, incidentally, the oldest or necessarily the most important early glass in New York City; they have been discussed at length because they are indeed fine windows but also because they can be examined closely and their sunbathed setting gives them full life. The frontispiece on page ii of this book, showing God (as Christ) closing the door of Noah's ark, is one of several splendid earlier windows installed at The Cloisters' parent institution, The Metropolitan Museum of Art on Fifth Avenue. Among the early windows at The Cloisters itself is a small section of ornamental border from one of the original windows (c. 1144) of St. Denis, now set in the hall that leads to the northwest terrace. In the Early Gothic Hall there are several windows besides those from Tours, the most remarkable being a head of Abiud, one of Christ's ancestors (Matt. 1:13). Abiud is from a clerestory window of an abbey in Rheims, and dates from around 1180.

The Early Gothic Hall at The Cloisters adjoins the

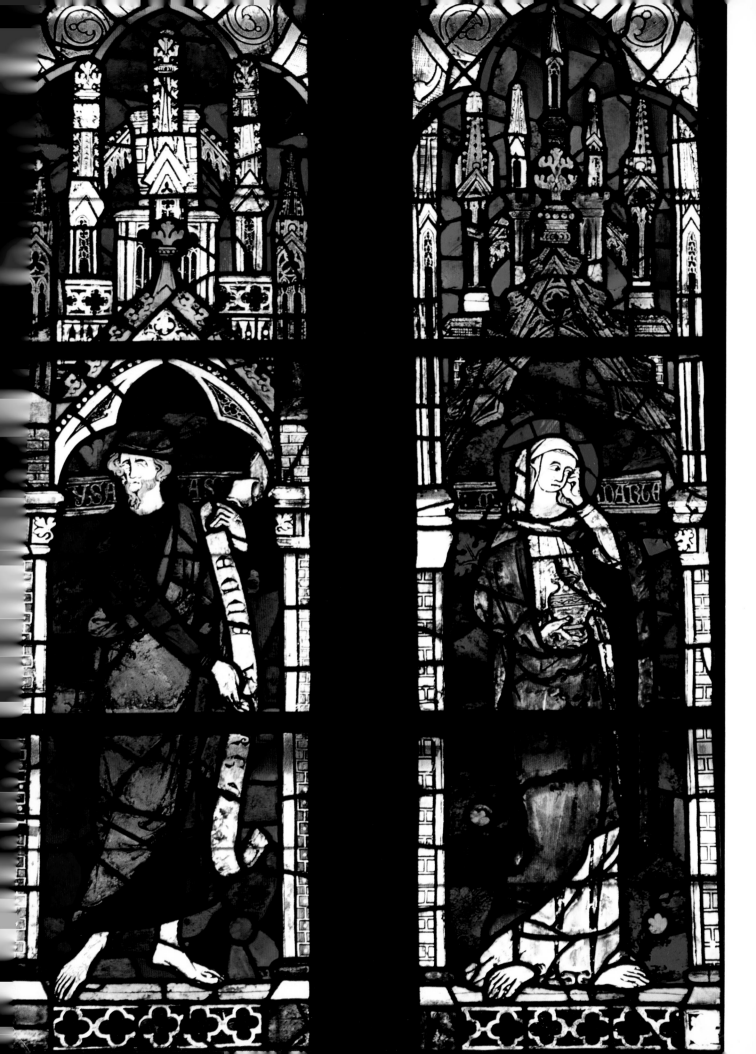

Gothic Chapel, whose windows illustrate major developments in fourteenth-century glass. To the right of the steps that lead down into the chapel are two windows, made around 1325, said to be from Normandy, France. Shortly before these windows were made, it was discovered that a solution of silver salts could be applied like paint to make a design, and then fired, with the surprising result that the silver turned golden yellow and sank into the glass as a permanent transparent stain. Because of the silver constituent the golden effect is called, rather confusingly, *silver stain.* This modest innovation had a substantial effect on the design of fourteenth-century glass and an even greater impact on subsequent eras, when it encouraged the development of more complicated, detailed painting on glass.

In the Normandy windows silver stain appears in the color of the hair and the ointment jar of the figure inscribed *M. MARTE,* who is not a "Marte," or Martha, at all, but Mary Magdalene. This mislabeling is another example of the carelessness that perhaps reveals the importance of the decorative over the didactic aspects of stained glass, at least to later generations.

Both figures in the Normandy windows stand beneath fanciful canopies. The glassy arches, gables, and pinnacles of the canopies provided an attractive answer to a problem created by Gothic structures. As the buildings, especially the great cathedrals, grew higher and higher, the windows became ever taller and proportionally narrower. (The process finally stopped at Beauvais when the architects built a cathedral so high and teetery that most of it fell down.) To fill tall, narrow windows figures were elongated, as one can see in the Normandy panels, but there were limits to that Procrustean solution, so the remaining expanse of window was filled with elaborate arches and roofs that rise above the figures. An alternative response to the high window opening was already at hand in the use of small scenes set in medallions and arranged up and down the window. The thirteenth-century panels from Tours in the Early Gothic Hall were probably originally part of such a medallion window. The medallion panels were costly, however, because so much time from master craftsmen was required to fabricate the little scenes within each medallion. Architectural ornaments like those in the tops of the Normandy windows could be confected more quickly and cheaply, and repeated endlessly.

3. The Cloisters. *Isaiah and Mary Magdalene,* from a church in Normandy. c. 1325. W. of each lancet 15″. The artist in glass has been forced since the beginning of his craft to conform his ideas to the shape of the windows. Elongated figures fill part of the Normandy windows, while spires and fanciful rooftops continue the design to the top of the casements.

It is always difficult to say whether innovations like the elongated figure were due to simple practicalities such as cost, rather than to changes in aesthetic desires. Western Europe in the fourteenth century was beset by the Black Death, famines, and the Hundred Years' War, and the income of the church seems to have suffered. Consequently one suspects costs to have influenced styles. However, there was also a desire for more light in churches. Elaborate canopies were a convenient device for light-admitting geometry in pale glass, above the more richly-colored figures. Another device for admitting light and lessening cost is apparent in the Normandy

4. The Cloisters. *Ebreichsdorf Annunciation.* Austria. c. 1390. W. 13½″. Famines marked the first decades of the fourteenth century, then the Black Death struck around 1347 and recurred throughout the remainder of the century. Despite the horrors of plague and starvation, scholars have been hard put to find a substantial darkening of the human spirit in the art of the fourteenth century. This exquisite Annunciation, formerly in the chapel of the castle of Ebreichsdorf, Austria, now greets the morning sun on the east wall of the Gothic Chapel at The Cloisters.

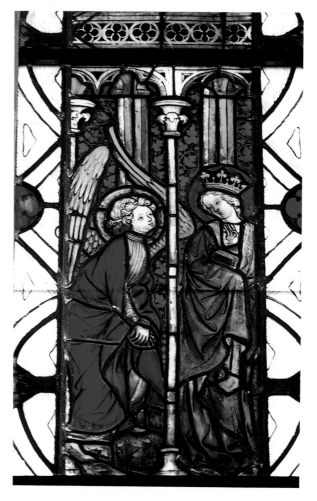

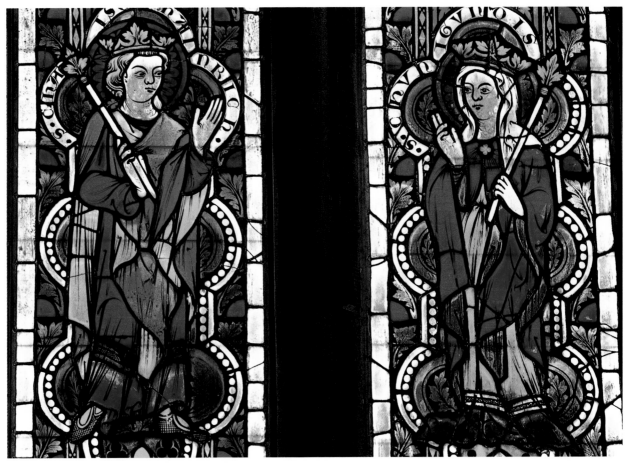

5. The Cloisters. Panel from St. Leonhard's Church, Lavantthal, Austria. c. 1340. W. 14″. A variety of brilliant colors, including typical German greens, and sturdy, firmly drawn figures characterize this window from a provincial workshop in southern Austria.

6. The Cloisters. The Boppard Windows. Germany. c. 1440. W. of each panel 28½″. High canopies rise above the figures in the Boppard Windows, giving harmony to an ensemble of six lancets and letting in much light through extensive passages of pale gold and white glass.

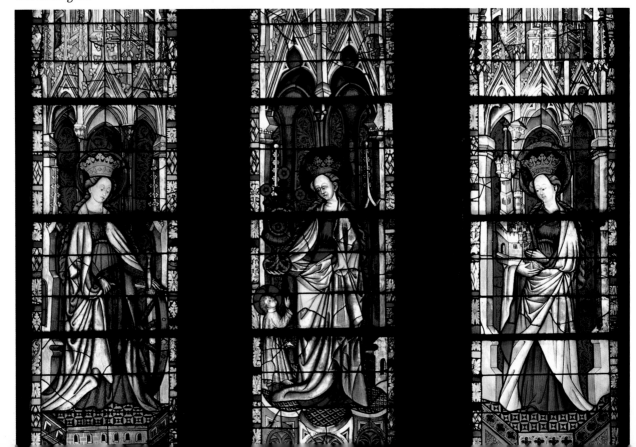

windows. Both above and below the figures are panels of colorless glass painted in a repeating pattern of foliage. This type of glass is known as *grisaille* (French, to paint or make gray) and will be discussed more fully later in this book. These grisaille designs could be repeated endlessly in tall windows as filling both above and below the band of colored figures. These windows that combine figures and grisaille are, in fact, called *band windows*.

In the east wall of the Gothic Chapel is an Austrian window that was probably made in the imperial workshops of Vienna. This gently humane *Annunciation* scene was designed around 1390. The elongated figures, delicate ornament (note the leaf pattern background), and vertiginous canopies can be seen as evolutions from the already-refined style of the Normandy windows into a widely practiced artistic mode—the International Gothic style.

To a Viennese or Parisian sophisticate of the four-teenth century the three tall windows in the chancel of the Gothic Chapel would have looked old-fashioned. A modern viewer quickly sees that they are indeed quite different stylistically from the Normandy and Vienna windows, yet they were designed around 1340, when the International Gothic style was supposedly imposing itself on European taste. The chancel windows (figs. 5 and 88, p. 90) are from the church of St. Leonhard in Lavantthal, southern Austria, and they demonstrate the continued vitality of older styles and the emergence of national or regional preferences in glass design.

This variety of styles persisted in medieval Europe and was revived in the glass of later eras. The medallions and the stocky figures in the St. Leonhard windows may suggest thirteenth-century glass, but the windows are surely from the next century, and one can find similar revival or persisting styles in many areas. Color preferences also changed with time and geography. Comparing the

7. The Cloisters. Detail from the Boppard Windows showing Christ crucified.

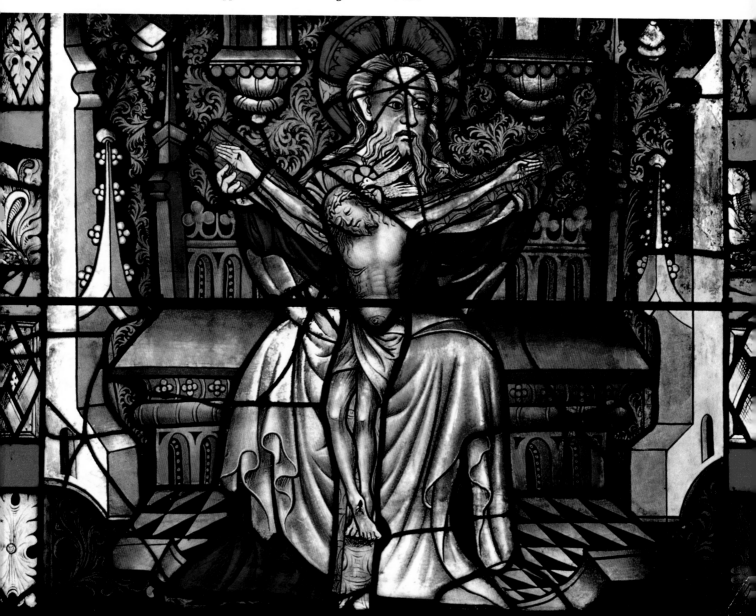

St. Leonhard windows with the Viennese *Annunciation,* one is more aware of red, blue, and violet in the latter window—probably French influences—as opposed to the palette of strong greens amid reds so frequently seen in German glass. The sturdy figures in the St. Leonhard windows are executed in a blunt and straightforward way, and the designs are intricate, but not delicate. In the Viennese *Annunciation* a deftly curling line evokes the foliage, the folds of the robes, and the sinuously turned figures. One sees by comparing the two sets of windows that the glass of one era, and one country, may exhibit substantial stylistic differences. That most eclectic of all centuries, the nineteenth, would take full advantage of the variety of traditions begun in the Middle Ages.

The Cloisters' most important example of fifteenth-century glass fills the south wall of the Boppard Room. Six large and extraordinarily well-preserved lancets (figs. 6 and 7) from the convent at Boppard, south of Cologne, fill the room with a golden light. They originally all came from one enormous window and were made around 1440, probably by masters from Cologne. They are less strongly colored than most earlier windows. A similar expanse of thirteenth-century glass would overwhelm the Boppard Room with deep colors and bold forms. One can see in medieval glass a slow evolution toward a paler palette, less bold figures, and combinations of color and design that admit more light, until, finally, stained glass was not used at all. The Boppard Windows are evidence of this evolution. One can see how the elaborate passages of white glass and silver stain in these canopies admit a good deal of light. In the Boppard Windows one can also see another function of canopies—to unify sets of figure windows. The repeated forms and colors of the canopies give harmony to the south wall of the Boppard Room, as they did in their original setting in the church. This architectural unity supports the assumption that stained glass is an architectural art. The six Boppard Windows interact with one another, with the framing stonework, and with the entire room: they create an environment. If one substituted other glass, say one of the St. Leonhard windows, for any one of these windows, the effect on the remaining panels and on the appearance of the room would be drastic. Not only would the harmony of the Boppard panels be lost but the light and the effect of the entire room would be changed. The Boppard glass is so harmonious and admits so much light that the room can be used as an exhibition hall for objects other than the windows themselves. The effect of the light that filters through them and that is reflected on the alabaster altar and the brass lectern in the museum gallery must be very like that of their original setting in the church at Boppard. One rarely sees in museums such a fully realized conjunction of glass and architectural context.

Descending the stairway adjoining the Boppard Room, one emerges in a hall glazed with two late medi-

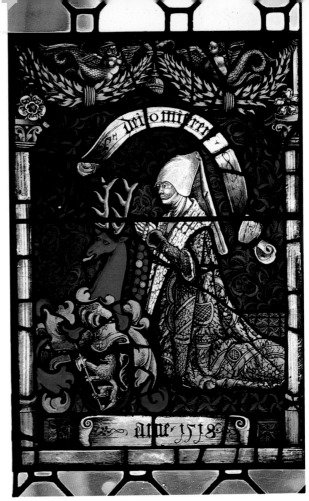

8. The Cloisters. *Barbara von Zimmern*. Germany. 1518. W. 16½″. The window commemorates Barbara's marriage to Wilhelm von Weitingen. When her family discovered that Wilhelm was courting her, she was sent away for a year, but Barbara overcame her family's objections to Wilhelm. The marriage took place, as memorialized here, in 1518, but the lovers' happiness was brief; Barbara died two years later.

eval (or early modern, if the reader prefers) windows from Swabia. Executed in rich colors and small in size, they do not admit much light. They could not be seen properly if strong illumination were introduced into the room from other sources, or if they had been placed in a large space like the Boppard Room. Hence the panels have the modest stairhall to themselves, as they must, for they were made originally for a domestic setting in a private house. The Swabian windows celebrate the marriage in 1518 of Wilhelm von Weitingen and his wife, Barbara von Zimmern (fig. 8), each of whom is depicted kneeling with his respective coat of arms. These windows show every technique invented in the Middle Ages for the manipulation of glass into imagery. Barbara von Zimmern's gown is fashioned from brown enamel and silver stain, as are the ornamental borders. To obtain the shadings of her face and headdress, the artist carefully applied enamel, scratched away highlights, and then fired it. The background of hop vines and birds was created on enamel-coated blue glass. The enamel was scratched off to produce the design and then fired. The head and neck

of the stag, its tongue, and the two gold flourishes at the base of the neck were all created on one piece of *red-flashed* glass (clear glass fused with a layer of red glass). Craftsmen ground away the red layer in the area of the stag's eyes, its tongue, and the gold flourishes. Silver stain was applied to these areas, and the glass was fired to turn the stain yellow-gold. A final series of firings fused the black enamels that the artist had applied to outline the tongue, the eyes, and the flourishes. The golden lion on the shield was created by a process similar to that required for the stag's head. After the separate pieces had received all the various treatments described, they were assembled in leads, putty was squeezed into the crevices between the leads and the glass, the central iron bar was added, and the window was finished. During any of the steps outlined above the glass might crack. In the kilns the paints might burn or run; after firing, the silver stain could be any color from light yellow to murky brown. The window thus represents an enormous effort in patience and skill.

The *Barbara von Zimmern* window was probably made for a house of one of the couple's parents, and a second set, apparently made for the other parents, can be seen at the Cooper-Hewitt Museum. The making of such windows was a custom of the time and suggests the growing popularity of stained glass for secular uses, particularly in the form of small panels installed in people's homes. Although religion remained a popular subject in stained glass as in all the arts of the Renaissance, secular scenes became more common and they were, of course, less freighted with conventional forms than were religious themes. Burghers who commissioned portraits of themselves in stained glass or in the new oil paints wanted realism, not icons. Realism included perspective, details of fashion, architecture, and commerce and gave more attention to individual character and worldly incidents. All had been present to varying degrees in medieval art and in the early Italian Renaissance, but the modern, bourgeois notion of realism as opposed to earlier ideals may be seen in extreme contrast by comparing a figure in early medieval glass with any oil portrait painted in the Netherlands or Germany in the fifteenth century—Jan van Eyck or Dürer offer familiar examples. To apply Renaissance realism to stained glass was difficult, and the growing fondness for verisimilitude made extreme demands on the craftsman in glass. The smaller size of domestic windows made matters worse; it is much easier to cut and work big pieces of glass for a vast cathedral window than the small pieces for a miniature scene to be viewed at close range. Being aware of the new demands swirling around the glassmakers' art and visualizing the effort that went into the *Barbara von Zimmern* window, one can imagine the eagerness with which craftsmen sought more flexible techniques.

The simplest way to make cheaper pictures in glass

was to exploit the already-known techniques of blackish enamel and silver stain. By the fifteenth century the original blackish enamel made from iron filings was used mainly for outlines. A warmer tone for modeling was achieved by using either iron sulfate or sienna earth mixed with ground glass. This new kind of enamel was often applied by stippling to obtain subtle effects. Enamels could be painted onto a single pane of clear glass, often disk-shaped and called a *roundel*. No leading was involved in creating the scene. After firing the roundel to make the enamel and stain permanent, the roundel could be joined with lead to the clear panes of a larger window. A window might have a number of these roundels in it. The Glass Gallery of The Cloisters is glazed with a fine collection of such small painted panels, mostly made in the Netherlands in the sixteenth century. Their fabrication was simpler and cheaper than the laborious techniques associated with the *Barbara von Zimmern* window. Of course the results were not nearly so rich, being limited to shades of yellow stain and sepia enamel on clear glass (fig. 9).

The technique tends to produce an effect not unlike a monochromatic woodcut. The resemblance to the pictures in early printed books was, however, more than merely coincidence of effects. After Johannes Gutenberg and others had made cheap printing possible, books containing woodcuts, engravings, and etchings were widely published. By using only sepia and silver stain, glass artists could copy printed pictures for reproduction in glass. Familiarity with the linear, monochromatic printed picture probably helped the public accept similar effects in glass. The design requirements for the simple, unleaded work were similar enough to the requirements for

9. The Cloisters. *Daniel Killing the Dragon*, roundel painted with sepia enamel and silver stain. Netherlands. Early sixteenth century. Diam. 11″. The intrepid Daniel offers a ball of pitch, a substance apparently fatal to dragons.

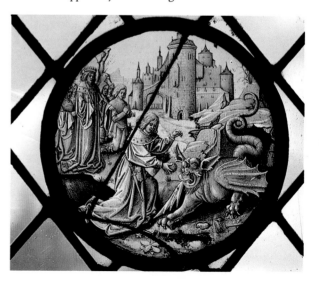

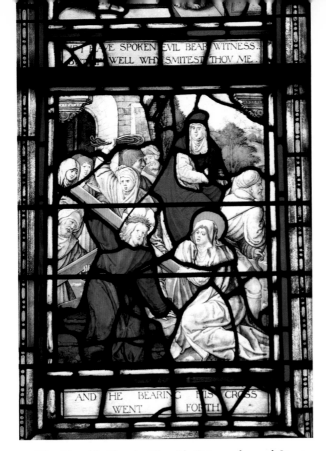

10. The Riverside Church, Riverside Drive and 122nd Street, Manhattan. The Flemish Windows. First half of sixteenth century. W. of panel shown 24″. This painterly scene is clearly a product of the northern European Renaissance, but much of the technique is still medieval: no colored enamels have been used, and the artist did not attempt to imitate an oil painting on glass.

A fine set of ecclesiastical windows from the first half of the sixteenth century is installed in the narthex hall of The Riverside Church (fig. 10). They were created in Flanders, perhaps in Antwerp. Although they were probably designed as a set, the models used by the painter are the work of more than one artist. Three of the scenes were copied from designs by Dürer. Each of the sixteen panels contains a small scene fully realized with perspective, foreshortening, shading, and anatomically believable figures. To obtain such effects, the artist used enamel paint and silver stain. The heavy use of enamel somewhat reduced the brilliance of the glass, and the windows are situated in a rather dark east wall, so they do not draw the eye from a distance. However, they repay close attention to their composition and details. The sixteen panels show incidents from the life of Christ.

The history of the windows is vague. They were transported to England during the Napoleonic Wars, but no record seems to have survived of their exact European origin. Brought to the United States in 1924 and installed in the Park Avenue Baptist Church, they were moved again in 1930 when the Park Avenue congregation took up new quarters on Riverside Drive.[2]

Another set of interesting sixteenth-century windows is in St. David's School (fig. 11) on 89th Street between Fifth and Madison avenues. Although these windows, too, are heavily enameled, their situation in a southern wall gives them the sunshine they need to come alive. They contain substantial quantities of pot-metal glass that is free of enamel, so on a sunny day they are exuberantly colorful. Although the scenes portrayed

printed pictures that some artists designed for both mediums. Albrecht Dürer not only designed for both glass and print, but his widely-known engravings and woodcuts were frequently copied in glass by other artists.[1]

The windows in the Glass Gallery represent the last glass designed with techniques developed in the Middle Ages. These windows may seem modest in comparison with the earlier glass at The Cloisters, thus encouraging the notion that stained glass was only a medieval and then, much later, a modern art form. One will abandon that notion after seeing some of the Renaissance glass at other locations in New York City.

The desire for Renaissance realism was felt in churches as well as in the secular world. Ascensions, Nativities, Annunciations, martyrdoms—the gamut of medieval religious subjects—were created anew in Renaissance styles. Artists in oil, tempera, and ink became more and more skilled at creating precise illusions of the perceived world, evoking nuance in events and space and personality. Designers of church glass struggled to keep up with the stylistic standards established by other mediums. Their efforts met with mixed success.

11. St. David's School, 12 East 89th Street, Manhattan. Untitled panels. Probably France. c. 1550. W. 48″.

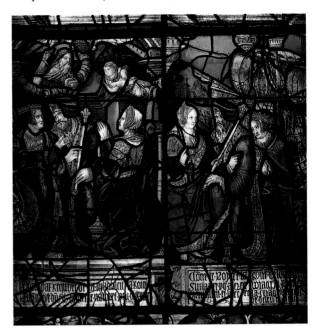

are religious and one suspects that a church was the original owner of the windows, they reflect strong secular influences. In early medieval glass people were often portrayed in vaguely archaic clothing. Such garments gradually gave way to fashions more like those worn by contemporaries. The St. David's windows are undated, but one can guess from the clothing styles that the glass was made around the middle of the sixteenth century. The inscriptions are in French, so one assumes the windows were made in France or Flanders; more likely France, because the king in the lower panels carries a French fleur-de-lis scepter. Despite the Renaissance fashions and a few tricks of perspective, these windows, as do early narrative windows, tell their story with a naïve charm. In the right-hand panel God peeps out of his cloudy heaven to suggest a pilgrimage to a king, a queen, and an elegant lady. In the next panel the royal couple have hurried down to the docks. So we can be sure to know who they are, they remain dressed in their court robes. The king, with his scepter still in his hand, is about to embark on a ship. He sails off to miraculous adventures in two adjoining panels, while elsewhere in the window we see Mary Magdalene relieved of seven squirming demons, and then we see her washing Christ's feet while he sits down to feast on a suckling pig. (Incongruities like pork on a Jewish table did not weigh heavily on the medieval and Renaissance mind.)

The provenance of these delightful windows is unknown, except that they were acquired from the Hearst Collection warehouses by St. David's School. The Hearst records are in disarray, but they may eventually reveal the origins of the glass.[3]

In both the Riverside Flemish Windows and the St. David's glass one can see the difficulty of combining subtle painting techniques with bold lead lines. In the Riverside windows the painting is especially fine, and consequently the leads look out of place among the delicate brushstrokes in enamel. One can see why artists working on glass in this period began to think of leads not as part of the design but as obstacles to its success. It is probably partly the scale of these small windows that makes the leads obtrusive. They are less noticeable in the grand scale of the Bastie d'Urfé windows at The Metropolitan Museum of Art. But even there the leads no longer play the role they did in medieval windows. Also, most Renaissance windows were designed by painters or even sculptors, and these artists were unfamiliar with the role of lead in glass designs. Thus, artists began to object to leaded compositions as being too crude for modern styles. Their objections, coupled with the high cost of the method, proved fatal to it. Leads had already been made superfluous in roundels like those in the Glass Gallery of The Cloisters. To minimize leads in more ambitious, fully colored work, sixteenth-century artisans developed colored enamels. These, coupled with silver stain and the old sepia enamels, allowed craftsmen to abandon

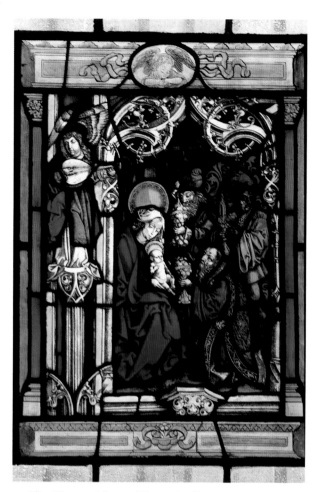

12. The Pierpont Morgan Library, Madison Avenue and 36th Street, Manhattan. *Adoration of the Magi,* unidentified artist. Probably Switzerland or south Germany. Sixteenth century. W. approx. 19″.

completely the mosaic method of composition using colored pieces of glass bound together with lead.

Colored enamels consisted primarily of ground glass and oxides that became fairly transparent when fused to clear or white glass. As an entire scene could be painted in colors on a single piece of glass, all the old techniques of flashing, abrading, cutting, and leading were rendered unnecessary, if one were satisfied with the appearance of colored enamel. Colored enamels seldom have the brilliance of pot-metal glass. Enameled glass can, however, take on a rich translucence when fine enamels are carefully applied. Such control seemed difficult to achieve in large windows, but on a small scale excellent results were regularly obtained by Dutch, German, and above all, Swiss craftsmen in the sixteenth and seventeenth centuries. Even when the enamels were crudely applied, the Swiss often had a fine eye for color and artfully interleaded enameled panes with pot-metal glass.

There are good sixteenth- and seventeenth-century enameled windows at The Pierpont Morgan Library on

Madison Avenue and 36th Street. They demonstrate how well the glass stainer's craft was adapted to small-scale enamelwork. Most of these panels are heraldic, and the stylized forms and bright specific colors of heraldry make for happy results when executed in glass. The panels in the West Library Room are particularly interesting. Most of them are from German-speaking regions (fig. 12) of Switzerland, or from Germany itself,[4] but their colors recall much older glass. Because the West Library Room is roped-off to visitors (one can only step inside the door), the windows must be viewed at a distance of some twenty feet. From that distance one's first impression might be of the fine blues and rich reds reminiscent of thirteenth-century France or Norman England, but one also quickly sees an abundance of silver (that is, gold-colored) stain, making these windows different from the coloration used in early medieval glass. The designs reflect the painting styles of the Renaissance. These panels were commissioned for homes, not churches. The lavish use of silver stain makes some of these windows essays in gold and red: the red a fine luminous ruby, the gold rich. The blue, which was so important in early Gothic glass and gave it a sense of deep mystery, appears in these windows as a subordinate chord to the harmony of the warmer colors.

Some of the windows show a complete break with the medieval tradition: their colored passages consist entirely of enamels on white or clear glass. This "debasement" of the craft could nevertheless produce a lovely effect, as witness the bottom panels of the southwest window. Other panels in the Morgan are even finer because they contain a judicious mixture of enamelwork and delicately leaded pot-metal glass.

Glass enamels, if properly prepared and fired, will endure for centuries without change. Unfortunately, many years may go by before a faulty enameling process reveals itself, and so the techniques remained somewhat imprecise and dependent on personal skill and luck. An example of decayed enamel from the Renaissance is found in the southwest window of the Morgan. The reds in the center panels are flaking off an otherwise very handsome work. However, most of the enameled glass at the Morgan was well made and has survived not only centuries in Europe but perhaps even more perilous decades amid the fumes of midtown Manhattan.

Glass painters using colored enamels concentrated their efforts on clear glass and wanted a smooth, flawless material. In the sense that their desires were fulfilled, the quality of glass improved in the Renaissance. Attention was no longer lavished on the production of the irregular, "imperfect," colored glass of earlier eras, and what was made usually looked smooth, clear—and lifeless. The uninteresting quality of such colored glass may have hastened the disappearance of fully leaded pot-metal windows. Whether poorer materials were cause or effect, stained glass of all kinds became less common as the Ba-

roque style developed dramatic sun-drenched interiors that required large clear windows. Stained glass might still be used for an occasional effect, as in St. Peter's Basilica in Rome where Giovanni Bernini's *Gloria* above the throne of St. Peter has a stained-glass panel for its central point, but this ornament is only a minor part of the basilica. Dramatically lit sculpture, opulence in marbles and metals, and gilding constitute the splendor of St. Peter's, not the mysterious soft light from stained glass. Although small domestic panels like those at the Morgan remained popular in the Low Countries and Central Europe into the early eighteenth century, stained glass as a major art form had disappeared from the rest of Europe two hundred years earlier.

Stained glass was thus in decline in much of Europe during the seventeenth and eighteenth centuries when

13. The New-York Historical Society, 170 Central Park West, Manhattan. Heraldic panel, attributed to Evert Duyckinck. Diam. approx. 10″. Duyckinck did not arrive in New Amsterdam until 1638, but the year *1630* inscribed on this roundel may refer to a past event. Whether or not Duyckinck actually made the roundel, contemporary documents confirm that he had a busy career in New Amsterdam as a "glass burner," making numerous panels that were similar to this one.

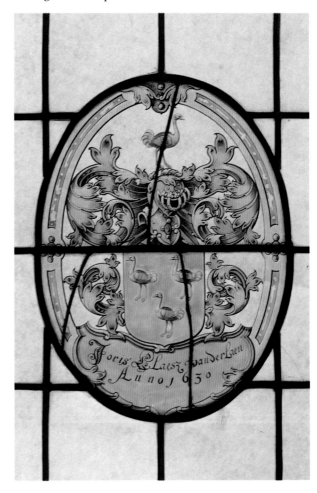

the English Colonies were being settled. Indeed, the Puritans of New England were coreligionists of the fanatics who hurled rocks and pikes against the stained-glass saints and "Popish gauds" in English church windows. The Calvinist Dutch who settled New Netherland were not so relentlessly pious. As we have seen in the roundels of the Glass Gallery of The Cloisters, depictions of a family's coat of arms or a miniature scene in glass were popular in the Netherlands during the early modern era.

Soon after the Dutch West India Company acquired Manhattan Island in 1626—with those little glass beads, among other trinkets and utensils the Indians wanted—ships' manifests from Holland began to include painted windows, presumably for the homes being built at the southern tip of the island. In 1638 Evert Duyckinck (1621–1702), a painter, glazier, and "burner of glass" came to New Amsterdam and set up his business on the outskirts of town, near Wall Street.

The free and easy notions of genealogy and nobility among the Dutch in what was, after all, a frontier settlement, made it easy to claim an impressive coat of arms, and many burghers wanted one. Duyckinck was happy to oblige. All through the seventeenth century he and his descendants made roundels of glass with coats of arms "burned" on them in enamel paint and metal salts. These were the first stained-glass images known to have been made in the thirteen Colonies. A few of these little panes have survived, stored away in the vaults of The New-York Historical Society (fig. 13) and The Metropolitan Museum of Art. Somewhat more elaborate windows

were sometimes installed in homes, with many armorial panes to display a family's ancestry. Duyckinck seems to have been a busy man. He made a window for the Council Chamber of the Stadhuis (city hall) showing the arms of the city. For this work he was to receive twenty beaver skins, although a year after he installed the window he complained to the council that he had not yet been paid. He also installed armorial windows in churches, as memorials to members of the congregations, but none of his larger works has survived. Duyckinck's descendants carried on his trade into the eighteenth century, but the glassman's craft was not then much appreciated. Although there may well have been other artisans in glass in the city, none is mentioned in surviving records.[5] The English, who came in the late seventeenth century, apparently did not adopt the Dutch passion for heraldry in glass. Little stained glass was being made then in England, and in the following century still less was done.

Public buildings and churches in both England and the Colonies increasingly were glazed only with clear glass. The eighteenth-century Enlightenment considered reason and simple daylight to be appropriate everywhere, even in church. The magical colored windows of the medieval cathedral were rejected along with all the rest of what was considered to be the darkness and superstition of medieval life. In the eighteenth century old windows were even being removed from some medieval churches; the ancient glass in Salisbury Cathedral was taken out and hauled away, "by the cartload," to be dumped in the town ditch.

The Gothic Revival

By the time of the American Revolution there were already signs of the coming Romantic age. In England a major aspect of the new sensibility was the appreciation of Gothic architecture and consequently, stained glass. The enthusiasm for Gothic architecture was *romantic* in the large sense of the word—daydreams, fanciful notions, emotion as an end in itself, and yearning for exotic places and times far from the dreary cities and factories of early industrial Britain.

William Beckford (1760–1844) was one of the early champions of the Gothic style. Even in a country famous for its eccentrics, this novelist and son of a millionaire managed to attract national attention. "I grow rich," he said, "and I mean to build towers." In the 1790s he set an army of laborers to work erecting a huge Gothic mansion, Fonthill Abbey. The so-called abbey had a tower 278 feet high, but was so jerry-built that it fell down shortly after completion; it was rebuilt and suffered another collapse some years later. Because ruins were greatly admired by Romantics, the collapse of the tower only made the abbey more popular. By the 1820s Fonthill was a major attraction for tourists. In an age when travel required considerable effort, as many as 500 visitors a day came to marvel at the building. Among its wonders were dozens of stained-glass windows, for which

Beckford had spent 12,000 pounds. Despite his extravagant enthusiasm, the windows of the abbey must have been inferior to medieval work. Nothing like medieval ruby or streaky blue glass was available to the glaziers of the time. Although most of the ancient techniques were still known, the few craftsmen still active in the late eighteenth century were wedded to the convenience and subtlety inherent in colored enamels. Asked to re-create ancient windows, their reaction was to paint on white glass a scene or figure drawn in a purposefully "barbarous" manner. Pot-metal glass might be inserted in parts of the design, but that material had become so lackluster that it simply further encouraged artists to cover everything with enamel.[1]

As the artists were unfamiliar with using lead lines as part of compositions, much of their leading was clumsy and meaningless. Many extraneous leads were added to imitate the repaired cracks scattered through old windows. (Incidentally, such slavish imitation died hard; when New York's Riverside Church commissioned copies of clerestory windows in Chartres Cathedral around 1929, they got exact duplicates, right down to every fracture that had been immortalized in lead over the last 800 years.[2])

As Gothic architecture became more popular, seri-

ous attention was paid to revitalizing the old techniques. Even at the height of the eighteenth-century enamel style it was recognized that the materials, if not the designs, in medieval glass were superior. To encourage better glass art in France, the government set up a studio at the Sèvres porcelain works (an indication of the assumed close connection between enamel painting and stained glass). The first products from Sèvres appeared in 1827, and in the same year Ludwig I of Bavaria established stained-glass works in Munich. The Munich works were the most important in Germany and were to have a substantial influence in other countries, but neither in Munich nor at Sèvres was much early progress made in creating the material or styles needed to equal the power of medieval windows.[3] There are references to stained glass in New York churches as early as the beginning of the nineteenth century, but one suspects that this glass was of little interest. Although one source asserts that by 1820 it was an exception to find a New York church without stained-glass windows, none of those windows seems to have been remarkable enough to create much comment, and the historical sources are almost totally silent. In 1833 a William Gibson set up a "manufactory" in the city for the production of stained glass, principally for church and theatre decoration. His firm soon failed, however, through what was apparently a combination of low quality in his product and the fact that people were "too poor" to afford stained glass.[4] In 1840 the *Evening Post* commented on a display of stained glass set up by the American Institute at Niblo's Garden, saying, "It is rather surprising to those who have observed how useful as well as ornamental windows set in stained glass are, . . . that they are not in more general use." At that time the firm of Carse and West at 472 Pearl Street furnished "specimens of staining upon glass . . . in a variety of figures and shapes, intended either for steamboat or packet ship lights, transparent signs, window blinds, skylights and other purposes for which stained glass is commonly used."[5] The few casual and vague references to early nineteenth-century glass make one suspect that the windows themselves were of little consequence. In the 1830s one American author suggested that the effect of stained glass could be obtained cheaply by painting Gothic imagery on linen or muslin and placing the translucent cloth in windows. However, in the 1840s a more serious attitude began to manifest itself, and in New York City three major installations of stained glass occurred.

The first of these major installations was in Trinity Church at the foot of Wall Street, the second was for the old St. Patrick's Cathedral on Mott Street, and the third was in the Church of the Holy Trinity in Brooklyn Heights. Before any of these projects got underway, however, a relatively modest window was made by William Jay Bolton in his backyard workshop in Pelham Bay.[6] This *Adoration of the Magi* window was completed by

1843 and it is the immediate precursor of the extraordinary set of windows that Bolton began around 1844 for the Church of the Holy Trinity in Brooklyn Heights.

William Jay Bolton (1816–1884) was very much a child of the Gothic Revival. His family was well-off, pious, and artistic; his grandfather Jay was a famous English minister who in his youth had worked as a mason's apprentice on Beckford's ill-fated Fonthill Abbey. During his childhood in England William Jay Bolton accompanied his grandfather on trips in the countryside, making picturesque sketches and seeing works of art. Family ties also brought William to Cambridge where he apparently was impressed by the sixteenth-century windows at King's College Chapel. In 1836 the Boltons came to America. They settled in Pelham Bay in Westchester County, New York, where William's father built a Gothic manor house, the Priory, and a family church. William came into New York—it was then a long rural journey from Pelham Bay to the city—to take lessons at the National Academy of Design. He studied under Samuel F. B. Morse, won prizes, and in 1840 sailed for Europe to see the works of the old masters, especially the Italians. When he returned to Pelham, he began his stained-glass work, with the first substantial result being the window for the family church. His next project was on a grand scale, sixty windows for the Church of the Holy Trinity (now St. Ann and the Holy Trinity) in Brooklyn Heights, but before those were finished, the glass for Old St. Patrick's, Mott Street, and for Trinity Church, Wall Street, had been completed.[7]

The windows for Old St. Patrick's were the gift of the King of France, Louis Philippe, to the rather beleaguered Roman Catholic Church of New York. Documents and details on the history of these windows are missing, but for some reason they were not installed in the cathedral, being given instead to the chapel of the little Catholic college that had just been founded on Fordham Heights up in the Bronx. Why the windows were not used in the cathedral is unclear—one story is that they were the wrong size and indeed they show signs of having been cut down to fit smaller frames. The windows are said to have been installed in 1846. The chapel was built in 1845, and Louis Philippe lost his throne in 1848, so the purported year of installation, 1846, seems to be approximately correct.

The six windows now at Fordham show the ambivalent French approach to the Gothic Revival. They have areas of pot metal in them and contain Gothic ornament in the canopies and in the predellas beneath the saint portrayed in each window. Despite these medievalizing effects, the windows could never be mistaken for real Gothic artifacts. *St. Mark*'s (fig. 14) contrapposto stance and foreshortened arm owe an obvious debt to the Renaissance, and the windows depend on enamel paint for much of their effect. The artist attempted with his enamels to give each figure a three-dimensional presence, in-

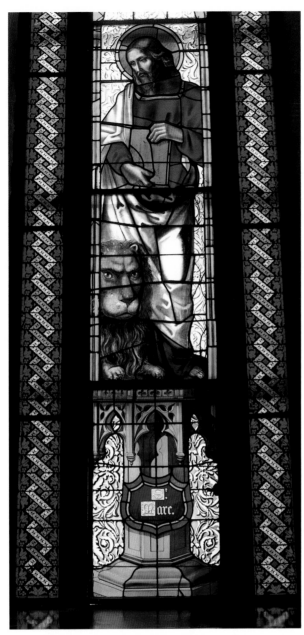

14. Fordham University Chapel, Fordham Road, The Bronx. *St. Mark,* probably painted in the Sèvres Studios, France. c. 1845. W. 40″.

cluding robes painted as if sharply focused light were making highlights and deep shadows in the rich cloth. The faces of the saints are examples of what was then (around 1846) considered to be modern realism.

The lead lines in the Fordham windows are curious indications of the search for Gothic feeling in glass. In the preceding century many lead lines were horizontals that were admitted to the window only to join large rectangles of clear glass on which enamels were painted. Although the Fordham windows are not made of such rectangles, the artists at Sèvres had obviously not gone far

from the rectangular technique; much of each window consists of approximately rectangular sections but with oddly skewed proportions. These irregularities were probably introduced to give an approximation of the irregularity found in medieval windows. The horizontal leads also vary in thickness and distance from one another. Both these effects lack any technical justification. As much of the window is painted enamel, the panels could have been all approximately the same size and set in leads of approximately equal thickness. However, some of the leads are placed for design reasons that would make sense to medieval glaziers—*St. Mark*'s right shoulder, for example, is separated from its pale background and given definition with a substantial line of lead. The top of the lion's head has no such lead line to distinguish it from the robe just above its head, and in this case the absence of lead is probably wise, as the lion is already such a dramatic intrusion in the window. A powerful lead line would increase the tension between the principal subject, *St. Mark,* and the secondary focal point, the lion. One can see that the artists at Sèvres were working toward an intelligent exploitation of lead in designs, but enamel, not lead and colored glass, was still clearly their most important design medium. The windows are technically well made and apparently did not need any major attention until 1975 when they were releaded and slight restorations were made to some of the enameling.[8]

Although the Fordham windows obviously are still tied to the earliest stages of the Gothic Revival and cannot be said to have either extraordinary glass or inspired painting in them, they are nevertheless handsome complements to their setting. Their broad color passages harmonize with the simple nave of the chapel. The pot metal in the windows lacks richness, but it has a purity of tone and on sunny days it fills the chapel with lambent color. The saints portrayed in the glass are conventional academic figures, but the painters of mid-nineteenth-century France apparently had fewer routine models of animals to draw from, and the lion peering out of *St. Mark*'s window has a naïve charm all its own.

The windows of Trinity Church at the foot of Wall Street and the Church of the Holy Trinity, Brooklyn Heights, vie with each other as the oldest major works in glass produced in this country. Trinity's great chancel window (fig. 15) was made in 1844 to 1845, while the more ambitious series at the Church of the Holy Trinity (fig. 16) was begun in 1844 and completed in 1847. The Trinity Church window represents a transition between the French mode used at Fordham and the methods we shall discover at Holy Trinity. Most of the colors in the

15. Trinity Church, Broadway at Wall Street, Manhattan. Chancel window, designed by Richard Upjohn (1802–1878); executed by Abner Stephenson. 1844–1845. W. 21′.

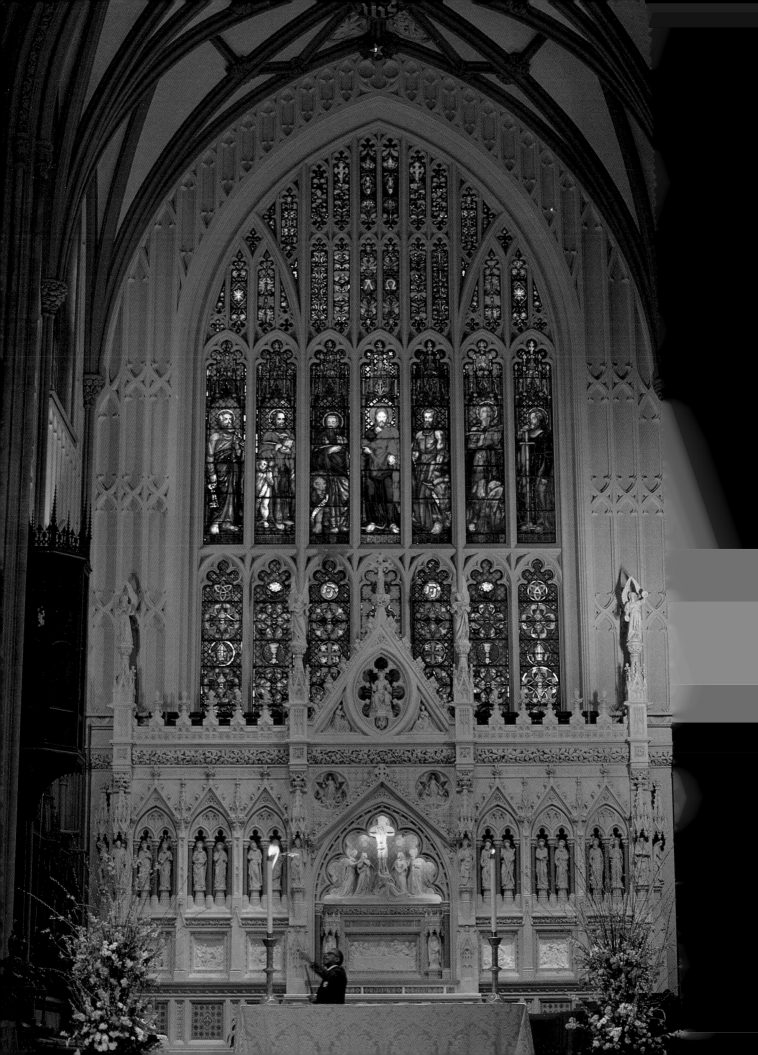

Wall Street window are pot metal, although substantial parts of the figures were painted in sepia and colored enamels. The geometric work that gives the window such decorative richness was executed in pot metal.

The window may have undergone some changes since it was made. It was controversial when new, even though the vagueness of some of the early complaints makes one wonder if critics were simply disturbed by the novelty of a vast expanse of bright-colored glass rather than by any specific flaw in the window. (Remember that in 1844 many Americans had never seen a substantial stained-glass window.) Soon after the chancel casement was glazed, a journalist reported that the glass had been "toned down" with smoke-colored glass to reduce the glare on the altar. Critics were still not satisfied with that modification, however, claiming it was inadequate to remedy "the poverty of the window's original design, and it [the smoked glass] has rendered the shadows thick and dirty and obliterated the bright lights."[9] The smoked glass was later removed, but no other changes, save releading, are mentioned in the records of Trinity Church[10] and there are no "thick and dirty" shadows in

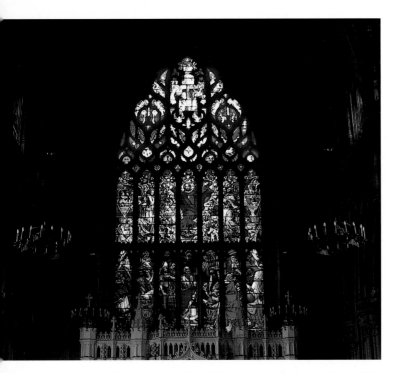

16. Church of the Holy Trinity (now St. Ann and the Holy Trinity), Clinton and Montague streets, Brooklyn Heights, Brooklyn. Chancel window, William Jay Bolton (1816–1884), probably with assistance from John Bolton. 1844–1847. W. approx. 20'.

17. Church of the Holy Trinity. *Christ Calming the Sea,* William Jay Bolton. 1844–1847. W. 66".

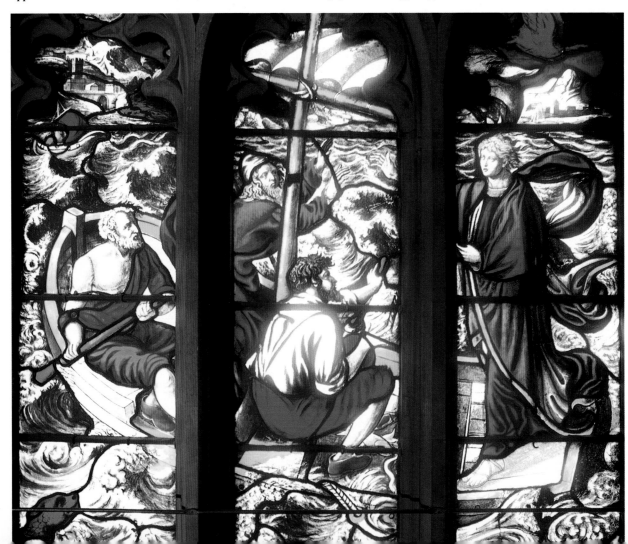

the glass. The glass is in fact only lightly touched by the glazier's trick of applying a grimy wash to "antique" and tone down a window. The light passing through the pot-metal glass at Trinity is controlled by elaborate, little enamel patterns applied to the glass surface. Such patterns, known as *diaper work,* have been used to control light since the earliest eras of stained glass, and they have the advantage of cutting out some light (where the enamel blocks it) while allowing the remainder to pass through the glass in sparkling purity.

Records at Trinity Church indicate that the glass for the window was imported from Germany. In quality it resembles the pot-metal glass in the Fordham windows: thin, transparent material in simple colors. The Trinity glass is so clear that one can make out the shapes of office buildings through some spots in the window, yet in the late afternoon when the sun is directly in the window, it does not flare in the glass or overwhelm the design. The fine diaper work successfully controls the window's appearance under extreme lighting conditions.

Richard Upjohn (1802–1878), the architect of the building, has been given credit for the design of the window, and Abner Stephenson supposedly fired and leaded it. Thomas F. Hoppin (1816–1872) was probably the artist responsible for the actual cartoons of the figures and for painting their images on the glass. Hoppin has been ignored in the skimpy accounts of the Trinity chancel window, and the whole question of who did what at Trinity is muddled, but the end result of the collaboration remains today almost unchanged. With minor repairs and one releading during some 130 years, the window has withstood weather, riots, subway trains rumbling below, and changing tastes.[11]

There is a substantial similarity between the *St. Luke* and *St. Mark* panels at Trinity and the same figures at Fordham. Since the arrival date of the Sèvres windows is in doubt, one cannot say whether they were in New York by the time Upjohn, Hoppin, and Stephenson executed the Trinity designs, but the similarities are numerous in the panels mentioned: the postures, the size and position of the accompanying beasts, and the form of the canopies. However, as the Sèvres windows themselves probably were derived from other models, it is quite possible that the Fordham and Trinity windows bear resemblances because both were based on currently popular designs.

All the figures in the chancel window at Trinity, Wall Street, were painted in "modern" styles, as were the figures in the glass at Fordham. At the Church of the Holy Trinity in Brooklyn Heights it will become clearer why such anachronistic combinations were employed— Gothic patterns, Gothic buildings, Gothic window openings, Gothic ornaments in the windows, but figures and scenery painted in styles inspired by the Renaissance and compatible with what has been called the "romantic neoclassicism" of artists like Ingres.

In the 1840s Brooklyn Heights was a wealthy neighborhood, and for the corner of Clinton and Montague streets, Minard Lafever (1798–1854) had been commissioned to build a grand neo-Gothic church. He designed a structure with sixty large windows, all to be filled with stained glass. In the chancel window in back of the altar the plans demanded a great window 20 by 40 feet, about the same size as the chancel window at Trinity Church on Wall Street. All the glass in the church, more than 2,000 square feet of it, was designed by William Jay Bolton assisted by his brother, John. They painted, fired, and leaded the windows in the modest studio on the Bolton estate in Pelham. How much assistance they had is unclear, but the design and execution all seem to be theirs, a remarkable fact, when one realizes the entire project was completed in less than five years.

Although the general principles of medieval glassmaking had never been totally lost, the specific techniques were poorly understood in the first half of the nineteenth century. A thorough exposition of the history and techniques of stained glass did not appear in English until Charles Winston's *Inquiry into the Differences of Style Observable in Ancient Glass Paintings . . .* was published in 1847—too late to help Bolton. Although Bolton had pieced together a relatively sophisticated approach to leaded glass, his windows show considerable evidence of experimentation. Lacking a full range of colors in the glass available to him and also probably unsure of his enamel tones, he occasionally painted thin layers of enamel on both sides of the glass, a technique generally not used in earlier or later eras of glass art.[12] Bolton also sometimes used a wash of enamel to modify the color of a piece of pot metal, which may have been an indication of the lack of variety and quality then available in pot-metal glass, but perhaps also a heritage of the heavily painted windows produced in the Renaissance. Bolton's compositions were mainly in pot-metal glass, and he used leads in a sensitive way as part of his designs. There are some meaningless leads inserted here and there but the windows have suffered seriously from time and many of the superfluous leads are repaired cracks rather than part of the original design.

Although Bolton's work marks an advance toward windows with the power of earlier glass, his style of painting was anchored in Renaissance verisimilitude. He particularly admired Raphael. The use of three-dimensional illusions in glass does not work well with the blunt lines and uncompromising color areas of a mosaic-style, fully leaded window. One may wonder why Bolton seized the technical opportunities of his medium and yet avoided the easy harmony of medieval styles on the undeniably flat, mechanistic surface created by a matrix of lead lines. A partial answer lies in a historical simplification: the development of Western art in the 500 years or more before Bolton began to paint was dominated by a drive to re-create perceived reality "scientifically." Bol-

ton could not be expected, in 1844, to wish to repeat the "bad drawing" of early medieval windows. Furthermore, enthusiasts of the Gothic Revival were often careless, especially in America, about archaeological accuracy. The Revivalists were creating a *new* style, based on the Gothic but not confined to it. They were aware of the pitfalls in treating glass merely as a surface for paint, and to obtain the brilliance of the old windows they returned to the mosaic method of composing in colored glass and lead. But they were unwilling to return to the imagery in medieval windows. To some extent they liked late medieval glass; Bolton particularly admired the sixteenth-century windows of King's College Chapel at Cambridge because they were not only filled with color and light but were more like "finished pictures." But even these were apparently not filled with sufficiently "modern" figures, figures in dramatic movement, realized in three dimensions. In 1872 Bolton wrote:

we cannot go back to the 13th or 14th centuries for anything, and we need not.... We want something fresh, varied, and adapted to our times.... If Gothic we must have, let it be enlightened, progressive, 19th century Gothic.... [W]e possess better materials, a less superstitious religion, and a more cheerful taste, with all the experience and examples of the past to guide and correct.[13]

Bolton's windows are clearly combinations of late Gothic and Italian Renaissance work. Bits and pieces of classical ornament appear in the windows, and many of the figures are derived from Raphael. Bolton's attention to perspective and textures are both remote from even late English Gothic glass. And yet his windows are not merely Renaissance paintings on glass. His extensive use of pot metal and lead required him to simplify his designs and modify many illusionistic devices, so that his style, although often derivative of Raphael, has a robust quality compatible with glass and lead.

The windows of Holy Trinity constitute a summary of the Bible. On the ground floor each window shows a section of a Jesse Tree, representing the ancestors of Christ. The Tree of Jesse was one of the most popular themes in medieval glass. Based on Isaiah's prophecy that the Messiah would be born of the royal line of David: "And there shall come forth a rod out of the stem of Jesse, and a Branch shall grow out of his roots" (11:1), most medieval Jesse Trees occupy tall windows, with Jesse reclining at the base of a great branching tree or vine. Limbs sprout above him, bearing the kings of Israel. In the crowning branches often appear Mary and, above her, Christ. There were endless analogies associated with the Jesse Tree: "I am the vine, ye are the branches" (1 John 15:5), "the Tree of Life" (Gen. 2:9), "the rod of Aaron" (Num. 17:8), and so forth, so that the Jesse Tree appears in many guises in medieval imagery. Bolton's interpretation, however, seems unique in stained glass, being a horizontal series with each window depicting a massive tree in whose branches sit three of Christ's ancestors.

To save time and to give harmony to his Jesse Tree series, Bolton resorted to reusing portions of a single cartoon; the tree trunks are all identical, and the angels flanking the trunk are mirror images of each other. The windows escape monotony through the use of the various ancestors of Christ perched in the tree branches, as well as miscellaneous ornamental work. The repeated elements in the windows not only lend harmony to the windows as a series but help unify the large interior of the church. Above the Jesse Tree series, which fills the windows of the aisle level, there are two more tiers of glass. A summary of the New Testament moves through the windows at gallery level, and above them, in the clerestory, are scenes from the Old Testament.

The glass in the clerestory windows is lighter-toned than that of the windows below, as it was thought that the best sort of "spiritualizing gloom" in Gothic churches should result from relatively bright high places with somber effects at pew level.[14] However, today at Holy Trinity some bright light breaks in at every level because of cracks and holes in the glass. Bolton in his haste and inexperience perhaps did not create the most permanent of work. At the beginning of this century a major restoration was necessary. It was done by the distinguished Otto Heinigke (1850–1915), who greatly respected Bolton's windows. In 1906 he described seeing them: "Surrounding me on every side was a grandeur . . . that is surpassed only by the very best work abroad. There is nothing in this wide country so worthy of our efforts at preservation."[15] Yet Heinigke's restoration has deteriorated rapidly, more rapidly than work he did elsewhere at approximately the same time. One therefore assumes that the poor condition of the Holy Trinity windows is due to problems other than either Bolton's or Heinigke's lack of skill. Stained glass requires frequent minor repairs; lead tends to sag and pull away from glass, and if not attended to minor lead failures compound themselves. For several years the church was closed (due to a bizarre quarrel between the congregation and the bishop of the Diocese of Long Island) and no maintenance was done. Another problem, probably the more serious one, is the subway under the Church of the Holy Trinity. The church once had a high steeple and other Gothic adornments but construction of the BMT subway so weakened the steeple that it had to be pulled down in 1904, along with much of the exterior ornament. The ensuing seventy-five years of rumblings in the basement have not been studied scientifically for their effect on the glass but one suspects that the subway has been a major culprit in the deterioration of the Holy

Trinity windows. A fund drive is underway for another restoration. Jane Hayward, Curator of The Cloisters, encouraged the preservation of the glass with these words: "The windows at Holy Trinity have a monumental nobility of spirit and architectural design ... preserving these windows is an absolute necessity, both on the grounds of their historical importance and their artistic merit. As a complex they are unique in this country."[16]

After the fine start at Trinity Church on Wall Street, and the even more impressive accomplishments at Holy Trinity in Brooklyn, American glassmakers of that generation created few distinguished windows. Although Upjohn designed several other ambitious churches in the city, any early glass in them has either disappeared or lacks distinction. Bolton completed a series of windows for the Church of the Holy Apostles on Ninth Avenue and 28th Street in Manhattan, but the glass here is less interesting than that of Holy Trinity. Minard Lafever, who again was Bolton's supervising architect, created a building closer to Renaissance ideals than those of the Gothic Revival. The interior of Holy Apostles has handsome barrel vaults echoed by round-arch windows. The church was completed in 1848, and in the same year Bolton finished ten large windows designed to harmonize with the lines of the vaulting and the window openings. Against a quiet background of leaf patterns Bolton painted in each of the ten windows three large roundels executed with brown enamel and silver stain. Unfortunately he was not a particularly gifted figure painter, and most of the interest in sepia roundels depends on the genius an artist can impart to simple line drawings; Dürer could succeed with a linear style; Bolton was not so successful. His windows at Holy Apostles are handsome and appropriate to their architectural context but they are not comparable to his work at Holy Trinity in Brooklyn Heights.

After the installation of the Holy Apostles windows William Jay Bolton went back to England. He worked on the restoration of the King's College Chapel windows for a year, then abandoned his artistic career, was ordained, and spent the rest of his life as an Anglican priest.

Despite the abrupt end of his artistic career, Bolton helped synthesize the Gothic Revival style in glass, which consists basically of a combination of late medieval and Renaissance techniques and styles.[17] That combination of styles varied widely. Some artists created windows that rivaled the best of previous eras, and efforts in England and France to improve the quality of glass resulted in splendid material becoming available again for the first time in hundreds of years. Despite such progress the use of colored enamels remained a temptation to other artists to repeat the unhappy process that had eventually corrupted the stained glass of the Renais-sance: the neglect of mosaic work in colored glass in favor of enamel painting on white glass. Artists as talented and sensitive as Bolton were rare in America. Many windows of the Gothic Revival are essentially paintings in enamel (see fig. 89, p. 91). As styles changed later in the century, the pseudo-Gothic designs in such glass looked old-fashioned, and because the poorly enameled windows lacked luminous splendor, they frequently were discarded for more fashionable works.

Many of the New York churches built from around 1850 to the early 1880s no longer have their original windows. In domestic buildings, which fall prey faster than churches to the wreckers' balls or changes in use, even fewer windows of the early era have survived. One of the rare examples of early domestic glass in the city is in the Jefferson Market Courthouse (built in 1876) on Sixth Avenue and Christopher Street in Greenwich Village. The courthouse was beautifully restored in 1967, except that much of the original stained glass was removed and panes of plate glass were installed in place of the delicately mullioned old windows.[18] Although the glass itself had little to recommend it, the original architects (Withers and Vaux) had happier notions about architecture, windows, and glass, than did the restoring architect, Giorgio Cavaglieri. A window can ruin a wall, and large single-pane windows are particularly treacherous because they often look like black holes and interrupt the continuity of the wall surface. When Cavaglieri took some of the stained glass out of the Jefferson Market Courthouse, he replaced it with the worst imaginable alternative—sheets of plate glass. The courthouse is Ruskinian Gothic, the Venetian-inspired Gothic that includes richly textured, polychrome walls. The windows of such a building should be part of the ornate wall surfaces. The style requires mullioned windows, or better yet, leaded and stained glass to integrate the walls and the window openings. If conventional stained glass is used, it of course has no color to speak of when viewed from the outside in the daytime, but the pigments in the glass catch enough sunlight to give the glass a soft tonality, and the leads do much to soften and articulate the window surface.

Happily, dozens of panels of stained glass were left in the courthouse, and one can see, particularly in the Sixth Avenue facade and the tower, how the original windows contributed to the general appearance of the building. One can also see how the new windows give part of the structure the blind look of a burned-out, abandoned building. The courthouse is now the Jefferson Market Library, one of the city's public libraries. The new windows are not even particularly functional; on gray days they let in more light, but on sunny days it is more pleasant to read in the rooms still lit by the softly tinted stained glass.

One should not be too critical of the restoring architect, for, as indicated, the glass itself is not remark-

18. Middle Collegiate Reformed Dutch Church, Second Avenue and Seventh Street, Manhattan. *Virgin and Child* (derived from a painting of the school of Giovanni Bellini), unidentified artist. 1860s (?). W. 14″.

able. It consists mostly of conventional diaper work painted on *quarries* (little squares) of dull-colored glass. The windows in the tower stairwell contain enameled portraits of dreamy women. The craftsmen who made the windows are unknown, although one suspects that they were Americans and local, as the building was constructed by the city government.

A well-executed survivor of the pure enamel style exists at the Middle Collegiate Reformed Dutch Church on Second Avenue and Seventh Street in Manhattan (fig. 18). The central scene uses no leads and no colored glass; it is, in the simplest sense of the word, a *painted* window. The window is undated and of unidentified provenance, but a likely guess would be that it was made in the 1860s, either in this country, Britain, or Germany. One can assume that the window was not designed for the present 1892 building. The central scene is not the right size for the casement it fills; the incongruous opalescent glass framing the central scene has surely been added later, merely to make the window fit its present frame. A painting in the manner of Giovanni Bellini or some similar fifteenth-century Italian master inspired the window, which deserves comment for its subject matter as well as its technique. As the discussion of Bolton implied, paintings by artists like Raphael were major sources for Gothic Revival stained glass. In figure 18 one sees that tendency in its simplest form, the mere copying of a painting onto glass. By comparison, Bolton transformed Renaissance paintings into true stained-glass designs. The mere copying of paintings became less common not only because Bolton and others exhibited more satisfying ways of exploiting Renaissance paintings but also because Renaissance paintings and medieval stained glass did not adequately express some of the ideas of the nineteenth century. The subject matter of the Bellinian window contains the basic elements of popular nineteenth-century imagery, but those elements were to be substantially changed by European and American artists and craftsmen in the era of Victoria.

The three main components of figure 18, the Virgin, the Holy Child, and the landscape background, were all transformed during the course of the last century. The *Virgin and Child* would of course continue as major subjects for Christian art, but for both religious and secular art there would also emerge two distinct, separate, new idealizations: childhood and womanhood.

The two topics were not merely derived from previous secular treatments of children and women, although such secular antecedents were very important. Childhood as we shall see it in stained glass is a reflection of notions developed in the last century that children were spiritually closer to God than adults, were even "angelic." Similarly, woman was elevated to a higher place and assumed to be both nobler and purer than man. The third subject in figure 18 is the landscape, but it is merely a background, of little importance in itself.

In the Middle Ages landscape was scarcely conceived of as a subject. With a few late exceptions like Jan van Eyck there was no serious landscape painting until the Baroque era, and even then masters like Nicolas Poussin and Claude Lorrain apparently felt that raw nature was an inadequate subject—their landscapes almost always contain human beings or the works of man. The Romantic era was the period that developed nature in itself as a great popular subject for painting and literature. Stained-glass artists exploited the Romantic notion of the sublime in nature to create a new ecclesiastical subject: the pious landscape.

As far as stained glass is concerned, the sublime or pious landscape and the apotheosis of woman both developed mainly in the later decades of the nineteenth century, therefore there will be discussion of those topics in succeeding chapters. However, the idealization of childhood begins early in stained glass, and to that subject we now turn. The introduction of putti into Renaissance art has been seen as an early aspect of the very slow development of warmer and more humane attitudes toward children. However, for centuries after the Renaissance children in art seem to have been mostly incidental subjects—with the exception of course of the numerous depictions of the Christ Child. The two cherubs in figure 19 are derived directly from a Renaissance painting, Raphael's *Sistine Madonna*. However, unlike figure 18,

which is probably derived in its entirety from a painting, the cherubs were originally mere details extracted by the stained-glass artist from Raphael's *Madonna*. The transformation of these details into subjects for a stained-glass window suggests the new importance, particularly in the English-speaking world and especially in America, of childhood. Foreign travelers had long noticed that Americans were indulgent parents, but their indulgence was often tempered by the stern aspects of our national heritage. The Reverend Lyman Beecher offers an example of a harshness that was fading. (He was the father of the famous Henry Ward Beecher and Harriet Beecher Stowe, both of whom had much to do with the magnificent windows at Plymouth Church of the Pilgrims on Orange and Hicks streets in Brooklyn, and both of whom eventually rejected their father's harsh views on children.) In 1835 Lyman Beecher escaped a charge of heresy partly through his testimony on infant depravity, telling the prosecuting Presbyterian synod that original sin manifested itself in the "selfishness, self-will, malignant anger, envy and revenge" that young children exhibited, and that children possessed "a depraved state of mind, voluntary and sinful in its character and qualities."

19. St. John's Episcopal Church, 1331 Bay Street, Fort Wadsworth, Staten Island. Memorial window (derived from details of Raphael's *Sistine Madonna*), unidentified artist. Installed c. 1876. W. of each panel 15″.

A half-century earlier Enlightenment thinkers had suggested that children might not be such monsters, indeed, they might even be inherently virtuous, but it was many decades before the optimism of a person like Jean Jacques Rousseau was accepted, and then exaggerated, in the Romantic sentiment that "Heaven lies round us in our infancy." Because the Romantics could assume that children were but recently arrived from heaven, "trailing clouds of glory," artists, and particularly artists in stained glass who were commissioned to make windows as memorials, began to reassure grieving parents that their lost children were restored to the state of bliss they had but briefly left for this earth. "Angelic children" became a notion applicable not only for memorial windows but also as components of stained glass devoted to a variety of other themes. By the 1870s many windows were crowded with baby angels, often merely little winged heads, like those that throng the glass illustrated in figures 96 through 100 (pp. 96–99).

One of the interesting expressions of the fondness for children and their aptitude for angelhood was the creation of rose windows filled with winged infants. The window in figure 92 (p. 93) was designed after 1888, and variations on it appear throughout the next fifty years. Indeed, the idealization of childhood seems to have increased in the last decades of the century, as the following chapters will suggest.

Among the earliest windows in America that have disappeared or remain anonymous are those of the oldest existing American stained-glass studio, J. & R. Lamb. J. & R. Lamb was founded in New York City in 1857 by Joseph Lamb (1833–1898). Lamb was educated in England and, like William Jay Bolton, had serious religious interests. On returning to New York he and his brother, Richard, started a business designing stained glass and church ornaments. They opened a studio on Carmine Street in Greenwich Village and prospered,[19] although none of their early windows in New York seems to have been remarkable enough to have been preserved or remembered as their work. Distinction would come to the studio later in the century. A talented grandson, Frederick (1863–1928), received international recognition, and his windows are still treasured as part of the city's stained-glass heritage. In the early decades of the studio, however, the works of foreign artists were favored over the Lamb brothers and other domestic studios, and the most important windows preserved from the 1860s and 1870s are from abroad.

Most of the glass imported to New York in the 1860s and 1870s was from France, England, and Germany. Each country had its own version of neo-Gothic glass, and although records are scant, one can be fairly sure of the national origins of windows by comparing styles. In ecclesiastical glass the denomination is also a clue to provenance: Catholics favored French or German

glass, while Episcopalians were drawn toward English work. In this era most other Protestant denominations and Jews avoided stained glass or used simple and inexpensive geometric windows.

FRENCH GLASS

When the Roman Catholic Archdiocese of New York began a new cathedral in the 1850s, the commission for the glass went to French studios. Documentary evidence is missing, but one may guess why the windows were made in France rather than elsewhere abroad. The Catholic Church in America had stronger cultural ties with France than with any other Continental nation, and in the 1860s German glass had not yet established much of a reputation in North America. British glass would have been unlikely in the cathedral dedicated to St. Patrick.

The new cathedral was begun in 1858. It was the largest Gothic Revival structure built in the United States in the nineteenth century, and it remains one of the world's largest churches. The commission for the windows was extraordinary not only because of its size but because the diocesan authorities wanted the glass finished simultaneously with the cathedral. Stained glass is so expensive that most elaborate buildings make do with temporary windows at first and gradually fill up the openings with finer glass. Not so at St. Patrick's. Illustrations of the interior made in 1878, the last year of construction, show many of the windows already fully glazed. Certainly the great aisle windows and the major transept windows were completed by 1879, when the cathedral was formally opened.

The commissions for most of the glass went to Henry Ely of Nantes and Nicolas Lorin (1815–1882) of Chartres.[20] Lorin's studio was in sight of the cathedral whose windows lent cachet to the name of his shop, but the "of Chartres" he appended never meant anything stylistically. There is no appreciable difference between his work and that of Ely. The windows from both studios are not remotely in the style or technique of the medieval glass at Chartres Cathedral. They are, on the contrary, examples of the most technically polished French enamelwork, composed in the colorful, romantic neoclassicism of early nineteenth-century French painting. Such painting had been exploited, for example, to dramatize the career of Napoleon and continued to be popular for grandiose works in oil.

In order to know something more about how the windows of St. Patrick's came to look the way they do, one should look first at their technical qualities and then at their imagery. The windows of St. Patrick's reflect the art of glass enameling in France during the Second Empire. In the brightly lit cathedral the enamels reflect so much light (as opposed to the sunshine passing through

them) that they appear more like brilliant opaque surfaces than compositions in colored glass. Indeed, part of their effect may be purposefully like the lustrous surfaces popular in Second Empire decoration. Faïence, cloisonné work, lapis lazuli, and several new kinds of glazes were part of the opulence that was equated with beauty in the society presided over by Napoleon III.

The porcelainized appearance of the windows is due not only to the elaborate enamel painting on the glass but also to reflected brightness from the cathedral walls and its electric lights. The cathedral looked much darker before its interior was completely cleaned and renovated in 1973 and 1974, and the windows had more luminous depth under the previous somber conditions. Persons who saw the windows during the blackout of 1966 report that they were magnificent, worth a special trip to see the glass glowing in a darkness as profound and as appropriate as that inside Chartres. (When all the lights are on at St. Patrick's, as they are for much of the day, a light meter reads about fifteen foot-candles of light at the crossing. The same light meter gives a reading of about one foot-candle at the crossing of Chartres Cathedral on a moderately sunny day.)

The renaissance of stained glass in the nineteenth century is usually associated with the Gothic Revival, and yet in France Gothic techniques and Gothic styles had little vogue. Perhaps the Napoleonic and Republican regimes of France imposed classical postures that were too entrenched for the Gothic Revival to budge. Whatever the cause, neoclassicism and its stepchild, the neo-Baroque, remained vital in France throughout the nineteenth century. There was of course a great interest in France, as everywhere during most of the nineteenth century, in things medieval. The brilliant medievalist Eugène Emmanuel Viollet-le-Duc (1814–1879) became Inspecteur des Monuments under Napoleon III and received a substantial budget to restore medieval French buildings, including the glass in them. The craftsmen he directed accomplished much in imitating the materials and styles in medieval glass. Despite the work of Viollet-le-Duc and a national program that resulted in many restorations, the French were not much interested in new buildings or in art done in a medieval manner. For new stained glass the French favored postmedieval styles and techniques. Artists like Charles Maréchal (1801–1887) and technicians like Tessie du Motay developed refinements in enamel technique that won popular acclaim. Even French experts who were dedicated to purist revivals of medieval glass admitted that some of the new enamel windows were excellent.[21]

The windows of St. Patrick's show how thoroughly the art of enameling in glass had been mastered during the French Second Empire. Although the windows combine pot metal and leading with enameled glass, there is little disjunction between the two mediums. The surfaces of the glass have almost everywhere been worked

with vitreous glazes, unifying the effect throughout each window. Although pot metal and enamelwork were thus harmonized, the leads proved more stubborn. Enamel was used to paint complex three-dimensional scenes, and blunt, opaque lead lines cannot be made to disappear completely in such scenes. A great deal of thought obviously went into the windows and the leads often are well hidden or exploited as part of the design, but inevitably some of them intrude on the illusions of depth and volume created by the painterly enamel technique.

Historians of glass have criticized the windows of St. Patrick's not only for their technique (that is, enamel rather than pot metal) but also for their anachronistic style. The windows are obviously not Gothic in any archaeological sense. Their polished enamel technique and intense illusionism take them much farther from medieval work than anything done by Bolton. They are, of course, not failed imitations of medieval work. They are a nineteenth-century French style consciously chosen to

20. St. Patrick's Cathedral, Fifth Avenue and 50th Street, Manhattan. *St. Henry,* probably Lorin of Chartres. c. 1878. W. 162″. The technical superiority of Second Empire enamelwork distinguishes this French window.

portray historical and religious truths. The style was assumed to be beautiful too, but that beauty had to incorporate "truthful" representation. In the nineteenth century truthful painting conveyed as fully as possible the illusions of depth, volume, and movement. Hence the style of these windows is determinedly "realistic" rather than imitative of Gothic imagery.

The windows do contain Gothic elements, but they are restricted to the ornamental borders and the elaborate canopies. The style of the ornamental work should not surprise us; its function is to frame the scenes in the windows, and provide transitions between them and the Gothic stonework of the cathedral.

The window dedicated to St. Henry serves as an example of the ideals behind the great enamel windows in the nave of St. Patrick's. There was more popular and scholarly interest in history in the nineteenth century than ever before. "The discovery of the past" was a fairly recent phenomenon. The nineteenth century reveled in that discovery, as one can see from the amazing variety of historical revivals produced by Victorian architects. History had always been an important matter to the church, too, which based itself on a historical document, the Bible, and a continuing record of miraculous and pious events. The narrative windows in medieval cathedrals related mainly biblical stories and the history of the church, but that history was reduced to a sort of hieratic notation unconcerned with details of time and place. By the nineteenth century such simplified illustrations were inadequate, not merely for the supposed crudeness of their style but because they omitted or distorted narrative detail, specifics of costume, evidence of architectural eras, of scenery, particulars of weapons, vehicles, and armor—in short, the details that distinguished "then" from "now." Nineteenth-century artists considered it absurd to portray Pharaoh as a fat burgomaster, or to dress Caesar Augustus in a shapeless nightgown. Although Catholics still assumed that the windows of a great cathedral should convey the timeless truths of Christianity, a modern window had to present miraculous events in believable historical settings. If the story called for some angels to appear in the scene, as they do in the *St. Henry* window, then one should take all the more pains in depicting the shoes of the soldiers, the terror of the horses, and the anatomy of St. Henry's spear arm.

The windows of St. Patrick's are thus not at all "mistaken" intrusions in a Gothic structure. Under the medieval canopies one sees framed, as if by time-dissolving portals, historical scenes that are to be believed explicitly. The perspective is flawless, the figures are anatomically perfect, the costumes are believably antique, and the action could not have been more accurately or abruptly frozen if we were seeing stills from a movie. These windows are the didactic, historical art of that romantic and yet literal-minded age, the nineteenth century.

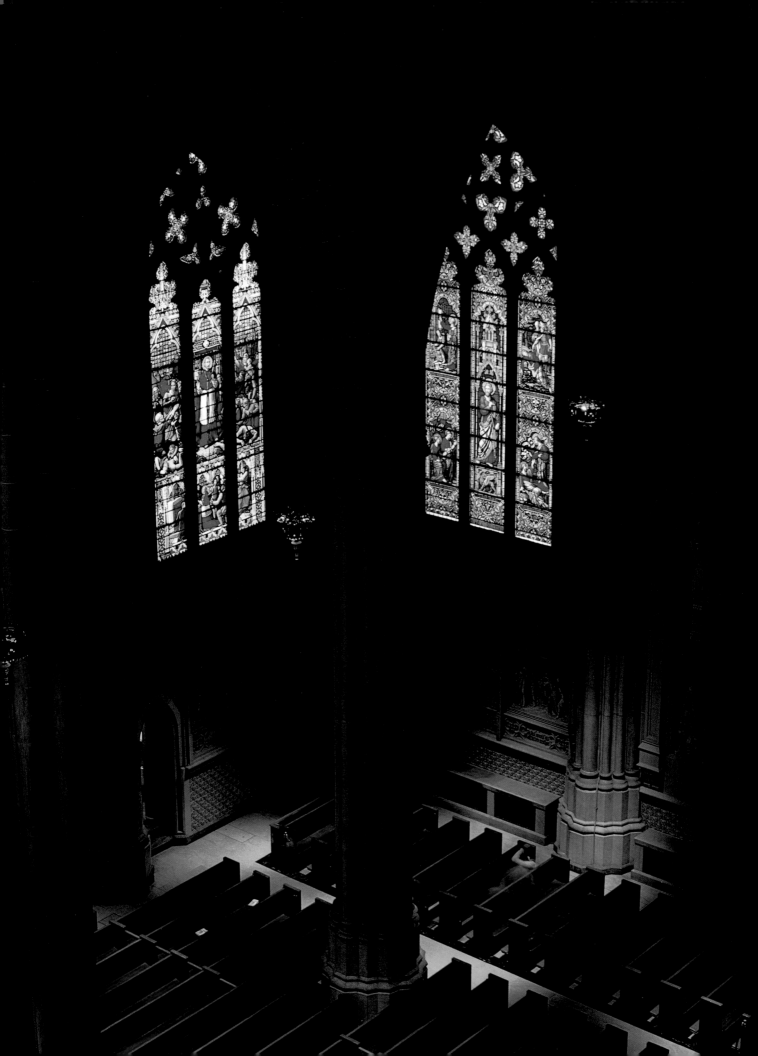

An interesting contrast to the French glass at St. Patrick's appears in Christ Episcopal Church in Riverdale, The Bronx. *The Supper at Emmaus* (fig. 22) was painted in the studio of Eugène Stanislas Oudinot (1827-1889). As the window dates from around 1890, it may have been executed by Oudinot's assistants, but clearly it is a work of his imagination and style. He founded his successful Paris studio in 1854 and was apparently influenced by the Pre-Raphaelite movement. Although he appreciated Pre-Raphaelite painting, he ignored the English Pre-Raphaelite glass, which was usually simpler and more stylized than that school's work on canvas. Oudinot used enamel to re-create the precise details and abrupt perspective of what was, in the 1850s, avant-garde English painting. He painted windows for the splendid Gothic Revival Church of St. Clothilde's in Paris and did work at Notre Dame, but his expensive glass (*The Supper at Emmaus* cost 25,000 francs) is uncommon in America.[22]

BRITISH GLASS

Victorian Britain contributed many windows to New York City. British designers, like their French counterparts, were caught between their desire to paint "realistically" and at the same time to create windows with a Gothic flavor. The English were more serious about the Gothic Revival than were the French, but like the French, British artists could not forget what they knew about mimicking depth, light, and human anatomy.

The windows of the Church of the Incarnation on Madison Avenue and 35th Street in Manhattan offer a summary of British work from the later Gothic Revival. The church dates from 1864, but all the glass was destroyed by fire in 1882. The prosperous congregation quickly restored the building, including many new windows, which were in place around 1885. The windows exhibit varied styles, mainly because different studios did the work. Even though artists might come and go, each studio tended to maintain its own style. Some ateliers in the 1880s were continuing designs they had developed in preceding decades, and some of the glass at the Church of the Incarnation is similar to work by British studios prior to the 1880s. (Once a cartoon has been worked up, the temptation exists to use it over and over again, especially if some of one's clients are foreigners who will never know the difference.) Other studios manifested

22. Christ Episcopal Church, 5030 Riverdale Avenue, The Bronx. *The Supper at Emmaus,* Eugène Oudinot (1827-1889). c. 1890. W. approx. 14'.

new directions in their designs, but in general the English glass at the Church of the Incarnation approximates a brief summary of British glass from the mid-1850s to the 1880s.

In this church there are too many windows by distinguished artists for one to call it a typical collection of glass, but the assemblage does represent a common connection between Episcopalians, Gothic architecture, and British windows. The relationship between the Anglican communion and English art deserves some comment beyond the obvious religious and cultural affinities. The Gothic Revival in architecture was stronger in Britain than elsewhere. This was partly because Britain was the most urbanized and most industrialized nation in the world during the nineteenth century and therefore the one most attracted to dreams of rural quaintness. To many Britons living through the late eighteenth and the early nineteenth century, classical architecture began to connote a tedious urbanity and even had associations with republicanism, paganism, Bonapartism, and the other horrendous doctrines of revolutionary Europe. The Gothic, by contrast, was a "Christian" style. The ideolog-

21. St. Patrick's Cathedral. Some of the finest windows in St. Patrick's are in the north and south transepts. Those shown here are in the north transept and are similar in style and origin to the *St. Henry* window (see also fig. 93).

ical virtues of the Gothic were taken so seriously that magazines and societies were started to agitate for "Christian" art, and intelligent people could believe that Renaissance styles were symptoms of moral decay. When he first went to Italy as a youth, John Ruskin wrote, "St. Peter's I expected to be *disappointed* in. I was *disgusted*. The Italians think Gothic architecture barbarous. I think Greek heathenish."[23]

Ruskin eventually relented somewhat in his hostility toward Renaissance classicism, but throughout his life he and many Englishmen felt that the culture produced by urban societies like ancient Rome or industrial Britain distorted human nature by removing mankind from direct contact with nature and simple, honest work. In short, Gothic architecture evoked for the British that better, rural world that was slipping away from them. The British also believed (wrongly) that they had invented the Gothic, thus making it a uniquely national and appropriate style for them. In France, as previously noted, the Gothic Revival consisted mainly of restoring or rebuilding medieval buildings, but in England thousands of new structures, including the Houses of Parliament, were built in various forms labeled "Gothic." Religious beliefs were entangled with the enthusiasm for the Gothic. "Purity" and "truth" floated through the antiquarian literature demanding authentic Gothic architecture. The imaginative synthesis of medieval and Renaissance techniques employed by Bolton at the Church of the Holy Trinity in Brooklyn Heights were unacceptable in some English church circles.

An alternative to Raphael and the Italian Renaissance was the late medieval style, like that used at King's College, Cambridge, and that, as mentioned before, was admired by Bolton himself. The window that fills the west end of the Church of the Incarnation (not illustrated) is in the style of fifteenth-century English glass. It was made by C. E. Kempe, whose studio was one of the first to flounder into the difficult problem of making stained glass that would be appropriately medieval without displaying too much "bad drawing."

Copying late medieval designs was difficult for most contemporary artists; the main way they developed an image was through the manipulation of dark and light areas: the image was not "there," not fully realized on the paper until shadows and highlights gave the contemporary eye the configuration and position of all objects and their relationship to the viewer and the light source. To copy medieval styles, with their relative indifference to light, perspective, and volume, was not only difficult conceptually but was an admission that one's own era lacked interpretative power. Although bishops, learned societies, and fanatical antiquarians insisted on "pure" Gothic art, modern ways of seeing and painting usually crept into the imagery of British windows. The windows that William Jay Bolton made for the Church of the Holy Trinity in Brooklyn Heights were his way of combining medieval and modern sensibilities, but his work, with its Renaissance ornament as well as Raphaelesque imagery, would be to English purists an example of how often artists corrupted Gothic ideals. Stricter attention to history was desired in England.

Clayton and Bell was a respected English house that had developed an acceptable quasi-medieval style. *St. Paul Preaching on Mars' Hill* (fig. 23), which it designed for the Church of the Incarnation, contains stiff, flat figures intended to harmonize with the canopies. (Note how these canopies lack all perspective, whereas the canopies at Fordham have sections painted so they appear to recede from the plane of the window.)

The Clayton and Bell window lacks the movement and depth found in the windows of St. Patrick's Cathedral, yet it cannot be mistaken for real Gothic work. One wonders if the artist made a "good" drawing and then introduced some mistakes of proportion, some stiff lines, perhaps left out some shading. The result still does not look like medieval art. Perhaps the closest analogy and maybe even an explanation of how the figures were created is to think of them as draped medieval statues.

23. Church of the Incarnation, Madison Avenue and 35th Street, Manhattan. *St. Paul Preaching on Mars' Hill*, Clayton and Bell, London. c. 1885. W. 48".

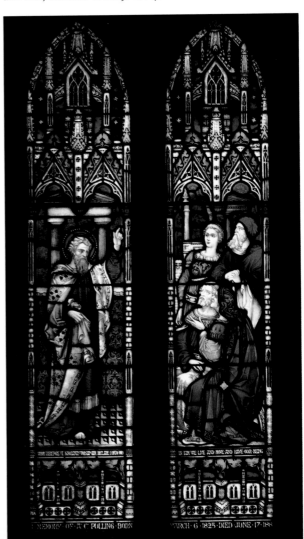

The artist may very well have envisioned a medieval jamb statue, and found therein a truly antique model that at the same time had the three-dimensional substance he could hardly avoid re-creating. Whatever the origins or inspirations of these Clayton and Bell designs, the reader can see that they are definitely meant to be evocative of another age in art, although they still reveal illusionistic devices.[24]

Before continuing the discussion of British glass at the Church of the Incarnation, one should know that almost two dozen windows by Clayton and Bell fill casements at Grace Church on Broadway and Tenth Street in Manhattan. The vestry at Grace Church apparently exercised some control in the selection of window makers—at any rate only a few studios are represented in the many windows at Grace, and no studio was more favored than Clayton and Bell. The *Te Deum* window (fig. 91, p. 92) is a handsome example of the kind of glass and imagery that filled the most prominent window (that behind the altar, or chancel window) in many Gothic Revival churches.[25]

Clayton and Bell windows are very well made. Although painting with enamel still dominates their composition, the lead lines are also an important part of the design. These windows represent a compromise in the search for a style appropriate to the Gothic Revival.

More bold than Clayton and Bell was the Pre-Raphaelite attempt to create a synthesis of medieval and modern sensibilities. The Church of the Incarnation has several windows that manifest that important episode in nineteenth-century art. The Pre-Raphaelite movement of the 1850s rejected the illusionism of artists like Raphael as being false, too clever, too neglectful of the details of nature, people, surfaces, and objects. The Pre-Raphaelites shared the common nineteenth-century belief in scientific observation, a belief that truth was to be found through scrupulous attention to facts. Through empirical investigations science and technology were uncovering the inner workings of the physical world. The Pre-Raphaelites felt that the artist could similarly reveal social and moral truths by carefully recording, by reporting, as it were, the observable world. Instead of beginning with generalizations and boldly building up salient points, the Pre-Raphaelite artist would accumulate details, and the accumulation would add up to a truthful whole.

There were many individual approaches within the Pre-Raphaelite Brotherhood, but drawing was important to the technique of most of them. The leaf, the veins of a hand, the pattern of a cloth or carpet were all carefully drawn, then colored with the rich palette reminiscent of late medieval illuminated manuscripts. Because each item in a Pre-Raphaelite painting deserved careful reporting, things in the background did not dissolve into misty vagueness or the dramatic light-and-shadow world of chiaroscuro. Misty vagueness and shadowy obscurity

help create depth and illusions of volume. The absence of such illusions was of course congenial to traditional medieval stained glass, as vague painted forms and obscuring shadows are difficult to create with the mosaic method of lead lines and pot-metal glass. The Brotherhood (as the Pre-Raphaelites are sometimes called) used perspective, which is a technique of drawing that may or may not be accompanied with paint and color, but the Pre-Raphaelites did not stress other depth-making techniques such as chiaroscuro. Some of the Pre-Raphaelites paid little heed to the importance of carefully drawn details, but most did, and so their paintings usually have a hard-edge quality. (Figure 48, *The Light of the World,* is an example of Pre-Raphaelite painting.) Although a scene full of minutely drawn details was inappropriate for conversion to stained glass, the hard-edge style was otherwise ideal for conversion to glass, and by simplifying their concepts the Pre-Raphaelites made splendid glass designs. The Brotherhood did not actually copy the painting styles that preceded Raphael. In fact, their relative inattention to previous schools of painting and their interest in observation caused them to paint in quite an original way, and their stained glass represents the first substantially new work in the field since the early Renaissance.

The Pre-Raphaelite movement attracted a number of followers, particularly William Morris (1834–1896), who were interested in translating the artistic ideals of the Brotherhood into broader social notions. Morris hoped to restore to everyday life qualities that had been destroyed by industrialization. Poorly made, tasteless machine productions should be replaced by handcrafted objects, whose qualities of design and fabrication would reflect the personal care of the craftsman. By restoring to English life the traditions of the craftsman, both workers and consumers would have the quality of their lives improved. Morris particularly cared about the decorative arts because they were, he felt, most appropriate to craft methods. Machine production had degraded the very everyday articles that could contribute beauty to the lives of ordinary folk. Furniture, wallpaper, wall hangings, textile patterns, Morris felt all these were made poorly by machines and needed the careful hand of an artisan to imbue them with functional excellence and pleasing design. Morris and other artists with Pre-Raphaelite inclinations originated a large repertoire of stylized designs for such things as wallpaper and fabrics; this artwork, like their hard-edge painting, proved appropriate for the needs of stained glass. Morris set up a firm to carry out his interests in craft production. Among the contributing artists were Dante Gabriel Rossetti (1828–1882), Edward Burne-Jones (1833–1898), and Ford Madox Brown (1821–1893). After a muddled period of idealism and adulterous distractions the association settled down to be "Morris and Company," with William Morris and Edward Burne-Jones in command.

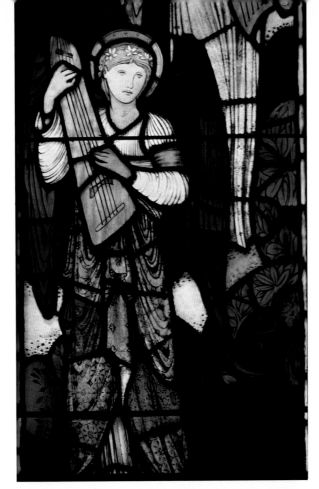

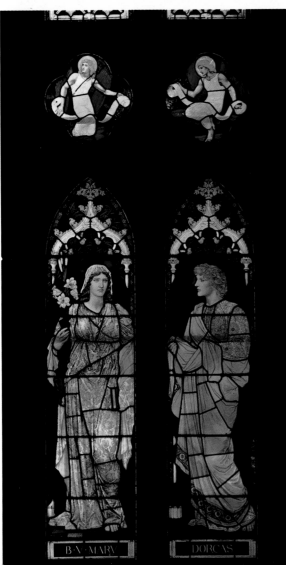

24. Church of the Incarnation. Detail of *Angels Ascending and Descending,* Morris and Company. c. 1885. W. 18″.

The business had little to do with medieval guilds or associations of craftsmen. It was a commercial studio dominated by talented artists whose style reflected the hard-edge, linear manner of Pre-Raphaelite painting. Because they understood and appreciated medieval glass, Morris and Company did not confuse painting with window making. They took the flat clarity of their early painting style, simplified it, and combined it with elements of their decorative design. (For a stained-glass window that is overtly in the style of a Pre-Raphaelite painting, see fig. 22, p. 27.)

At the Church of the Incarnation there are three windows from Morris and Company. The first two are a pair of lancets designed after the early style of William Morris (who in turn depended on Burne-Jones for many of his figures, as is probably the case in these windows). By the 1880s Morris was no longer directly involved with glass designing, but these windows are based on his early work. The theme, *Angels Ascending and Descending* (fig. 24), is meant to commemorate "infant children." Two assistants of Morris, Bowman and Dearle, actually painted the windows. The faces exhibit the Grecian profile peculiar to much Pre-Raphaelite work. The figures are line drawings whose tones depend mainly on pot-metal glass. Some colored enamels have been used along with details in sepia enamel. The figures stand against backgrounds of completely stylized foliage, and exhibit the simplicity and harmonious color typical of earlier work by Morris.

The later windows of the Morris firm tended toward more visual recession, and in the "infant children" lancets the overlapping angels imply depth in the window. This effect is not substantial, however, and the overlapping probably exists mainly to tie the figures into a tighter composition. Compared to the visages in the Clayton and Bell window, these angels lack fleshiness—no shadows or highlights give roundness to their faces.

25. Church of the Incarnation. *Faith and Charity,* Edward Burne-Jones (1833–1898). c. 1885. W. 48″. Burne-Jones painted for the privileged classes of imperial Britain. Henry James wrote of his art, "It is the art of . . . intellectual luxury . . . , of people who look at the world and at life not directly, . . . but in the reflection and ornamental portrait of it furnished by art itself in other manifestations; furnished by literature, by poetry, by history, by erudition" (*The Painter's Eye,* p. 144). Burne-Jones shed the medievalisms of the Pre-Raphaelites for a languid classical elegance that marked the end of the Gothic Revival. Despite his great reputation in Britain, the opulence and elegance of Burne-Jones were too subdued for American tastes, and his work is rare on this side of the Atlantic.

The figures are all approximately the same size, which denies their spatial recession. The ornamental foliage is of the same scale, clarity, and tone everywhere in the windows, so the general appearance of the glass suggests a design on a single plane.[26]

The third window associated with the Pre-Raphaelites (fig. 25) consists of four lancets and two little quatrefoils, all by Edward Burne-Jones, who entered the Pre-Raphaelite movement when it was already formed. He began painting pictures in the painstaking manner prescribed by the Brotherhood. To paint apple blossoms, he shivered in orchards while cold winds tore the blooms away. His paintings have the rich, detailed two-dimensionality of Pre-Raphaelite work, and most critics classify him as a member of that school. However, Burne-Jones never actually joined the Pre-Raphaelite Brotherhood, and he was too great a talent merely to imitate the style of his teachers. Neither was he interested in archaism for its own sake. Even more than the founding Pre-Raphaelites, Burne-Jones liked medieval "honesty" but not medieval art. He considered himself a thoroughly modern painter, and his stained glass is designed without any hints of the Middle Ages. He was not much interested in squabbles over whether or not Raphael was corrupt. His classicized figures show that he was no enemy of the "Victorian High Renaissance," and his discreetly sinuous lines suggest the role he would play in the development of Art Nouveau. In a few of his paintings Burne-Jones used relatively soft outlines, compared to some other Pre-Raphaelites. In stained glass, however, he understood well the needs of the medium. His windows were clearly designed from drawings, not paintings, and he depended on line rather than shadow to evoke images in glass.

Burne-Jones has been criticized for the monotony of feeling in his art, including his windows. He portrayed, Quentin Bell said, "a world without tears or laughter, a world in which no violent emotions exist, in which every one is quietly and decently sad."[27] In the Burne-Jones window at the Church of the Incarnation one learns who the figures are or what they symbolize only by reading their titles. The figures are so decorous, their attitudes so serene, that nothing seems to have touched their lives. The little figures in the quatrefoils show more energy and suggest better than the larger panels why Burne-Jones was considered a great artist by his contemporaries.

The glass and colors in all three of the Morris and Company windows show delicacy but not much genius. Morris has received praise as a great colorist, and some of his windows are gorgeous. He was probably not personally responsible for any of the color used at the Church of the Incarnation, although the palette of the *Angels Ascending* lancets is certainly derived from his inspiration. There was a tendency for the backgrounds of late Morris windows to be dark, leaving all the lighter color for the figures, as one sees in the *Angels Ascending* panels. The equipoise dear to Burne-Jones included a quiet palette,

but his window at the Church of the Incarnation contains unusually pale colors, mainly delicate golden stain laid on fine transparent glass. Although the window is in a dark north wall that is very close to a neighboring building, it manages to transform its gloomy natural light into a radiance whose warmth is remarkably subtle and elegant.

Henry Holiday (1839–1927) had connections with later Pre-Raphaelites. Some of his work has been confused with that of Burne-Jones, although the two windows by Holiday at the Church of the Incarnation are rather obviously different from the delicate golden panels just discussed. Holiday consciously considered himself a champion of the medieval tradition of window making, a composer in lead and colored glass. He wrote an intelligent book on stained glass and throughout the volume he stressed the special nature of glass as an artistic medium and reiterated the danger of too much reliance on enamel painting. As often as not he paid no attention to his own good advice. Of course, by the 1880s public taste was changing again, returning in one of its recurrent cycles toward an opulent Renaissance style that was needful of the enameler's subtleties. But whatever direction public taste had taken, Holiday had within himself the inclinations of a painter. He loved beautifully rendered details, full-fleshed studies of the human figure, opulent costumes, and dramatic situations. He also cared strongly about glass and its artistic exploitation, as his book declares and his windows prove. His painterly inclinations caused him to produce many heavily enameled windows. The two top panels in his *Ascension* (fig. 26) window at the Church of the Incarnation show how uneven his work was. The panel with the ascending Christ is a brilliant work. The symmetry of the composition helps integrate it with the surrounding architecture. The ingenious symmetry does not interfere with the energy and movement necessary to the subject. Holiday has dealt successfully with the difficult concept of a man floating up into the sky. By cropping the figure (it extends slightly beyond the mullions), Holiday strengthened its presence and eliminated an unnerving void; all is majestic and steady, while the swirling robes suggest a powerful upward flight. The unusually good red pot-metal glass adds fiery drama to the window.

All the glass in this *Ascension* has been beautifully worked, and one wonders if the red might be something quite special. It would be interesting to have it examined microscopically. There were numerous experiments at making medieval ruby glass in England during the last century. Most of the attempts came to nothing, but one wonders about this glass. The blue robe has been delicately etched with acid to bring out different azure shades. The yellows and browns include beautifully worked passages in silver stain. After seeing this panel one would scarcely credit the adjoining *Now Is Christ Risen . . .* to the same artist. Major studios like Henry

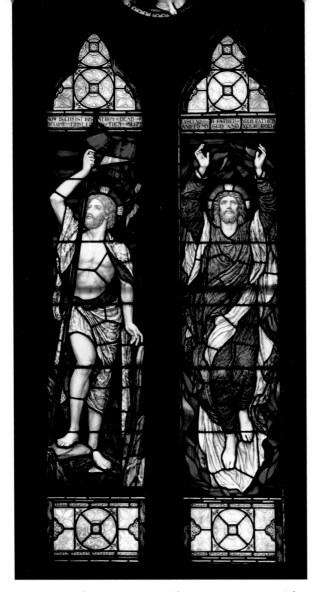

26. Church of the Incarnation. *The Ascension,* Henry Holiday (1839–1927). c. 1885. W. 48″. The figure of Christ in the right-hand panel shows Holiday's genius when he broke away from stiffly posed studies of the human form.

Holiday's employed many apprentices and assistants, and someone other than Henry Holiday may be responsible for this panel, but Holiday let it go out with his name on it, and he must be judged for that. In this lancet the posed figure is awkward—how the model's right arm must have ached—the colors are uninspired, and the window conveys little feeling in either its imagery or its glass. Many of Holiday's figures, like those of Burne-Jones, lack character and emotional power. When discussing Holiday, however, one must always expect exceptions. In his *Old Testament Window* at the Church of the Incarnation (not illustrated) he portrays Jacob blessing his children, and in that scene there are several arresting figures. Unfortunately, Holiday introduced such delicate relief to the faces that they seem out of place, like photographs cut out and pasted onto painted torsos. Portrait faces, precise, pale, and exquisitely conceived, are usually incompatible with the bold lead lines, the strong colors of pot-metal glass, and the glowing enamels such as one sees in the scene of Jacob and his children. A talented and serious artist, Henry Holiday never did shoddy work—his enamels remain perfect today—and he refused to be hurried or compromised, but he often compromised himself because of his conflicting loves for paint and glass.[28]

GERMAN GLASS

The studios established in Munich in 1827 were the first of many in that city, and "Munich glass" proved popular not only in Germany but throughout the world. English and American patrons who did not favor the gothicized styles of their own countries could find in Munich richly enameled windows, full of anecdote and painted in ebullient styles reminiscent of Baroque and Rococo art. The patron might also find excellent craftsmanship; the skills of German glassmen were so admired that the British sometimes consulted Munich experts before major projects were commissioned.

Southern Germany had been a scene of intense artistic activity in the Baroque era, and that tradition was revived by Ludwig II (1845–1886). Ludwig was interested in various historical eras—the famous Castle Neuschwanstein was testimony to the king's medieval fantasies—but his most ambitious efforts centered on daffy plans to re-create the ambiance of his Bourbon heroes and heroines, including Louis XIV and Marie Antoinette. The king spent enormous sums of money on architecture and art reminiscent of the French Baroque and Rococo, and thereby created in Munich a minor revival of those exuberant styles, wherein "much" is considered to be "barely enough." Many Munich windows are overpainted with curlicues and flourishes clumsily executed by apprentice enamelers. But much of the criticism of Munich glass stems from the simple prejudice against its style rather than the manner in which it was executed. Other opposition was propaganda from American glassmakers against "inferior" imported windows. As almost everything written about glass in America has come from the pen of an American glassmaker with the nationalist prejudices of past eras, the merit of Munich glass has been consistently underestimated. An example of the light style that Munich studios could produce is found in Grace Episcopal Church on Jamaica Avenue in Jamaica, Queens. Here the angel of *The Annunciation* (fig. 27) hovers in swirling robes enameled with a deftness seldom found in the glass of any era or nation. The transparency of the glass has been wonderfully preserved. The figures are well and actively drawn. Although their expressions can hardly be called inspired, they like the rest of the imagery are rendered in a deft, linear way whose texture helps transform the entire window into a shimmering veil of light.[29]

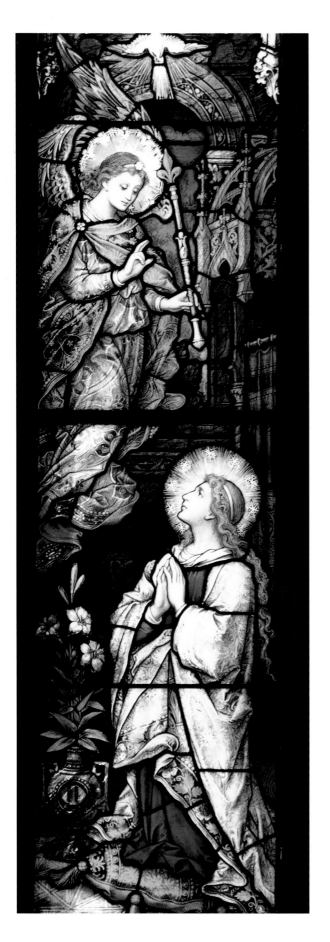

In summary, the Gothic Revival encompassed a wide variety of styles. Some of the Revival designs were closely imitative of medieval models, thus reviving an appreciation of artworks that had been ignored or denigrated for many generations. This "pure" aspect of the Gothic Revival also produced technical achievements, retrieving most of the glassmaker's arts, which had languished since the early modern era. Much of the Gothic Revival was not, however, dedicated to the re-creation of medieval work but was a new interpretation of old forms, combining them with Renaissance and contemporary ideals and producing a new, richly varied sensibility that one should recognize as part of the contribution of the nineteenth century to world civilization.

27. Grace Episcopal Church, Jamaica Avenue and 153rd Street, Jamaica, Queens. *The Annunciation,* Mayer Studios, Munich. c. 1908. W. 22″. The Bavarian Baroque genius was obviously still alive when this window was painted.

The Opalescent Era: Tiffany and La Farge

Edward Burne-Jones was among the most respected late Victorian artists in the world, and Americans could afford to buy his or any other artist's work, but little of his glass or painting came to the United States. His serene elegance had limited appeal for Americans in the Gilded Age. More colorful and dramatic art was wanted on this side of the Atlantic. Grandiose landscapes like Frederic Church's *Niagara Falls* (1857) or Albert Bierstadt's paintings of the western mountains were popular throughout the last half of the nineteenth century. Americans with more advanced tastes began to appreciate the excited tones of the French Impressionists, who were more popular in America than in London. Stained glass began to reflect the American preference for color and drama and became a major domestic art form. As there was no established church to insist on a canon of taste or subject matter, ecclesiastical windows followed domestic windows toward the emancipation from Gothic traditions. The new styles were more French than English, but eventually became a uniquely American contribution to glass.

Two American painters, John La Farge and Louis Comfort Tiffany, began experimenting with glass in the 1870s and independently arrived at results that expressed the American desire for opulently colored windows.

Their search led them to create an entirely new form of glass, now called *opalescent,* although it was once known in Europe as *American glass.* The latter term may be useful because opalescence is only one of the characteristics that distinguishes the glass of Tiffany and La Farge from the techniques and materials of European windows.

Streaky imperfections appear in medieval glass like that in the Early Gothic Hall of The Cloisters. Although these imperfections were desired for their rich effects, medieval artisans usually ignored the possibilities such imperfections had for developing the imagery in the windows. For instance, in the red halo of the saint in figure 2 on page 2 , no apparent attention was given to cutting and placing the pieces of glass so that they exploit the lighter areas of the red glass. These lighter areas seem to contribute nothing to the notion of a halo as an aura of light radiating from a head. (One should remember that the gradations are perhaps more apparent now, because of corrosion, than when the glass was new.) Any possibilities of exploiting irregularities in glass decreased over the centuries, because, as we have seen, glass became less and less irregular, until by the Renaissance it was smooth and nearly flawless. Designs made with such uniform glass could achieve varied tones and textures only with enamel paints, or through elaborate etching and grind-

ing processes like those used in the *Barbara von Zimmern* window (fig. 8, p. 8).

The innovation of Tiffany and La Farge was to create glass with exaggerated textures and color variations in the glass itself, and then to use those variations as part of their compositions. "American glass" thus represents a third and unique way of working glass into an ornamental window. (The other two being, as seen in chapter 1, the original medieval mosaic idea and the Renaissance technique of painting with glass enamels.)

The new technique had roots in the airy, free landscape painting that was widely popular in the nineteenth century. Painters as diverse as Constable, Monet, Whistler, and Homer attempted to use paint in ways as agile and free as the evanescent moments they sought to evoke. Tiffany and La Farge were both fascinated by light and had learned in their careers as painters how to evoke its presence by breaking up objects into dappled surfaces and surrounding them with lambent air. Rather than capturing the hardness and exact reality of things, as the Pre-Raphaelites had tried to do, artists like Tiffany and La Farge painted in more suggestive fashions. They independently became interested in stained glass and began to seek ways of expressing the luminous aspect of the medium without being subdued by its stubborn mechanical necessities of lead and enamel. The search for flexibility had already led other artists to painting on glass, but it was understood by the middle of the nineteenth century that paint decreases the luminosity of glass. To achieve their goals, La Farge and Tiffany began to manipulate the glass itself, treating it as a plastic medium. By adding chemicals, by working semimolten glass into evocative surface textures, by fusing all sorts of glass together, Tiffany and La Farge sought to create a new medium of expression in glass. *Peonies Blown in the Wind* (fig. 29) is a full-fledged example of their type of glass.

Peonies Blown in the Wind (c. 1879) was made by John La Farge for the Marquand House in Newport, Rhode Island, and is now in The Metropolitan Museum of Art. There is no paint on this window. To create the peony imagery, La Farge selected streaked and mottled glass whose colors were appropriate to the subject, then cut leaf or petal shapes with mottlings suggestive of light and shadow playing on plant forms. He heightened the effects by molding some of the flower parts so they have properties of low relief. The rich border consists of chunks of glass, most of it pot metal rather than opalescent, but used in ways foreign to previous glass masters. The irregular chunks were set in thin lead, which allowed them to protrude as much as one-half inch from the back of the window. On the front of the window the chunks were overlaid, or "plated," with pieces of smooth clear glass. Each piece of plating covered several of the rough chunks and mellowed their brilliance, which might otherwise have overwhelmed the softer luminosity

28. National Academy of Design, 1083 Fifth Avenue, Manhattan. *The Reaper,* Louis Comfort Tiffany (1848–1933). 1881. W. 19¾". Americans quickly accepted Impressionism, perhaps because many American artists, including Tiffany, were already painting in a style suggestive of the Impressionist fascination with broken scintillating light playing on the surface of their canvases. His fascination with light probably helps explain why Tiffany eventually turned to stained glass. (Photograph courtesy National Academy of Design)

of the opalescent glass in the peony imagery.

The *Peonies* window, with its use of molding, plating, and three kinds of glass (opalescent, pot metal, and clear plates), demonstrates how much more there was to the new technique than merely the use of opalescent glass. The variegated glass and its ancillary techniques became the artist's materials, whereas in previous techniques the artists created cartoons on paper, which were then translated into enamel paint and colored glass by craftsmen. Thus, the opalescent window required a high degree of artistry throughout its fabrication. The success of the finished window depended on an ability to see in a

bit of mottled glass the tone of a shadowed leaf or a sunlit peony petal, and then to be able to exploit those possibilities in a coherent composition.

Plating was one of the techniques that required sensitive application. It could be crucial to artists working in opalescent glass, for they depended on qualities in the glass itself, its density, color, and contours, for almost all of their effects. (Faces and a few other details continued to be painted in enamel.) Plating was usually done after the main design leads had been worked out and the glass had been found to fill them. This preliminary work was set up in a light easel (see figure 36, p. 44, from the Lamb Studios), and the artist could then adjust transitions, produce shadings, or create other effects by adding glass over areas where colors seemed raw or where the transitions between pieces of glass were too abrupt. The technique sometimes got out of hand, and both Tiffany and La Farge used as many as three layers of plates. These attempts to get subtle effects could make the window murky, as grime tended to work its way into the spaces between the plates, making them look even darker. The heavy plating also tended to pull away from the leads. Consequently plated windows today often look murky and misshapen, and observers may not realize how much better the windows looked when they were new.

La Farge and Tiffany had been friendly acquaintances: they were both part of the world of young New York artists. But as they brought out the innovations that became *American glass,* their relationship cooled and innuendoes of plagiarism drifted through the art world. It must have seemed strange that not just one, but several similar innovations were claimed almost simultaneously by Tiffany and La Farge.

Tiffany and La Farge shared an attraction for luminous, light-filled painting. They were related to what has been loosely termed *American Impressionism.* (Although their windows do not resemble at all the work of the French Impressionists, many of their paintings do.) They came to be glass artists by rather different routes, but eventually they would both help express the desire for luminous imagery and rich surfaces characteristic of late nineteenth-century decoration.

Exactly how they benefited from each other's explorations is unclear, but La Farge probably deserves credit for first conceiving of window designs based on

patternings and variations within the glass itself. However, some of the most beautiful opalescent windows are based on abstract or geometrical work, which Tiffany introduced and which exploited his own technical innovations in glass. He was also probably the creator of the landscape window in opalescent glass.[1]

Evidence of Tiffany's own originality is found in the window he designed for the George Kemp House in Manhattan in 1879. (This window is now in The Morse Gallery of Art, Winter Park, Florida.) In this early effort Tiffany used no enamels but depended on irregularities of color and surface in the glass itself to suggest images. A much later but very similar plant-and-trellis design is found in a 1907 sunroom panel at the Brooklyn Society for Ethical Culture.

In 1880 Tiffany completed panels for the Veterans' Room of the Seventh Regiment Armory (still standing, with the glass intact, at Park Avenue and 67th Street). The Veterans' Room panels manifest several geometric styles from subtle grid patterns to a very free assembly of irregular pieces of opalescent glass and rough, broken chunks of pot metal. All of these windows are rather dark and do not photograph well, but the variety of styles and the richness of materials demonstrate Tiffany's exotic imagination. The pillars of the Veterans' Room are wrapped in chains, not the least of the effects that contributed to the artist's reputation for aesthetic daring.

John La Farge (1835–1910) was born in New York City of French parents. His father was an officer in the Napoleonic campaign to subdue Santo Domingo, and his mother was a member of the planter society on that island. After the campaign failed, they both fled to New York where they married and set up a household. La Farge later recalled this home of his youth as being closer to the France of Napoleon than to the Victorian England most upper-class New Yorkers then emulated. La Farge's upbringing and education were genteelly Catholic. He had no particular career plans when he went to Paris in 1856 after being graduated from college, but to focus some of his interests he took classes with the popular artist Thomas Couture. La Farge was intelligent and charming and he made a good impression on his teacher, as he had on Parisian society. He traveled, copied old masters, and in London spent some time with the Pre-Raphaelites. He was too cool a person, and also perhaps too Gallic, to be swept up by the rather cranky English "Brotherhood," but he liked the Pre-Raphaelites' bold colors and he understood what they had to say about composition. He also understood the intent of other major contemporaries, like Ingres and Delacroix, and he observed the controversy between classic and Romantic painting. From his acquaintance with great paintings he claimed to keep in touch "with that greatest of all characters of art, style, not the style of the Academy or of any one man, but the style of all the schools."[2] When he returned to the United States in the winter of 1856/57, his open-

29. The Metropolitan Museum of Art, Fifth Avenue and 82nd Street, Manhattan. *Peonies Blown in the Wind,* John La Farge (1835–1910). c. 1879. W. 45″. This was one of the first and most successful works in opalescent, or American, glass. Instead of using enamels to assist in the suggestion of forms, as had been done since at least the eleventh century, La Farge used the streaks of color and surface irregularities in the glass itself to evoke images. (Photograph courtesy The Metropolitan Museum of Art)

ness and intelligence, plus a respectable artistic gift, made him a major figure in the American art world. Although he apparently lacked the genius to turn his sophistication into creative greatness, he could exploit his understanding of the "how" of art to become a technical innovator. In his landscapes he said he wanted "to indicate very exactly the time of day and the exact condition of the light in the sky."[3] Thus La Farge's fascination with light was anticipating the *pleinairism* of the Impressionists. Although he admired the full-colored, Romantic action of Delacroix and he showed an early sense of the Impressionists' quest, La Farge was not a passionate painter. Decorative details and Pre-Raphaelite moods suggest a highly intellectualized aestheticism that was further refined by his appreciation of Japanese art. He assumed that European painting in the grand illusionistic manner was superior to Oriental art, but he admired Japanese skills in composition and subtleties of line. *Peonies Blown in the Wind* probably owes some of its bold form to Japanese inspiration, whereas its wildly energized palette stems from lush precincts of European painting.

In 1873 La Farge was in Europe again and was impressed by the stained-glass windows the Pre-Raphaelites were designing. However, he felt that glassworkers overseas had about reached "the end of their rope." He objected to their method of designing glass on paper and then entrusting the execution of the window to craftsmen. La Farge felt that better windows could be made under the direct guidance of an artist. Some of the Pre-Raphaelite windows were in fact made, not merely designed, by artists, but even in Pre-Raphaelite workshops there was a gap between the designers and the people actually working with the glass.

La Farge said that he was thinking about how he would make a window as early as 1872 or 1873. Although he had assistants to help him with the execution of his designs, La Farge gave much personal attention to the fabrication of his early windows. He said that the idea of using opalescent glass had already occurred to him in the early 1870s when he noticed the rich color in some cheap glass toilet articles. Opalescent glass had been used for years in commercial glassware, but apparently no one had thought to use it in stained-glass windows. La Farge's experiments proceeded with a magpie's enthusiasm for varieties of glass, and by 1875 his work was noticeably different from traditional enamel or pot-metal windows. A trial window of 1875 (now lost) was described as based on a "new process of manufacture" that gave "exceptionally brilliant and artistic results."[4] Opalescent glass appeared in a window he made in 1877, but he seems not to have settled on his full technique until around 1879. He had already undertaken an ambitious window for Harvard's Memorial Hall. When it was half-installed, he decided it would not do and took it back to New York, and in November 1879 filed a patent for a new method "to obtain opalescent and translu-

cent effects in windows . . ."[5] The Harvard window was not finally completed until 1881, during which time La Farge seems to have concluded his major innovations in glass.

La Farge produced some of his innovations in glass at Heidt's Glass House in Brooklyn, where Louis Tiffany had also been doing experimental work. La Farge was extremely gentlemanly and abhorred disputes, but in private he called Tiffany "a knave" in "these transactions concerning glass." Tiffany was shameless in arrogating to himself all the honor for the invention of American Glass,[6] when it is certain that La Farge was responsible for at least a substantial part of the early ideas. The history of invention is full of simultaneous independent discoveries, and it is possible that both Tiffany and La Farge were justified in their claims of originality. By the time La Farge filed his patent, Tiffany had been working successfully for at least several years to develop variations in glass. Although Tiffany's experiments were aimed at somewhat different goals from those of La Farge, there were substantial similarities in his career as an artist. His innovations, like those of La Farge, included creating rich glass surfaces appropriate to the *belle époque*.

Louis Comfort Tiffany (1848–1933) was the son of Charles Lewis Tiffany, whose New York jewelry store was already well known when Louis Comfort was born. The young Tiffany had a comfortable childhood, went to boarding school but not to college, and in 1865 set off for Europe where he did some sketching and watercolors. When he returned to New York in 1866, he enrolled in the National Academy of Design. Besides his classes at the academy, he also studied with George Inness (1825–1894) at his studio in New Jersey. Landscape was the grand subject of nineteenth-century American painting, and Inness was one of the great practitioners of the genre. He was influenced by the Barbizon School in France and the tradition of the Hudson River painters. His landscapes pay particular attention to the air, to light-filled atmosphere creating variations of mood over the countryside. Inness liked dramatic effects and he exploited haze, sunsets, and gathering storms. Dramatic landscapes were certainly not unique to Inness; they were part of the Romantic fascination with nature, but his painting technique was interestingly different from that of many Americans working in the landscape genre. To achieve his light effects, Inness often worked paint into a jumbly, jewellike surface—a characteristic Tiffany sought in his later glasswork.

Tiffany apparently had another teacher in Samuel Colman (1832–1920), who became his friend and informally his mentor. Colman helped Tiffany discover the Near East and its decorative art. Colman was also a painter of the American landscape, part of the later Hudson River School. He paid more attention to color than some of the early Hudson River painters, whose vistas

frequently dissolve into vague browns. One of the so-called luminists, Colman repeats the theme of many of the artists appreciated by Tiffany and La Farge: light and color, melded in almost palpable atmosphere.

Tiffany also painted in watercolors and took the medium more seriously than most artists of his time. The American Society of Painters in Water-Colors was founded in New York in 1866, to encourage work in the medium. Samuel Colman, in another instance where he anticipated Tiffany's interests, was the first president, and Tiffany exhibited with the society in 1871. The society published a brochure that virtually describes the effects Tiffany later achieved in some opalescent landscape windows.

Of the advantages that water color painting in some respects possesses over oil, it may be well to say a few words. No artist pretends that it can ever take the place of oil painting. The masters of water color, however, maintain, with some reason, that for certain luminous qualities, for purity of tint and tone, for delicate gradation, especially in skies and distance, their favorite style of painting has decided advantages over oil.[7]

One notes an emphasis on light and color, which are obvious qualities of stained glass, but here also is mention of "delicate gradation," and that quality, so foreign to medieval stained glass, Tiffany would attempt to introduce into his work in glass. In his watercolors as in his oils he exploited textures and dramatic contrasts of color, intermixed with the subtle gradations typical of most artists in watercolor. Tiffany's skies are almost always beautifully toned, from palest light-filled noontimes to aquamarine evenings and rich sunsets. Warm golden foregrounds, full of sunlight, occur again and again whether the subject is a New England wheat field or a market in Tangier.

Non-Western art had a major impact on Tiffany's career, and this distinguishes him from La Farge. La Farge felt the attraction of alien, mainly Japanese, culture, but his appreciation was limited and more intellectual than sensual. Tiffany did some collecting of Japanese artifacts, but his interests had been directed by Colman toward the Near East. After Tiffany exhibited some American landscapes, he went to Spain and North Africa around 1870. From that trip and subsequent journeys came many paintings, and he developed a reputation as a painter of exotic subjects as well as American scenes. In the Near East Tiffany found not only an exotic subject matter, he also discovered and began to think about the indigenous art of North Africa. From the interlaced mosaic work on mosques and palaces, from carpets, and from ceramics, he began to realize there were lessons to be learned from "the Orient."

The Orientals have been teaching the Occidentals how to use colors for the past 10,000 years or so. . . . The men of the East who supplied barbarians with rugs and figured textiles considered color first, and form only incidentally. Their designs were spots or tracts of color, and during the course of time they learned through reasoning and instinct that a fine design can be spoilt if the wrong combinations and juxtaposition of colors are chosen.[8]

Tiffany did not apply such notions directly to his paintings, which retain, despite their rich surfaces, the illusion of three-dimensional space within a frame. In his stained glass, however, Tiffany often abandoned himself to wonderful abstract work reminiscent of North African, Celtic, and other exotic cultures.

In the mid-1870s Tiffany began to take a serious interest in the decorative arts. This part of his career is vague, partly because records are not available but also because Tiffany liked to exaggerate his role as an inventor. He claimed to have begun his investigations into glass as early as 1872, but one cannot say whether these were serious efforts. Without being precise about dates, one can be sure that he was experimenting with glass tiles in the mid-1870s and by 1878 he was introducing them into his decorative work. These tiles probably owed something to Islamic ceramics (of which his friend Colman was a collector) as well as to the iridescence that he admired in ancient Roman and Egyptian glass. He said that his glass "eclipsed the iridescence and brilliancy found in the Roman and Egyptian glass."[9] The tiles were not produced for use in windows, but as decorative wall mosaics and for use in exotic lamps. Although they had the iridescent and irregular surface that Tiffany later incorporated into some of his glass for windows, many of the tiles were nearly opaque, and probably inappropriate for windows, even though obviously technically similar to stained glass.

In 1876 Tiffany made stained-glass windows for Sacred Heart Church, 457 West 51st Street, in Manhattan. They were based on bull's-eye glass, which is made from a flattened blob of glass. These pancakes of glass tend to have concentric ridges and other irregularities that enrich the light passing through them. Tiffany selected particularly irregular and densely colored pieces of bull's-eye glass for his Sacred Heart commission. Although they were perhaps more richly colored, the windows would not have seemed strikingly unusual when they were new, particularly as American windows often contained bull's-eye disks as part of ornamental patterns. Tiffany's first windows show little thought; they appear to be no more than a casual by-product of his interest in glass tiles. The artist was, however, becoming more and more interested in the decorative arts as a career and he began to include more glasswork in his projects.

In 1878 he produced a window for St. Mark's

30. Flatbush Dutch Reformed Church, Flatbush Avenue, Brooklyn. Untitled window, Tiffany Studios, New York. Undated. W. 54″. A significant portion of Tiffany's work in stained glass consisted of geometric designs rather than the curvilinear style for which he is best known. Tiffany's fondness for geometric designs was shared by many Protestant denominations, whose heritage included a dislike of images in church.

31. Flatbush Dutch Reformed Church. Detail of a window similar to the one in figure 30, Tiffany Studios. Undated. Geometry comports very well with opulence, as the Moslems learned centuries ago; the inch-thick chunks of glass in this window provide a surface that melts sunlight into jeweled patterns.

Church in Islip, Long Island, that used bull's-eye glass to make much of the field. In this field was set a figure of *St. Mark* made of opalescent glass. The window is very amateurish—Tiffany obviously had neither read much about nor experimented much with stained glass. The lead lines make little sense and the window declares itself to be an experimental effort. *St. Mark* is nevertheless an innovative advance and a much more serious effort than the Sacred Heart windows (most of which were removed in 1951).[10]

Tiffany's early opalescent windows, such as those he made for the Seventh Regiment Armory, continued to be mainly geometric. In 1881 he provided opulent interlaced patterns in glass for several windows at the Union League Club on Fifth Avenue and 39th Street (now demolished).

His glass began to be appreciated outside New York, and in 1882 he was asked to redecorate the White House. He installed for President Chester A. Arthur a large screen of opalescent glass along the ground-floor vestibule hall. This screen was mainly geometric in design. Although Tiffany's interest in abstract work dominated his early years in glass, he did not for long ignore the potential of opalescent glass for rendering landscapes. He had little interest in monumental figure studies. Unlike La Farge, Tiffany left such work to assistants, but he used his skill as a landscape painter to develop a new genre in stained glass—the landscape window. Records and datable windows seem to be lacking to document the evolution of the Tiffany landscape window, but as early as 1881 a drawing appeared in *The American Art Review* of a Tiffany landscape window. The rather crude drawing may give an unfair impression of the window, which seems unsubtle—an opinion not shared by Roger Riordan, the author of the article accompanying the drawing. Riordan wrote, "Mr. Tiffany has shown that . . . many of the most beautiful and poetic passages of landscape can be better represented in glass than in paint. Effects of rippled or quiet water, sunset and moonlit clouds, mysterious involutions of distant hills and woods, are given with a force and suggestiveness impossible in any other medium." Tiffany then receives precedence over La Farge in landscape: "Mr. La Farge has not yet attempted in . . . [glass] what Mr. Tiffany has, but in his Harvard window a distinct landscape effect, though of an extremely simple character, has been produced."[11] Despite his early start, Tiffany seems to have done relatively little with landscapes in glass until late in the 1880s. Of the scores of landscape windows by Tiffany in the New York area none has been dated before around 1885. Many windows remain undated, but of those identified as from around 1880 to 1885, either figures or geometric work make up the principal subject matter. After around 1890, however, many landscape windows were produced by Tiffany and other studios for New York City.

32. Memorial Presbyterian Church, Seventh Avenue and St. John's Place, Park Slope, Brooklyn. *Blessed Are the Pure in Heart* . . . , Tiffany Studios. c. 1891. W. approx. 96″. Celtic interlaces, like North African arabesques, were among the exotic influences on Tiffany. The interwoven rose patterns in these lancets conceivably could be traced to a source such as the Irish *Book of Kells.*

Landscape windows when used in homes or other secular structures could only please a nation infatuated with landscape paintings. The long nineteenth-century affair with landscape was nowhere more passionate than in America, and the Romantic concept of *sublime nature* was eagerly accepted by a nation otherwise a little short on grand subjects for its national painting. However, the introduction of landscape windows into churches was unorthodox. Indeed, for Christians with a long tradition of stained glass, like many Anglicans and Roman Catholics, the landscape window had no iconographic place. A landscape window would have no role in a "program" of biblical instruction such as Bolton created at the Church of the Holy Trinity in Brooklyn Heights. Although Roman Catholics almost never used any kind of landscape window, other ritualistic churches often succumbed. Amid much controversy, even Episcopal parishes

installed many landscape windows. For Episcopalians of the Low-Church persuasion and for other Protestant denominations that had long resisted images in their churches, the landscape window was a godsend. Many Protestant denominations in the mid- and late nineteenth century began to desire more art and ritual as adjuncts to their religion, and yet they were uncomfortable with the trappings of "Popery," such as saints and martyrs portrayed in stained glass. Jews also were seeking richer artistic expressions for their houses of worship, but were of course even more concerned than Protestants about images.

The landscape window was the perfect answer to this dilemma for both Protestants and Jews. Theologically the landscape window was as innocent as geometry, which was, as we have already seen, one way to bring stained glass to a congregation fearful of idolatry. But better than geometry, the landscape window added not just beauty, but beauty with a pious message. The landscape window could be expected to inspire reverence in its beholder, for was it not true, as poets particularly began to suggest in the late eighteenth century, that God was manifest in nature? There were a few cranks

33. The Metropolitan Museum of Art, Fifth Avenue and 82nd Street, Manhattan. *View of Oyster Bay* (also known as *The Wisteria Window*), Tiffany Studios, c. 1905. W. 73″. This window was originally in the William Skinner House on East 39th Street, Manhattan. (McKean Collection, on extended loan to The Metropolitan Museum of Art; photograph courtesy The Morse Gallery of Art, Winter Park, Florida)

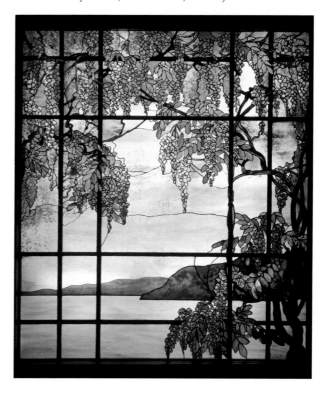

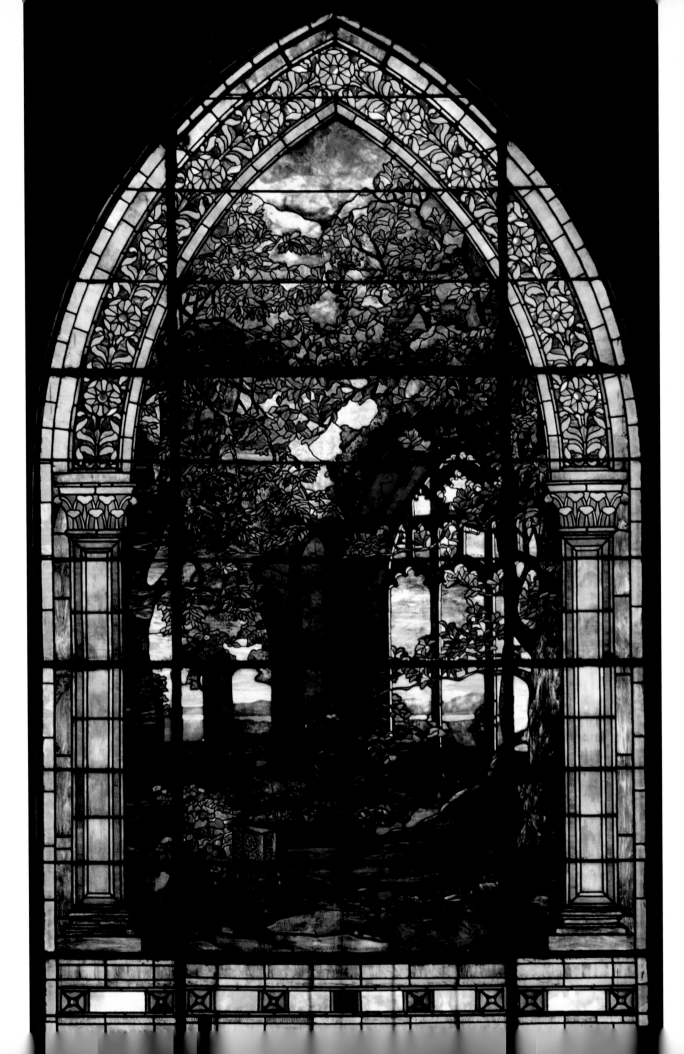

who insisted that nature was a snare for the Christian, but such opinions carried little weight in America, where most divines concentrated on the wickedness of man and assumed that the world would still be Eden were it not for the misconduct of Adam and Eve. With the potential of both mankind and the world to be good, the chance to reenter Eden became an increasingly common, even if heretical, notion as Americans contemplated the vision of the Republic spread in Christian hegemony across all the continent.[12]

River of Life (fig. 108, p. 103) and *At Evening Time* . . . (fig. 34) manifest that gentler theology that replaced the grim Calvinism of the early Presbyterian Church. These windows, both in the First Presbyterian Church, 124 Henry Street, Brooklyn Heights, evoke the Romantic belief in nature as basically good, the manifestation of a beneficent deity. Nothing in either window suggests a God of wrath or the world as a snare. The windows' twilight mood does, however, suggest the transience of mortal man. *At Evening Time* obviously has as part of its theme the vanity of human works, but that fact is not meant to distress us. We look through the empty mullions of the ruined church toward a vista of ancient hills and the eternal sea. "The works of the Lord endureth forever." The oncoming night offers rest, sleep, and the promise of the coming dawn. The landscape window thus easily became a metaphor for the optimistic theology of late nineteenth-century America, and one can imagine many a sermon preached from such glass, just as medieval priests may have elaborated the life of a stained-glass saint into a Sunday morning homily.

Artists working in opalescent glass often combined landscapes with figures, but the landscape had an importance far beyond the mere backgrounds like the one in figure 18 (p. 22). The window in figure 35, *Then Shall Thy Light Break Forth as the Morning,* offers a metaphor whose first, immediate level is the physical dawn revealing the world as a place of beauty. The metaphors continue of course, identifying Christ with the dawn and as the Light of the World, but those metaphors had been developed in Christian art at least as early as the twelfth century, where Christ appears bearing the sun and the moon, or surrounded by a sunburst. Figure 68 (p. 70) is a modern adaptation of such medieval imagery and suggests

what in fact was true, that in the Middle Ages there was a complete lack of interest in landscape as an inspirational or metaphorical subject, and a medieval artist would probably have thought Constable a fool for painting a picture of nothing—a landscape—and a madman for asserting that "the sky is the chief organ of sentiment."[13] One assumes that Clara Burd, who designed *Then Shall the Light Break Forth . . .* , was not only illustrating the metaphor of Christ and a new dawn for the world but intended to inspire with the landscape itself. The Devil tempted Christ by taking him to a high place and offering him the world, which he rejected. In this window Christ stands on a high place and seems to offer the world to the beholder, not as a temptation but as an inspiration to reverence.

La Farge did little to exploit the potential of opalescent glass for landscapes; he used landscape backgrounds for many of his windows, following the Renaissance precedents he admired, but he felt that deeply receding imagery, as landscape almost always is, was inconsistent with the virtue of keeping a window close to the same

35. West End Collegiate Church, West End Avenue and 77th Street, Manhattan. *Then Shall Thy Light Break Forth as the Morning,* Clara Burd. 1913. W. 108".

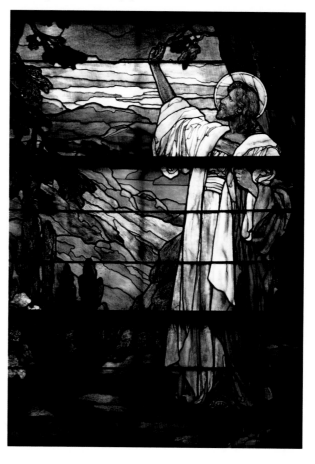

34. First Presbyterian Church, 124 Henry Street, Brooklyn Heights, Brooklyn. *At Evening Time It Shall Be Light,* Tiffany Studios. 1901. W. 83". This window is a "common" product of Tiffany Studios, unmentioned in any of Tiffany's published remarks, unsigned, and undated, although a note in the church archives indicates that Tiffany and Company installed the glass in 1901. *At Evening Time* testifies to the talent, lost in the shadow of their employer's reputation, of the designers and craftsmen at Tiffany Studios.

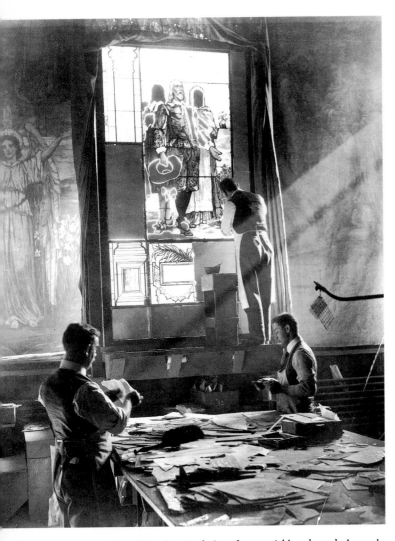

36. Established stained-glass firms quickly adopted the techniques for working in opalescent glass. This photograph was taken in the Lamb Studios, New York, around 1915, but it could represent a scene from the 1880s. A trial arrangement of the glass for *The Landing of the Pilgrims* is being "waxed up." The principal sections of the window are attached to a plate-glass window easel with wax. Cardboard covers the areas for which the glass is not yet ready. If the colors should prove inappropriate, different pieces of glass will be tried, or what is already in place may be modified by fastening a plate of tinted glass over it. The convolutions in the glass and the streaks of color, both of which help suggest folds of cloth, may also not look right; in which case different pieces will be tried, or an existing piece may be subdivided along lines that echo the desired effect and leads will be inserted in the divisions. Few of the leads have been inserted at the moment shown in this photograph; their absence is indicated by the glaring lines around such objects as the hat held by the central figure. After the leads have been placed, a final series of platings may be applied to soften any lead lines that look too bold.

flat, decorative plane as its surrounding walls. However, Tiffany and many other artists in opalescent glass made hundreds of landscape windows for churches, indicating how remote most American churches were from the iconographic traditions of stained glass.

La Farge joined Tiffany and other nontraditionalists in glass in exploiting Victorian sentiments toward children, which have already been seen in the glass of the Gothic Revival. At the Church of the Incarnation on Madison Avenue and 35th Street, one can see La Farge at less than his best in four lancets featuring childish angels. The glass (not illustrated) has some beautiful qualities but the infants reveal that even the reserved La Farge might succumb to painting treacly children. Further up Madison Avenue, at St. James's Episcopal Church on the corner of 71st Street, is an example of a sentimental but beautiful window, *At the Morn Those Angel Faces* . . . (fig. 98, p. 97), by Tiffany Studios. Very thick but well-articulated chunks of glass turn three lancets into rich frames for enamel cameos of angel faces (probably not painted by Tiffany himself). The fading images are fascinatingly vague and seem more interesting than the La Farge faces on 35th Street. At 71st Street Tiffany managed to create an opulent window and yet not be pretentious. With its joyous colors and exuberant chunk-glass work this is a window about children and also, in the happiest sense, for children.

Neither Tiffany nor La Farge had been attracted to stained glass through the Gothic Revival, and their eclecticism did not extend to the Middle Ages. Neither artist was the least modest in comparing his works to medieval glass. They thought their glass was the technical equal of medieval work and their artistry they held to be self-evidently superior. Aside from Tiffany's abstract designs, both artists wished to work in "modern" styles, which implied three-dimensionality.

They were, it should be recalled, more oriented toward France than England, closer to French classicism than to English Pre-Raphaelite thought. Although both artists shared the nineteenth century's love of freely rendered landscapes, they also assumed that formal, classical figurework like that of Burne-Jones (but more richly colored) should be part of any artist's repertoire, and their new glass allowed them to render such imagery with full three-dimensional character.

Both La Farge and Tiffany were too ambitious and talented to confine themselves to the drudgery of making the actual windows. They both began to expand their studios in order to meet the demand for their work. Some of the assistants La Farge and Tiffany hired had to be artists in their own right, as opalescent glass required much discrimination in the selection of colors, the cutting, and the positioning of glass, not to mention the painting of enamel faces and other details. Gifted assistants often preferred to be independent, and the demand

37. Plymouth Church of the Pilgrims, Orange and Hicks streets, Brooklyn Heights, Brooklyn. *The Landing of the Pilgrims,* Lamb Studios. 1915–1916. W. 68″. This is the same window shown being assembled in figure 36. The wide border of classical ornament in white glass preserves the style and sunny beauty of Plymouth Church, which evokes the interior of an eighteenth-century Colonial church.

39. The New-York Historical Society, 170 Central Park West, Manhattan. Main Reading Room, *The Revocation of the Edict of Nantes,* Mary Tillinghast. 1908. W. 78″.

38. Grace Church, Broadway and Tenth Street, Manhattan. Detail of *Jacob's Dream,* Mary Tillinghast (d. 1912). 1887. W. of portion shown 24″. Tillinghast became a nationally recognized glass artist after she left La Farge's studio in 1885.

45

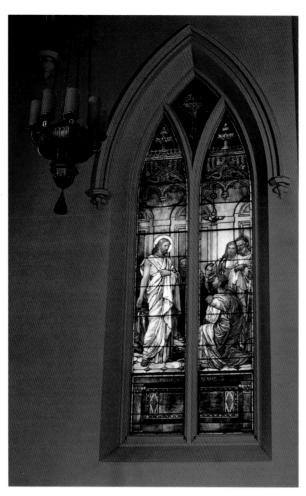

40. Church of the Ascension, Fifth Avenue and Tenth Street, Manhattan. *Christ's Admonition to Thomas,* Joseph Lauber (1855–1948). c. 1900. W. 66″. Lauber worked with both La Farge and Tiffany before he established his own studio.

for opalescent windows made it easy for talented persons to set up their own studios. One of the first artists to set up in competition with La Farge and Tiffany was Mary Tillinghast (d. 1912), who had worked for La Farge before she established her own successful studio in 1885. Lamb Studios quickly adopted opalescent materials, and by 1890 there were many studios making opalescent windows. American glass in a great variety of styles, quality, and materials had transformed the notion of what a stained-glass window could be.

American society on the eastern seaboard, and particularly in New York, was entering an era of grandiose pretensions. As we shall see in the next chapter, architectural styles began to shift toward notions of Renaissance splendor, and Tiffany, La Farge, and their host of ready imitators found that the new glass was readily adaptable to the needs of the coming era.

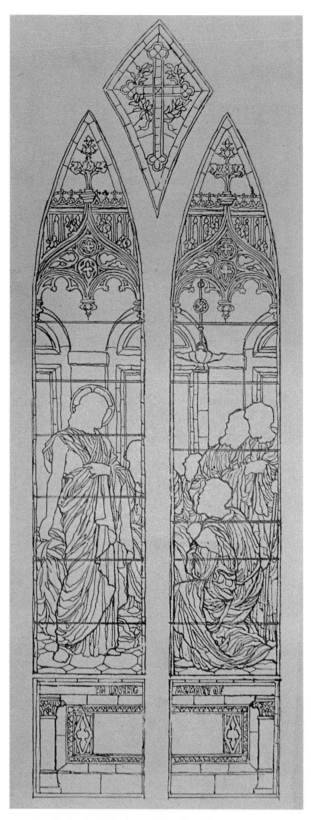

41. Joseph Lauber's leading plan for *Christ's Admonition to Thomas.* Templates for cutting glass were based on plans like this one. When the leads were added to the glass, the basic imagery was complete. The faces, Christ's arm, and some of the lettering were the only effects produced with paints, thus causing some opalescent craftsmen to claim that theirs was a "purer" form of the ancient art of window making.

Opalescent Glass and the Architecture of the "American Renaissance"

The era of opalescent glass coincided approximately with the revival of a learned and classical architecture on a grand scale. The new opalescent glass became an important part of this American Renaissance, reflecting its style and serving as a distinctive part of many of its buildings. Architecture was becoming one of the "educated professions," and formal education then began, as it had for centuries, with the Greek and Latin classics. For most well-educated gentlemen, refinement and high civilization were synonymous with Greco-Roman culture. The mid-Victorian jumble of Italianate, Moorish, Romanesque, Persian, and even Egyptian styles seemed dubious to the new class of professional architects, who were often trained at the École des Beaux-Arts in Paris and acquainted with the neoclassicism reigning in British artistic circles.

Richard Morris Hunt (1827–1895) was one of the first, and among the most successful, of the architects who managed to wed scholarly sophistication to colossal extravagance. He was a favorite of the Vanderbilts, who by the 1880s wanted Mrs. Astor to stop snubbing them for being the children of a ferryboat captain. The old Commodore had finally died in 1877, and in 1878 William K. Vanderbilt showed the refinement of a third-generation millionaire by commissioning Hunt to build an enormous Renaissance château that was historically "correct" and beautifully adapted to its urban setting. It also succeeded in making the neighbors' houses, including Mrs. Astor's, look old-fashioned. Most of the mansions of the city had been built of brownstone, in so-called Italianate designs. From now on the mode was a limestone or marble palace of the kind Mr. Hunt, trained at the École des Beaux-Arts, was so good at designing.

William K. moved into his new house in 1879, and that same year the firm of McKim, Mead and White was formed. Although they designed in many historical styles, their favorite was neoclassical and they generally used that mode when they emerged as the leading firm in America. Their grand neoclassicism was popular in New York City, where many institutions and individuals were attracted to, and could afford, their imperial forms. The scale of New York City made a grandiose architecture particularly appropriate. (McKim said, "The scale is Roman, and will have to be sustained.") The old Pennsylvania Station, The Pierpont Morgan Library, and Columbia University's Low Library are among their works. The definitive triumph of neoclassicism, and coincidentally of McKim, Mead and White, was the World's Columbian Exposition of 1893 in Chicago. There, on the shores of Lake Michigan, a Roman city arose, built on a

42. The Players' Club, 16 Gramercy Park South, Manhattan. Reading Lounge, Tiffany Studios. Undated. The artists and architects who presided over the opalescent era could often be found together in clubrooms like this one. The building was remodeled in 1888 by Stanford White, at which time the transom panels may have been installed.

43. The Players' Club. Detail of the windows in figure 42.

scale that would have astonished Tiberius, although not, perhaps, Cecil B. De Mille.

Of course the Gothic and other nonclassical styles were still used after 1893, but they were all overshadowed by neoclassicism and the preference for architecture conceived with strong lines and masses and executed with historical sensitivity. The sometimes pinched verticality of Victorian Gothic (see, for example, the gates of Green-Wood Cemetery, Fifth Avenue and 25th Street, Brooklyn) gave way to bulky forms derived from the Romanesque and early Gothic structures. However modified, forms reminiscent of the Middle Ages could no longer claim special preference even for churches and universities, and after around 1895 public buildings were usually built in classical or occasionally Romanesque styles. Despite its historical incongruity in such structures, stained glass flourished in this era of Romanized art and architecture. Thousands of square feet of stained glass went into the ambitious edifices, right along with caryatids, Corinthian columns, coffered ceilings, and acres of marble.

Part of the continued popularity of glass may be explained by the clients' stubbornness: they liked stained glass, they were used to it, and were not dissuaded by architects' fussing about historical precedents. But a further reason for the survival is that the architects of the buildings and the designers of glass were already professionally and personally acquainted, fond of one another's work, and believed that the kind of stained glass being designed in New York in the late nineteenth century worked well with neoclassical buildings.[1]

As mentioned in the preceding chapter, the dominant figures in the creation of opalescent glass were part of New York's established art world. The architects of the neoclassical revival also belonged to that world. At the same clubs one might find, in addition to the leading stained-glass artists of the city, the members of the McKim firm, as well as other exponents of Renaissance classicism, such as George Browne Post (1837–1913) and Bruce Price (1845–1903). In addition to association at the National Academy of Design, these artists and architects shared memberships or were guests at the National Arts Club, The Players' Club, and other institutions where social life included informed conversations about architecture and the decorative arts. The collaboration of geniuses in the decoration of Renaissance buildings appealed to the imagination, and the vanity, of these late nineteenth-century gentlemen, and ambitious collaborations frequently were hatched among the McKim firm, La Farge, Augustus Saint-Gaudens, Daniel Chester French, and others of their colleagues. Tiffany inhabited the more exotic but still thoroughly respectable regions of the late nineteenth-century art world. His studio contained dozens of artisans who were perfectly competent in the vocabulary of classical design and produced numerous works for established architectural firms. In the

44. National Arts Club (the former Samuel J. Tilden Mansion), 15 Gramercy Park South, Manhattan. Skylight, Donald MacDonald. c. 1884. W. 18′. MacDonald headed a respected Boston studio. The globules of tinted glass that comprise this dome were another way of seeking the lustrous effects characteristic of opalescent glass.

1880s Tiffany himself painted murals that demonstrate his own fluency with the forms and subject matter derived from ancient Rome and Greece, and some of his earliest figure windows are adaptations of Renaissance statuary.

Thus in the late nineteenth century Greek temples, Roman baths, and Renaissance palaces went up all over New York City, designed with an unimpeachable historicity, except that many of the casements contained stained glass.

The glass favored by neoclassical architects was opalescent; the same material preferred by Tiffany, La Farge, D. Maitland Armstrong (1836–1918), Lamb Studios, and many other American glass artists of the time. Opalescent glass, unlike antique pot-metal glass, reflects as well as refracts light, and its variegated surface harmonizes with marble and the other stone surfaces used in neoclassical interiors. However, opalescent glass admits even less light than pot-metal glass or most enameled glass. One wonders how such material could have been reconciled with neoclassicism's need for bright interiors to show off the statuary, the elaborate carving and fixtures, and the rich stone surfaces that are appropriate to that style of architecture.

The reader will recall that Gothic buildings have been called stone cages, with windows replacing much of the walls. Neoclassical buildings are practically the opposite. The walls not only clearly hold up the building but

they are also often heavily decorated, carved, and set with statuary. Windows must let in light to illuminate these ornamental surfaces, but not be so large as to leave the wall looking weak, or too small to develop decoratively. There was thus a tension between the need for light and the permissible size of windows. By the 1890s, however, one could fill large windows with softly tinted opalescent glass, perhaps designed with classical motifs, and thus open the wall to light without producing a glaring hole or an abrupt interruption in the stonework. The principle is not greatly different from the use of pot-metal and enamel glass at the Jefferson Market Library, except that opalescent glass was particularly harmonious with neoclassical stone walls. If the opalescent glass did not admit enough light, as was often the case even with large windows, modern technology in the form of electric lights could remedy the problem.

Besides electricity, the nineteenth century had provided another innovation so that classical forms could be combined with opalescent glass: Joseph Paxton had astonished the world in 1851 by using plate glass and iron to build the enormous vaults of the Crystal Palace. Later in the century architects were thus prepared to build Renaissance domes out of steel ribs and panels of opalescent glass—glass that had the happy quality of harmonizing with the marble of the rest of the structure. Similarly, expanses of ceiling could be made of glass supported by iron or steel trusses. The glass could be designed to imitate the materials used in classical ceilings. Although a ceiling of luminescent stone might have startled Bramante, such glass-and-steel wonders offered American neoclassical architects the happy combination of illumination and rich surfaces.

Finding glass designers to make neoclassical windows was no problem. As we have already seen (chap. 2), most nineteenth-century artists designing "Gothic" windows had in fact been setting Renaissance art in Gothic frameworks. The emergence of neoclassical architecture must have been welcomed by many artists, who could now design glass without tension between their personal, "modern" style and the needs of architecture.

An example of the new harmony between architecture and glass can be seen at Judson Memorial Church at 55 Washington Square South in Greenwich Village. The church was designed by McKim, Mead and White in a

45. Judson Memorial Church, 55 Washington Square South, Manhattan. *St. Paul,* John La Farge. After 1892. W. 60″. At Judson Church La Farge successfully exploited the potential of opalescent glass for harmonizing with a Renaissance interior. The barrel vaults of the church are echoed in the casement arches, then repeated by La Farge in the arches and disks of the window glass.

style they called "Neo-Italian Renaissance," which combined Romanesque and Renaissance elements. For this church La Farge designed a series of windows (fig. 45) that were installed over a number of years after the building was completed in 1892. The glass surfaces are all opalescent, the figures (*St. Paul, St. Peter,* and so forth) are dignified Romans, and the glass ornamentation around them resembles the marble inlays one might find in a Renaissance church. Between these saints' halos and the windows' round arches La Farge placed concentric forms that unite the halo imagery with the form of the window arch.[2] Other designers also exploited the idea of a Renaissance wall niche (portrayed in glass) as a device to unite the space between a figure and the frame of a neoclassical window. The Flatbush Dutch Reformed Church, Flatbush Avenue, Brooklyn, was built in the 1790s, during this nation's first affair with neoclassicism, and not surprisingly the prosperous congregation of one hundred years' later commissioned windows in the Renaissance manner for their round-arch windows. Tiffany Studios made *Samson* (fig. 106, p. 101) at about the same time La Farge was working on his Judson Memorial Church commissions.[3] *Samson* is quite clearly derived from Renaissance sculpture and painting, in which classical figures (in this case Hercules) were simply retitled to make them appropriate imagery for Christian churches. In the *Samson* window Tiffany employed a different version of the Renaissance stonework used by La Farge at Judson Church. Here Samson stands in an opalescent niche. The glass illusion is continued by the popular sixteenth-century device of a scallop shell, which crowns the niche and brings it back to the plane of the wall.

Although Tiffany Studios did many neoclassical windows in New York City, Tiffany himself tended to favor more exotic themes or landscapes. The window shown here, *Adoration of the King of Kings* (figs. 46 and 47), was certainly part of the movement away from Gothic references, but the antiquity which in this case attracted Tiffany was more Byzantine than Roman. The success of Sarah Bernhardt in *Théodora* had encouraged Byzantine motifs in America. This window, incidentally, was originally in St. James's Lutheran Church (now demolished) on Madison Avenue and 73rd Street, just one block from Tiffany's mansion.[4] The opulence of *Adoration of the King of Kings* probably reflects Tiffany's notion of what was appropriate for the princes of capitalism who were his neighbors. The massive rock-glass work in the crown and jeweled collar and the lordly gaze evoke a Byzantine *Pantocrator.* More modest Byzantine themes than the St. James work, but carried out with similarly rich glasswork, appeared in domestic windows as alternatives to the neoclassicism that helped declare American upper-class affluence.

William Holman Hunt's (1827–1910) *Light of the World* (fig. 48) is supposedly the most-reproduced reli-

46. Chapel of the Lutheran Church of the Good Shepherd, 7420 Fourth Avenue, Bay Ridge, Brooklyn. *Adoration of the King of Kings,* Tiffany. c. 1885. W. of each panel 28½ ″. Tiffany designed these windows originally for St. James's Lutheran Church, Madison Avenue and 73rd Street, Manhattan.

47. Chapel of the Lutheran Church of the Good Shepherd. Detail of figure 46.

48. *The Light of the World,* William Holman Hunt (1827-1910). c. 1855. W. 10⅜″. Hunt was one of the most popular of the Pre-Raphaelites, and although he did no significant stained glass, this painting was reproduced over and over again in glass.

gious painting ever, and there are literally hundreds of stained-glass versions of it, including dozens in New York City. It is one of the few enduringly popular works by the Pre-Raphaelites. Detailed and specific, a good example of the Pre-Raphaelite style, this particular painting reflects Hunt's dark religious imagination. By the 1890s some artists were dissatisfied with Hunt's original concept of nocturnal gloom and decrepitude. At the New Utrecht Dutch Reformed Church, 18th Avenue and 83rd Street, Bensonhurst, Brooklyn, in a window of around 1895 derived from Hunt's painting, we see Christ knock-

ing at an antique but obviously not old door (fig. 49). It is daylight, Christ is handsomely draped, no Crown of Thorns, Celtic buckles, or Gothic lanterns intrude. Mediterranean cypresses rise in the background, and classical pilasters, along with Roman lettering, frame the scene. This revised version is not necessarily a classical scene, but it obviously has shed Hunt's original conception of tumbledown quaintness and Gothic spookiness. And of course it completely rejects Hunt's painful point that the door to the human soul "is fast barred," its threshold overgrown with brambles and weeds.

Another transformation of the Gothic appears in a window (not illustrated) at St. Mary's Episcopal Church, 521 West 126th Street, Manhattan, where St. George appears in medieval armor, but wearing the laurel wreath

49. New Utrecht Dutch Reformed Church, 18th Avenue and 83rd Street, Bensonhurst, Brooklyn. Untitled window derived from *The Light of the World,* unidentified studio. c. 1895. W. approx. 66″. American artists in opalescent glass often discarded the brambles and gloom of Hunt's painting and suggested a more cheerful somewhat classical scene, such as this one in Bensonhurst.

50. St. Michael's Episcopal Church, Amsterdam Avenue and 99th Street, Manhattan. Detail showing *St. Michael,* designed, according to his own statement, by Louis Comfort Tiffany. 1894. W. of detail 60″. This detail is part of a vast scene displayed in seven windows, each 23 feet high. St. Michael marches forward in triumph while angels throng the heavens to celebrate his victory over the Dragon in the Book of Revelation.

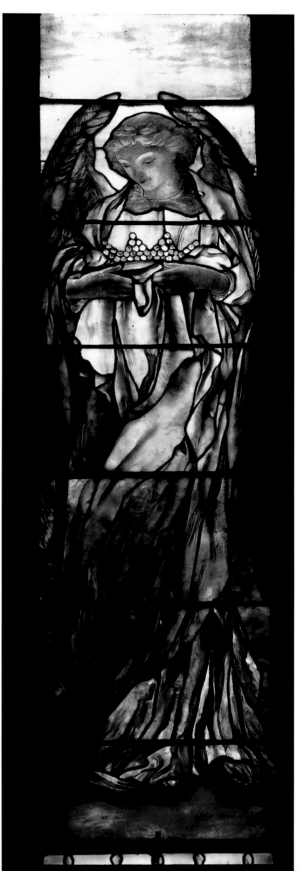

51. Memorial Presbyterian Church, Seventh Avenue and St. John's Place, Park Slope, Brooklyn. Bryan Memorial Window, Tiffany Studios. c. 1895. W. 42″. Many Baroque artists used dramatic light illusions in their compositions, and similar effects could be created easily in opalescent glass, thus satisfying an American desire for both melodrama and classical references.

of a Roman victor. There is an echo of Jacques-Louis David's portrait of Napoleon as Caesar in this unusual window.

Other themes common to stained glass underwent transformation as the century waned. Angels became noble creatures with glorious wings like those of the Nike of Samothrace. The Archangel Michael (fig. 50) in his church on Amsterdam Avenue and 99th Street spreads wings like an eagle's. At All Saints Episcopal Church in Park Slope, Brooklyn, the angel of the Annunciation (fig. 110, p. 104) appears as a herald with a Grecian profile, dressed in garments fit for a heavenly Senate-House, and standing beside some sort of Roman stonework. Although there are bits of Gothic ornament in the design, this conception of a divine messenger would of course never have occurred to medieval artisans, and it makes fewer concessions to its Gothic frame-

work than earlier nineteenth-century windows often do.

In another Park Slope window, this one in Memorial Presbyterian Church, an angel's swirling robes speak of late Renaissance or Baroque art (fig. 51), and the radiance bathing the face recalls magicians of light such as Georges de La Tour (1593–1652). The luminescence of La Tour's nighttime scenes did not necessarily inspire the similar radiance cast onto the face of this stained-glass angel but the combination of supernatural light with superrealism was a Baroque (and late nineteenth-century) way of evoking sublime situations.

Light effects like that of La Tour are also associated with Mannerism, but except for his uncanny light, La Tour bears almost no resemblance at all in his style to the Mannerism that was popular in the sixteenth century. He avoided the twisted, violent movement often associated with that school. But late nineteenth-century glass artists, moving farther and farther from the relative stasis of many Gothic and early Renaissance figures, often pursued Mannerist or Baroque drama. Continuing to use angels as illustrations, one can see Mannerism in the twisted torso of the angel (fig. 111, p. 104) from the Lafayette Avenue Presbyterian Church in Brooklyn. Such angels suggest how Art Nouveau developed out of an era dominated by classical traditions (stretching *classicism* as a term to include succeeding and much freer uses of the classic vocabulary, so that one may perceive the connections rather than the differences between the classicism of the Renaissance and the styles known as Mannerism and the Baroque). Many influences went into Art Nouveau, including a conscious rejection of the classic mode as too cold, formal, and lifeless; yet Art Nouveau figures frequently have the "noble" profile and heroic figures associated with classic sculpture. The restless curving forms of Art Nouveau have also been associated with plant forms, and properly so, for so much Art Nouveau ornament is directly based on sinuous plants. But much of the Art Nouveau sensibility derives from the flowing draperies, the streaming banners, swagged hangings, and other elaborately convoluted forms characteristic of various classic schools. Just as Renaissance classicism in the sixteenth century could be transformed into the free, effulgent forms associated with the Baroque, so the neoclassicism of the late nineteenth century contributed much to Art Nouveau. The angel bearing a crown (fig. 51, p. 54) may be said to display Mannerism, but the figure also shows classical forms transformed by another kind of imaginative energy, not just in the imagery of light but also in the conception of the swirling robes. It is a proto–Art Nouveau figure. Tiffany became the leading exponent of the Art Nouveau style in America, so it is not surprising to see adumbrations of the style in this angel. One can see numerous examples of a sinuous, reiterated movement in late nineteenth-century windows that at first glance seem to employ only the vocabulary of Romantic classicism.

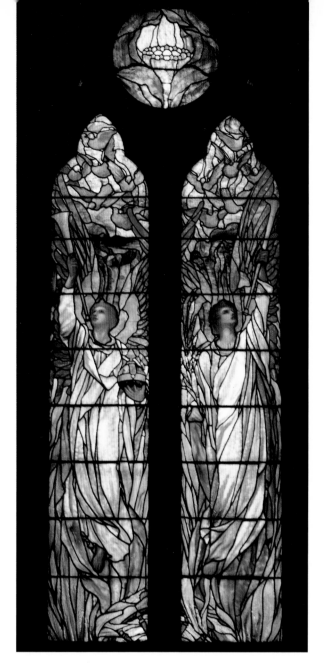

52. Church of the Incarnation, Madison Avenue and 35th Street, Manhattan. Angels from *The Victory of Lazarus over Death* window, Tiffany Studios. c. 1890. W. 48″. Art Nouveau was not divorced from the American Renaissance that preceded it. The swirling energy in these draperies and arching bodies suggests how Art Nouveau sprang from the dynamic use of the flowing lines of more conventional classical art.

Neoclassicism was sometimes wedded to another artistic current popular in nineteenth-century art—the genre scene. Genre painting depicts everyday activities, as opposed to portrait work, religious themes, heroic moments, or landscapes. Sir Lawrence Alma-Tadema (1836–1912) made himself an international reputation by painting genre scenes in classical, mainly Roman, settings. Genre painting with its emphasis on everyday life usually portrayed activities from the era and the nation of the artist—people fishing, getting married, playing

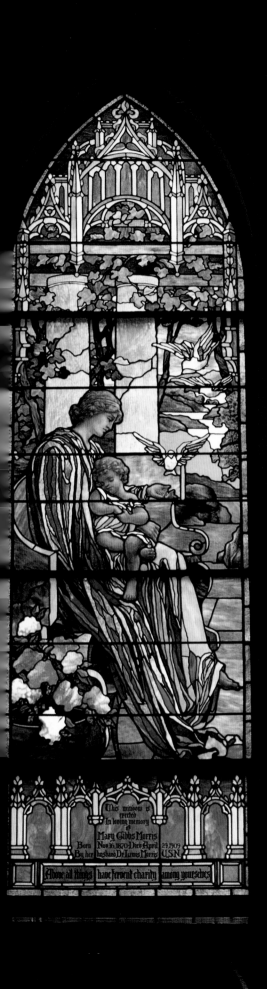

53. St. Ann's Episcopal Church, St. Ann's Avenue and 140th
Street, Mott Haven, The Bronx. *Above All Have Charity Among
Yourselves,* unidentified artist. c. 1900. W. approx. 46″. The
original building of 1841 still stands despite changing tides of
population. Although the structure is simple Gothic Revival,
this late opalescent window reflects the classical tastes of turn-
of-the-century New York. Nature was also an attractive topic
to Americans, and it appears here civilized, like the virtue ex-
tolled by the title of the window.

54. New York Society for Ethical Culture, Central Park West
and 64th Street, Manhattan. *Per Aspera ad Astra,* Louis D.
Vaillant. c. 1910. W. 68″. The classical tradition and nine-
teenth-century beliefs about the purity and nobility of femi-
nine nature combined to make women the preferred figures for
the high-minded, if rather vague, allegories of the American
Renaissance.

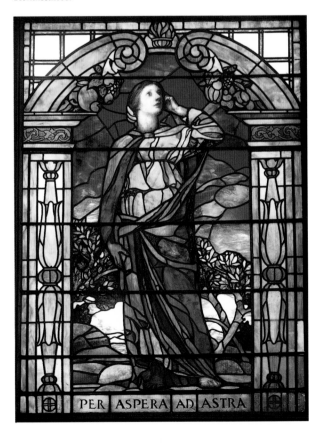

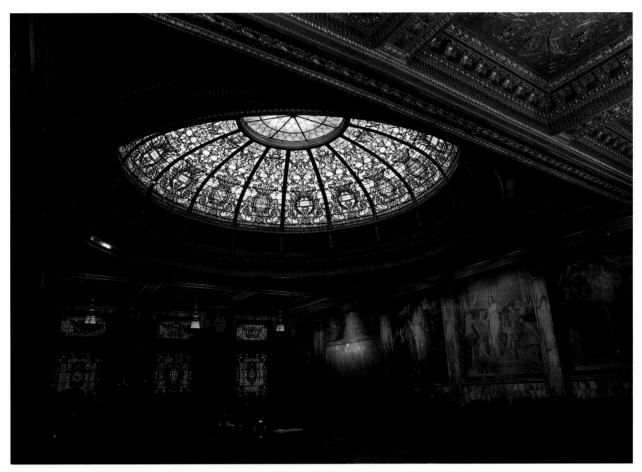

55. Appellate Division Courthouse, New York Supreme Court, Madison Avenue and 25th Street, Manhattan. Dome and windows, D. Maitland Armstrong (1836–1918). Probably completed 1900. W. of dome 25′.

games, courting—but Alma-Tadema transferred such activities to Rome or ancient Greece. He tended to confine his subjects to upper-class folk, lounging about in their palaces, participating in elegant rituals, or listening to lyres being played by handsome youths. Other artists also painted genre scenes with classical settings. The popularity of classical genre works (Alma-Tadema was only the most successful of many such painters) suggests that the late nineteenth-century public liked to see scenes they could identify with, but glamorized by the luxury of imperial Rome. One gains from this subject matter further insight into the varied nature of late nineteenth-century neoclassicism. *Dignitas* and noble virtue were part of the appeal of classical themes, but also pleasing was any imagined similarity between oneself and the elegant upper classes of imperial Rome.

At the Church of St. Luke and St. Matthew, 520 Clinton Avenue, Fort Greene, Brooklyn, the classical genre scene has been expanded to include a visit by Christ (fig. 112, p. 105). Here one sees in opalescent glass Christ in relaxed, familial conversation with a Roman matron, while in the background a servant sets the table.

Thus might an ordinary day in ancient Rome be transformed, and more converts gained for Christianity.

At St. Ann's in Mott Haven, The Bronx, there appears another exploitation of classical settings (fig. 53). The woman in antique costume sits amid the tranquillity of a Roman country scene, a child nestled by her side. The inscription simply asks Christians, *Above All Have Charity Among Yourselves*. Fluttering doves and the slumbering child suggest a vague and sweet tenderness, but the architecture and dress of a presumably civilized and noble culture not only help decorate the sentimental scene but lend dignity to the idea of "Charity among yourselves." In a related way classical seriousness invokes the nobility of an ideal, humanism, in the memorial window to Alfred R. Wolff (fig. 54) at the New York Society for Ethical Culture at Central Park West and 64th Street.[5]

Classical motifs provided architectural continuity for the skylights and domes of opalescent glass that architects began to design for the neoclassical buildings of the late nineteenth century. The Appellate Division Courthouse (Madison Avenue and 25th Street) has a

stained-glass dome twenty-five-feet wide (fig. 55). It is decorated with the State seal of New York and escutcheons in the form of standards like those carried by Roman legions. The dome seems elaborate and luxurious; it was meant to be, in this building whose decoration represented one third of the structure's total cost. Many of the same muralists and sculptors who had worked on the World's Columbian Exposition were reassembled to work on this courthouse, so that a temple of justice unsurpassed in the world might be built, and a demonstration made that Americans were "most completely the children of the Renaissance."[6]

Opalescent glass was used in windows with Gothic arches throughout the era when Tiffany and La Farge were in the ascendancy. Sometimes the window designer made an effort to conform to the Gothic frame and whatever mullions were present, but just as in the earlier Gothic Revival glass, not much more than the ornamental details of the glass even approximated what would be archaeologically correct as a medieval style. Like the enamel windows of St. Patrick's, opalescent windows in what was called "the Gothic style" usually consisted of more or less elaborate canopy work and framing details derived from Gothic architecture. These ornamental features of the window framed figures or scenes done in some "realistic," that is, postmedieval style. Holy Trinity Lutheran Church on Central Park West and 65th Street in Manhattan has a rich array of such windows done by major New York studios. The window of the *Second Advent* (fig. 115, p. 106)[7] draws on familiar post-Renaissance versions of the subject and fully exploits the potential of opalescent glass to evoke dramatic light effects. The canopy work, on the other hand, is stylistically close to its medieval predecessors, except that it is not designed to let in more light or to give the window a paler general appearance. On the contrary, the canopy work is opulent, and photographs can hardly do justice to its deep jeweled colors. The canopies thus define themselves as yet another interpretation by nineteenth-century artists of Gothic styles; they are a Gothic for the Gilded Age.

Windows like those at Holy Trinity Lutheran Church are relatively uncommon. The classicizing tendencies of the time and the potential of opalescent glass for dramatic illusions of depth in space and subtlety of light effects did not encourage designers to work in the medieval manner.

Even when a building seemed to demand Gothic windows, it might not receive them. Architects could suggest "appropriate" windows for their buildings, but stained-glass windows, particularly those for churches, were often paid for by individual donors and they frequently had the last word.[8] Consequently, an opalescent landscape or a classical design might be installed despite the architect's protests. At the turn of the century Ralph Adams Cram (1863–1942) designed The First Presbyterian Church of Far Rockaway, Queens, in his historically

careful Gothic style. For this church he wanted medieval-style glass, certainly not opalescent glass and also not the Gothic Revival work of earlier decades with its medieval decoration framing three-dimensional scenes. Unfortunately for Cram, a salesman for Tiffany Studios got to Mrs. Russell Sage, who was paying many of the bills for the new building. The Tiffany salesman proposed something more interesting than stiff saints posed between mullions. Despite Cram's protests, a vast landscape in opalescent glass flowered in the narthex window—the most important window in the church (fig. 56). Cram disliked Tiffany and he must have been furious when at the dedication of the church scant attention was paid to the building but the Tiffany window was the subject of much praise and discussion.[9]

56. The First Presbyterian Church of Far Rockaway, 13-24 Beach 12th Street, Far Rockaway, Queens. Russell Sage Memorial Chapel, untitled landscape, Tiffany Studios. c. 1910. W. 21′. This is said to be the largest and most expensive window produced by Tiffany Studios until 1910. Although the window was a popular success, it annoyed the new breed of architects who wished to design Gothic buildings that were faithful to medieval precepts.

57. Church of the Transfiguration (Little Church Around the Corner), 1 East 29th Street, Manhattan. Edwin Booth memorial window, John La Farge. 1898. W. 40″.

Similar installations of opalescent glass were made in older buildings. Because stained glass is expensive and nonessential, it is often the last item installed in a building. Many Gothic Revival buildings built before the Civil War still lacked some stained glass when the opalescent era dawned, and consequently one often sees opalescent windows in Gothic Revival buildings. In some cases opalescent glass replaced stained glass installed in earlier decades; fashion in glass, as in so many things, can be remorseless. Usually the style and subject matter in such new windows followed the preference for classical treatment. An interesting example is the Edwin Booth memorial window (fig. 57) at the Church of the Transfiguration (Little Church Around the Corner) at 1 East 29th Street, Manhattan. The building is a romantic version of an English Gothic country church and there is nothing classical anywhere in its buttresses, finials, tiny dormers, and mullioned windows. Neither is there any-

thing apparently classical in the theme of the window dedicated to Booth. According to church records Booth appears in this window dressed for his great role of Hamlet, but aside from the fact that the window inscription quotes the play, nothing in the design bespeaks a prince of medieval Denmark. Nevertheless, La Farge, who designed the window (along with some annoying assistance from The Players' Club, which paid for it), was not interested in the specifics of Hamlet or the Gothic setting of the window. La Farge was celebrating the theme of Booth as the great and lost tragedian. Apparently only Greek theatre props and Roman wreaths offered appropriately elegiac and noble metaphors for La Farge's theme.[10]

Opalescent glass was so popular in this country that by the end of the century few domestic studios made windows of any other material. Enameled windows were still desired, especially by the Catholic Church, but they tended to be imported from Europe, where opalescent glass never caught on, and continued to be called "American glass." Windows made mainly of pot-metal glass and following more or less medieval principles were also usually imported, mainly from Britain. Very few windows, whether made in this country or imported, were really designed to resemble medieval work. Renaissance painting, romantic landscapes, and abstractions echoing exotic cultures were all popular, but true medieval glass was unattractive to the tastes of late nineteenth-century Americans. Of course nothing is more important in understanding style than realizing that it changes for the sake of change—sometimes the changes are slow, sometimes fast—and the changes take directions one can dissect and sometimes explain, but above all, genius and ennui are continually eroding whatever is currently popular. While Gothic Revival windows were being torn out to be replaced by opalescent glass, other directions were being considered by glass designers who returned to Chartres for a new look at some of the oldest stained glass in the world.

Twentieth-Century Gothic

Opalescent glass continued to be popular into the 1920s, but stylistically its development had stopped with Art Nouveau. That flamboyant style had a short life: what had briefly been daringly modern soon became dated. Art Nouveau became a banished upstart, and with it, guilty by association, went much opalescent glass with its florid colors and melodramatic effects. Stained glass of all kinds fell into disfavor for homes and public buildings (except churches). Architecture and the decorative arts accompanying it remained largely classical, but forms and surfaces became increasingly simple. La Farge's richly colored, romantic classicism began to seem excessive.

Theodore Roosevelt rebelled against Tiffany's opulence as early as 1904, when he had the White House remodeled in the relatively chaste classicism of the Monroe era. Roosevelt took out Tiffany's opalescent screen, and not satisfied merely to have it gone, ordered it smashed to pieces. Other people who were equally sure of their taste and social status, like Edith Wharton, began to reject as ostentatious the whole idea of living in a palace, no matter how elegantly designed. In Mrs. Wharton's book on interior decoration she recommended simpler houses furnished in the more intimate styles of eighteenth-century France. English Georgian styles were also recommended, and by the 1920s fashionable society was

jettisoning the potted ferns and hanging lamps, the exotic wallpapers and hoarded bric-a-brac, which made an interior designed by Tiffany look like a robber's cave. People were also following Mrs. Wharton's dictum that windows should not be swagged and draped and curtained or in other ways perverted from their function of letting cheerful sunlight into her French interiors.[1]

Besides becoming unfashionable, stained glass for homes was becoming less practical as more and more city dwellers, even the very wealthy, were forced by the cost of urban land to abandon their freestanding houses and take up apartment living or build row houses. The urban social classes who could support serious glass art were ceasing to have a place to put it. In both apartments and row houses there are of course fewer windows than in freestanding dwellings. Casements filled with stained glass would only increase the closed-in feeling of the new dwellings.

Although freestanding houses and mansions were disappearing in Manhattan during the 1920s, the same era saw such structures built in enormous numbers in the expanding suburbs around American cities. Suburban land values were low enough to allow a wealthy person to build a house of practically any size, but less pretentious buildings were preferred in the suburbs and

58. Montauk Club, Eighth Avenue and Lincoln Place, Park Slope, Brooklyn. Reception Room, windows by an unidentified glazier. Installed after 1891. These windows manage to be decorative without excluding light or the splendid views of Grand Army Plaza and Prospect Park.

countryside as well as in town. The notion of the suburb as a half-rural village fitted nicely with the revival of eighteenth-century styles. The suburban home would be Colonial, meaning some version of one of the Georgian styles, or architects might work in rustic fashions, such as half-timbered Tudor, to come up with houses that were large—enormous if one desired—but not built to emulate a palace, or likely to be filled with grand decor like La Farge's *Peonies Blown in the Wind*. Windows of clear, diamond-shaped panes, perhaps set with a small stained-glass escutcheon, were popular in the so-called Tudor house, but otherwise that style did not suggest ambitious stained-glass compositions. In Georgian architecture, as in its French equivalents, stained glass had no place whatsoever, either historically or by the lights of early twentieth-century taste. Whatever style one chose for a suburban home, one of the presumed reasons for moving out of the city was to live among trees and lawns. Stained-glass windows would only interrupt the connection between the home and its pleasant surroundings. Some stained glass continued to be installed in homes throughout the 1920s—Tiffany Studios functioned all through the decade—but the domestic work consisted mostly of trivial panels for town house or apartment light wells, or rehashes of landscapes made for both town houses and country homes. Nothing new, nothing to excite the imagination came of domestic glasswork in the East. When distinguished architects and arbiters of fashion withdrew their support from stained glass, major artistic efforts became impossible because

stained glass is one of the arts, like architecture itself, whose expensive materials and substantial nature require significant economic support. Starving artists cannot pursue their dreams if the dreams are conceived as stained glass.

In the Midwest innovation and vitality in glass continued through the second decade of this century, until

59. Montauk Club. Detail of a window in figure 58.

"good taste" caught up with that region too.[2] The windows in Frank Lloyd Wright's Prairie houses were designed to fulfill the same function as the plain glass windows of suburban houses on the East Coast, but Wright and the other designers centered in the Chicago area were not willing to abandon the decorative potential of colored glass and leaded panes. They designed with much clear glass set in a matrix of leads and scattered bits of colored glass (see figs. 73–76, pp. 77–79). Their windows let in sunlight and allowed good views of the outdoors, particularly as the eye, like a camera, can focus out much of what it does not wish to see. Thus, a Prairie house window virtually disappears when one looks through it to the outdoors, but if one focuses on the window itself, the outdoor scenery dissolves into a vague green background and the glittering geometry of the window emerges.[3]

The midwestern architects had almost no effect on the eastern seaboard, and there are no buildings in New York City with Prairie house windows in them. However, a number of significant midwestern windows have found their way to New York museums and private collections. The Francis W. Little windows (not illustrated) in the New American Wing of The Metropolitan Museum will demonstrate Wright's ideas about the symbiosis that can exist between glass, sunlight, and outdoor scenery. The Little windows were designed by Wright for a home in Wayzata, Minnesota, in 1913. In their new setting in The Metropolitan they will look out onto Central Park, and although it is regrettable that all the rest of The Metropolitan's stained glass is denied sunlight, if only one set of windows in that rich collection may have an outdoor exposure, it should be the glass from the Little House, designed specifically to frame and enhance views of grass, trees, and sky. Prairie house windows were the last, and perhaps the most brilliant, American domestic work in the first half of the twentieth century. By the 1920s styles strongly reminiscent of Colonial America had reconquered architecture in the Midwest just as they had done a decade or two earlier in the East. The careers of the Prairie School architects went into decline, and serious work in stained glass for American homes (and office buildings) ceased. As we shall see in the next chapter, office buildings began to abandon all historical styles. Except for some rather functional-looking skylights and glass ceilings, stained glass seldom went into commercial buildings after around 1920. Only churches continued to use stained glass.

Ecclesiastical design is usually conservative, and opalescent windows continued to be made for churches during the 1920s, but around the turn of the century a revival of medieval-style glass began. The revival, ironically, was part of the chaste historicism that had eventually ended the use of stained glass in domestic architecture. Gothic architecture had not been totally eclipsed by classicism in the late nineteenth century. For churches and sometimes for schools, Gothic buildings were still popular. Like the architects working in Renaissance modes, the architects designing Gothic structures at the turn of the century were trained to know the historical styles intimately and to exploit them with a faithfulness varying from respectful plagiarism to creative eclecticism. Above all, the architect was educated to avoid the distortions of proportion and details that Victorian architects cheerfully and/or ignorantly perpetrated in their adaptations of historical styles.

The emergence of the professional, scholarly architect turned the tables on the glass artists and resulted in stained glass for Gothic buildings being designed with much closer attention to medieval precedent. Gothic structures have been described as frameworks for walls of glass, and the architect could hardly expect success if he could not control the design of the very walls of his building. For the architect of twentieth-century Gothic buildings, there could be no more opalescent landscapes in medieval mullions, or vast Raphaelesque dramas painted with glass enamels. Above all, the material of the new windows had to be pot-metal glass, the same material used in the Middle Ages, which alone could be expected to create the luminous air that filled Chartres Cathedral and distinguished a true, glass-walled Gothic church from all other structures built by man. For architects to control the glass installed in a church required the cooperation of church authorities. The clergy had to be able to get money from the donors of windows without having to accept their artistic advice. This was no small task. Finding money to pay for good stained-glass windows often went on for years after a church was finished, so the architect's vision had to be accepted and guarded, as it were, by clergymen who assumed the burden of financing windows.

The Episcopal Church was most likely to satisfy the needs of medievalizing architects: it was hierarchical—the church officials rather than the congregations made

60. Park Avenue Christian Church, Park Avenue and 85th Street, Manhattan. Narthex window. W. 18′. The scenes at the base of this enormous window were made before 1893 for the old South Reformed Church and were so admired that they were removed from the church for exhibition at the Chicago World's Columbian Exposition of 1893. When the congregation moved into the new Gothic-style church, designed around 1909 by Cram, Goodhue, and Ferguson, the illusionistic panels were incorporated into the soaring Gothic lancets seen here. The window is interesting because it uses opalescent glass in a relatively pure Gothic format. The older parts of the window were made by Tiffany Studios, and judging from the rich rock-glass work in the newer portions, one suspects that Tiffany did them also.

most policies—and there was an informed sympathy for the new medieval work. Recalling how earnest was the Gothic Revival in England, one should not be surprised that opalescent glass received cold frowns in the Church of England. Similar disapproval came from some Episcopal circles in America. All through the opalescent era glass traditional in both materials and subject was imported from Britain for some Episcopal churches, and occasionally for other ritualistic Protestant congregations. The windows of the Church of the Incarnation discussed in chapter 4 are examples of English glass imported when the enthusiasm for opalescent glass had already begun in this country. The variety of those windows—almost every one by different firms, and in different styles, including six American opalescent works omitted from this discussion—indicates that the Church of the Incarnation did not have a firm policy about what kind of windows would be set in its casements. In the nineteenth century relatively democratic, Low-Church sympathies were strong in Episcopal circles. Rectors often allowed the donors of windows to select the studios and the themes for the glass. The rector and the lay trustees of the church could disapprove the choices, but the variety of the glass at the Church of the Incarnation and most other American churches of all denominations (except the Roman Catholic) show that latitudinarianism reigned. Similar policies continue to this day in many churches, but in others commitments were obtained around the turn of the century by newly determined and persuasive architects: henceforth only medieval-type windows would be installed, and opalescent and enamel glass would be banished.

The Moses who emerged to lead Americans away from the stylistic confusion of nineteenth-century Gothic glass was Ralph Adams Cram (1863–1942). Cram loved the Middle Ages. He thought that skyscrapers were just a passing fad and preferred to concentrate his efforts on designing Gothic churches true in style and materials to the Middle Ages. Aside from being born about 700 years too late, Cram should have been a happy man. He managed to turn many of his dreams into monumental masonry, including the Cathedral of St. John the Divine, Amsterdam Avenue and 112th Street, Manhattan, which is the largest Gothic church in the world. Cram was not the best architect working in the historicist Gothic style—that honor perhaps belongs to his partner Bertram Grosvenor Goodhue (1869–1924)—but he was surely the greatest propagandist of the style. Besides his own writing and lecturing, he saw to the publication of Henry Adams's *Mont St. Michel and Chartres* (written and privately distributed around 1904 but not published until 1913). He founded the Medieval Academy of America, was Professor of Architecture at the Massachusetts Institute of Technology, and did all he could to encourage American glass artists who might

emulate and perhaps rival the craftsmen of thirteenth-century Chartres. Other patrons of glassmakers gave innovatory support too, of course—as we have already suggested, architectural and artistic movements do not spring from the actions of a few individuals—but Cram provided a clarity of purpose and direction that was particularly important to the development of neomedieval glass in this country.

Cram liked the authoritarian nature of medieval society, and it was a congenial notion to him that the architect and "ecclesiastical authorities" should get together and work out general policies for the windows of a church. Materials, style, and iconography should all be decided without interference from lay benefactors. The architect and various glass artists might then discuss more specific guidelines for colors and designs for specific windows, after which the artists could submit competitive designs. In at least one major instance, the Great West Rose window at St. John, Cram even managed to select the artist without a competition. Cram may seem like something of an eccentric tyrant, but he understood the importance of the relationship between glass and Gothic architecture and he successfully fought to establish the importance of that connection. The interior of St. John, particularly the nave, exemplifies the notions he fought for, and the windows there are splendid examples of twentieth-century Gothic glass.

The story of St. John the Divine begins in 1889, when George L. Heins (1860–1907) and C. Grant La Farge (1862–1938) won the international competition to design a cathedral for the Episcopal Diocese of New York. They planned a "semi-Byzantine" interior (recall the *Théodora* enthusiasm of the 1880s) culminating in an apse held up by the largest functional columns in the world. All this was to be buried within a 500-foot-high pile of Romanesque architecture. Although C. Grant La Farge was the son of John La Farge, the cathedral authorities determined that nothing but English glass was to go into the new structure. Considering the exotic building, their insistence on such "purity" in the glass may seem a little strange, perhaps a symptom of anglophilia rather than a substantive aesthetic bias. Whatever the reasons for insisting on British glass, that decision soon fitted into the evolution of the plans for the cathedral.[4] The plans of Heins and La Farge were the last gasp of a relatively unsophisticated American eclecticism, of an architecture that Frank Lloyd Wright described as full of "awkward stupidities and brutalities."[5] (Of course if the cathedral had actually been built as planned, it would today be, like Chicago's Water Tower, the most beloved monstrosity in the city, a Matterhorn of vulgarity.) Workmen began to dig the cyclopean foundations in 1892, despite complaints about the structure's bastard style, and construction went on until around 1910, when Heins and Bishop Henry Codman Potter (1835–1908) both died within a short time. By then two chapels were

finished, as well as the vaulting of the choir and the piers of the crossing. In 1911 there was a consecration ceremony for the choir and the two chapels. That same year Cram was named architect of the cathedral.

The glass commissioned under the Heins–La Farge regime showed some interesting variations of style. The window in the chapel of St. Saviour, at the eastern end of the cathedral behind the high altar, was made by Hardman of Birmingham, England (fig. 61). Its enamels, small-scale details, and combination of two-dimensional ornament and three-dimensional figures made it an example of late Victorian glass. Its imagery is flatter and more iconlike than the windows of around 1885 at the Church of the Incarnation (figs. 23 – 25, pp. 28, 30), but it is still recognizably a work of artists trained in the Victorian mode. High above this window are the large (28′ x 17′) clerestory windows of the ambulatory. These are supposedly made "according to thirteenth-century methods," but in fact they combine pot-metal glass with extensive passages of colored enamels. James Powell of London made the windows, and two of them are masterpieces. The central window, *Christ in Glory* (fig. 61), is constructed with a monumental but agitated verticality. Angels swirl away from the perpendicular lines of Christ's figure. The head of Christ with its aura, as well as the entire composition of *The Woman in the Sun* (fig. 63), the other splendid window in the series, recall the Orientalized fantasies of Gustave Moreau's *Jupiter and Semele* (1896). It is extraordinary that such free and dramatic windows fill the casements above the high altar of the cathedral. Both windows show how brilliant enameled glass can be, but the five flanking windows offer equally strong examples of overpainting. The enamels here are too thick and dark, and from the cathedral floor on cloudy days one can see only murky patternings of brown and green. Nothing but very bright sun will bring them alive. Even *Christ in Glory* and *The Woman in the Sun* will seem a little flat and dull on very dark days, or near sunset, and there seems to be some deterioration of the enamel in spots, but these two windows usually appear as great explosions of color and fully serve their function, which is to bring to a climax the long vista from the nave to the high altar.

One other chapel was finished in 1911, that of St. Columba, and the three-light window in that chapel indicates the direction the cathedral would take both architecturally and in its windows. The central light of the St. Columba Chapel window (fig. 62) once had figures in it, but they were blown out in the hurricane of 1946 and replaced with grisaille work similar to the side panels. (*Grisaille* comes from the French "to paint or make gray," and refers to windows made up mainly of clear panes painted with lacy patterns of sepia enamel and interleaded with bits of colored glass. Despite the meaning of the word, such windows are usually more silvery than gray.) The two original grisaille panels show how close

61. Cathedral of St. John the Divine, Amsterdam Avenue and 112th Street, Manhattan. High altar: lower window behind altar, Hardman, Birmingham, England. c. 1911. W. 17′. Upper window, *Christ in Glory*, James Powell, London, c. 1911. W. 17′.

62. Cathedral of St. John the Divine. St. Columba Chapel: detail of grisaille window, Wilbur Herbert Burnham (1887–1974), Boston. Side lights, Clayton and Bell. c. 1911. Central panel, Burnham, 1947. These panels were all modeled on the famous thirteenth-century grisaille windows in York Minster known as the Five Sisters, but the work of Burnham reveals the American preference for more colorful interpretations of medieval ideas.

63. Cathedral of St. John the Divine. *The Woman in the Sun,* James Powell. c. 1911. W. 17′. *The Woman in the Sun* depicts another of the extraordinary visions recorded in the Book of Revelation: "And there appeared a great wonder in heaven; a woman clothed with the sun, and the moon under her feet, and upon her head a crown of twelve stars" (12:1). Like the adjoining *Christ in Glory,* this window relies on extensive enamel passages and yet retains the brilliance of a pot-metal window.

some English glassmakers were to their medieval sources, especially if no human figures needed to be portrayed. For these panels Clayton and Bell of London imitated thirteenth-century compositions in the famous Five Sisters windows in York Minster. The Five Sisters windows, and these little excerpts from them, exemplify a grisaille that is more English than French, with the color passages held down and the silvery-gray effect emphasized. The center panel, replacing the figured one destroyed in the hurricane, is rather more colorful than the flanking panels. It was made four years after Cram died, by the American artist Wilbur Herbert Burnham (1887–1974), and with him we can now return to the story of Cram and the revival of medieval window making in America.

Hurricanes are among those disasters called by insurance companies "acts of God," and in the case of the hurricane-wrecked window in the St. Columba Chapel, Cram would surely have rejoiced at the work of the Lord. There was not only so much to be done to finish the

cathedral but so much to be undone. By 1911 when Cram (with C. F. Ferguson [1861–1926], one of his partners in the firm of Cram, Goodhue and Ferguson) took over as master architect, he had become an extreme enthusiast for the early Gothic of northern France. Having discovered the best possible church architecture, Cram had to deal with the fact that Heins and La Farge had wasted almost twenty years and vast amounts of money building in the wrong style. Cram set out to redesign the cathedral. He was good at getting his own way. In the years before the hurricane blew out the Victorian-looking panel in the St. Columba Chapel, Cram convinced the New York Diocese that the cathedral should be "pure" French Gothic. He rebuilt the choir with Gothic ribs and constructed his gigantic French Gothic nave. He also had searched England for stained-glass artists who could carry out his dream of a structure to rival Chartres or Rheims. In the early 1900s he said that in the United States he could not find artists capable of executing the glass he wanted but he also soon found that contemporary English designers lacked the feeling he was looking for in his windows. If the windows were not successful, the cathedral would be a failure.[6]

While Cram was redefining the Gothic idiom at the turn of the century and still hiring English artists to make windows for his churches, American glass artists were reexamining the medieval heritage of their craft. Even during the height of the opalescent era literary appreciations of the early medieval windows frequently appeared, and from England came loving treatises on early glass. Although the opalescent masters thought their own work was superior stylistically and perhaps materially to medieval glass, they, too, admired the old windows. The placement of pot-metal chips and other clear, gemlike glass into opalescent windows shows that the opalescent artists had an appreciation for the brilliant light found in antique windows. Otto Heinigke (1850–1915), who restored William Jay Bolton's windows at the Church of the Holy Trinity, Brooklyn Heights, began to experiment with glass that favored transparency. His Hillis Hall windows in the Plymouth Church of the Pilgrims (figs. 116 and 117, pp. 107 and 108), Orange and Hicks streets, Brooklyn Heights, contain thick but clear glass liberally worked in among the opalescent material. The clear glass is not conventional pot metal, but it is not exactly opalescent either. Although the reputation of his opalescent windows was established, Heinigke began to reconsider medieval glass and traveled to Europe in 1896 to study those windows. On his return he continued doing opalescent work in the Brooklyn studio he established with Owen J. Bowen, but he was privately infatuated with medieval glass and began to write and agitate in its favor.[7]

While Heinigke was experimenting with less densely toned glass, other artists were making both technical

64. Cathedral of St. John the Divine. The Great West Rose window, Charles Connick (1875–1945). c. 1935. Diam. 40′. From the exterior one can see that some of the stone traceries are nearly 2 feet wide. From the interior the traceries look more delicate because Connick wove white glass along the stone spokes; the radiating power of the light from the pale glass diminishes the apparent width of the adjoining masonry.

65. Cathedral of St. John the Divine. The Great West Rose window, Charles Connick. c. 1935. Diam. 40′. The Great West Rose in the late afternoon. The window is made of pot-metal glass and responds actively to changing light conditions (compare this illustration with figure 64).

and stylistic moves toward medieval glass. William Willet (1867?-1921) was developing a style that would function well with medieval mosaic glass. Willet was born in New York and studied painting with John La Farge, from whom, one assumes, he developed an interest in stained glass. He went to Europe and gave the windows there careful attention. When he returned to the United States, he was offered a job as designer for a Pittsburgh stained-glass studio.[8] Willet designed mostly opalescent windows, but medieval windows were apparently more on his mind when he met Charles Jay Connick (1875-1945), who was a cartoonist for a local newspaper. Connick became fascinated with glass and eventually gave up cartooning to join Willet. The work of a cartoonist resembles the method used to realize figures in medieval glass, and Connick apparently found himself at home in the two-dimensional, linear imagery of medieval windows. Willet eventually established his studio in Philadelphia, while Connick went to Boston, partly because Cram was there. Although their studios were not in New York, they made many windows for the city.[9]

Three other early experimenters with medieval work all had studios in New York. Henry Wynd Young (d. 1923), J. Gordon Guthrie (1874-1961), and Ernest R. Lakeman (1883-1948) all worked in a similar style and at times collaborated with one another. Both Guthrie and Lakeman spent part of their early careers in Britain. All three artists were familiar with European medieval glass, but the pale tonalities of their windows were closer to medieval British glass than to Continental work. There were other artists who experimented with pot metal and styles closer to two-dimensional designs (Nicola D'Ascenzo [1868-1954] in Philadelphia deserves particular mention), but none of these early figures had achieved success based on their medievalizing efforts until around 1910, when Cram, Ferguson, Goodhue, and other architects began to be able to insist on glass styles of their own choosing and to encourage the development of American glass consciously modeled on early medieval work.[10]

The new generation of artists in glass devoted considerable amounts of time to studying and writing about medieval glass, particularly the glass of Chartres Cathedral. The spell of Chartres, as evoked by Henry Adams, eventually produced a substantial, somewhat scholarly literature, which resulted in the best understanding of the relationship between glass and architecture since the Middle Ages. The passion for Chartres did not rest merely on Henry Adams's beguiling book; rather, that cathedral provided a great laboratory for the analysis of the dynamics of medieval glass and its architectural context. Chartres alone of the great French cathedrals still had all its glass and Chartres alone was always filled with an extraordinary radiance, the "continuous light" written about by Abbot Suger.

Chartres demonstrated the importance of totally controlling the glass and all the other light mediums in a building. Chartres also showed the importance of pot-metal glass, because it was the only type of glass that could pour enough colored light into a building to permeate the very air and tint the stonework with the colors of the glass. Furthermore, one could learn from Chartres that all the glass had to be approximately of the same quality; strong variations in brightness or tone broke the rhythm of the walls of glass that were so much the substance of Gothic architecture. Raw light was particularly fatal: Connick, Cram, Heinigke, and all their compatriots in the American rediscovery of medieval glass saw at places like Poitiers and Rheims that splendid windows, windows as fine as anything at Chartres, were debased by raw sunshine coming through adjoining casements of plain glass, or by light from carelessly placed electrical fixtures.[11]

Cram as a student, propagandist, and practitioner of medieval arts was matched by Charles Connick. Connick,

66. Church of St. Vincent Ferrer, Lexington Avenue and 66th Street, Manhattan. Lancets and rose windows, Charles Connick. c. 1925. W. 20'. Partly out of personal preference, but also because Viollet-le-Duc had concluded "scientifically" that blue was the dynamic agent in medieval windows, Connick used much blue in his glass.

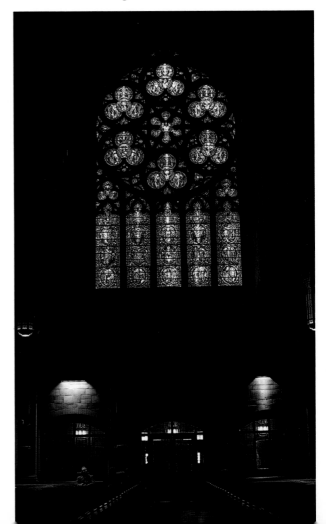

like Cram, was not the greatest artist in the movement he championed but he did more than anyone else to persuade and cajole the profession and ecclesiastical patrons toward the historicist medieval style. His writing and lecturing during the 1920s and 1930s were summarized in his book, *Adventures in Light and Color* (1937). By doing so much to stress the relationship between glass and architecture, Connick and the other neomedievalists helped glass artists to accept their craft as a part of architecture and not as a branch of painting. By the 1930s it was understood that a stained-glass window was not a picture that happened to fill a hole in a wall; it was part of the wall with a potential for transforming or controlling the quality of light in a building. The window should also add decorative relief or evocative imagery to the structure, but that function had to take place within the context of the window as part of the structure. To maintain the rhythm of the walls, the imagery in the windows should be flat, eschewing three-dimensional illusions. The two-dimensional imagery in medieval glass was ideal for the needs of Gothic architecture and did not interfere with the progression of walls, buttresses, and pillars that formed a delicate envelope around a great Gothic interior; the neomedievalists understood this and they did not carp about "bad drawing" in medieval glass, as had the Gothic Revival artists of the preceding century.

The accommodation to the imagery of early medieval glass was no doubt made easier by the awakening of twentieth-century minds to the power of primitive and non-Western art. Indeed, by the 1930s "realistic" imagery like that created in the studios of La Farge and Tiffany was embarrassingly old-fashioned, and the primitive energy of medieval art was about the only claim to artistic respectability that stained glass could make.

The ties between stained glass and twentieth-century Gothic architecture were particularly close in the designing of large clerestory windows, such as those that line the nave of St. John the Divine and St. Patrick's (see figs. 140 and 141, p. 121). The St. John windows are 44 feet high, and their tops are 111 feet above the floor. Such gigantic architectural spaces require gigantic treatments, designed to complement the cathedral's feeling of soaring vastness. The large standing figures in medieval clerestory windows had the monumentality appropriate to their place in the building, and consequently adaptations of medieval clerestory figures seemed the most reasonable (and historically appropriate) way to deal with similar windows at St. John. To have done otherwise with such large windows would have substantially intruded on the sense of timeless historicity (ironic wish!) that Cram was striving to achieve.

At The Riverside Church (fig. 67), for equivalent casements, the architects simply ordered copies of clerestory windows at Chartres. Literal copying of medieval work was considered bad form by the neomedievalists,

67. The Riverside Church, Riverside Drive and 122nd Street, Manhattan. *St. James,* Simon of Rheims or Lorin of Chartres. c. 1929. W. approx. 84″. This window is almost an exact copy of the *St. James* in the clerestory of Chartres Cathedral. Many of the lead lines in the original window were not put there by the medieval designers; they were added later to repair cracks. The only substantial differences between these windows and the originals, as they looked in 1929, are that visages darkened by time were reproduced in colors closer to the original tones and the glass is not so good as the thirteenth-century material. These windows would look better if The Riverside Church were not so brightly lit; Chartres Cathedral is very dark inside, and consequently its stained glass appears more radiant. On dark rainy days these windows take on an appearance closer to the originals, which were designed for the softer light usually found in northern France.

and Connick among others refused commissions like those from Riverside.[12] (The Riverside windows were made by French firms.) The clerestory windows made by Americans usually emphasized the strength rather than the delicacy of their medieval counterparts. The shoulder-thrusting sculpture for large modern buildings of the late 1920s and the 1930s (see *Atlas* at Rockefeller Center) probably influenced the neomedievalists' notion of

68. The Riverside Church. Detail of an aisle window, Reynolds, Francis, & Rohnstock, Boston. c. 1930. W. approx. 24″.

what a monumental figure should look like. Some twentieth-century clerestory figures, although they have great dignity, otherwise lack character, as does much of the public sculpture of the era.

Smaller windows intended for little churches or the aisle walls of large buildings were more varied and showed interesting approaches to the problem of modern artists' designing in an archaic style (see figs. 142 to 145, pp. 122 and 123). Like the aisle windows of medieval churches, such windows in modern buildings could be seen in detail by persons on the floor of the church, and the windows did not play such a dramatic role in the architecture of the interior as do big clerestory windows. The aisle windows at St. John follow the medieval practice of illustrating saintly or heroic stories. The technical quality of these windows is superb. Although they seldom contain glass quite as good as that in genuine twelfth- or thirteenth-century windows, it is virtually all hand-blown pot-metal glass full of light-enriching irregularities. (Microlayered medieval red was made in small batches in the 1920s, but it was expensive, and the pseudoscientific research of Viollet-le-Duc convinced artists that the "radiating power" of blue was the vitalizing element in medieval glass. The magnificent blue-toned west windows at Chartres further enhanced the mystique of that color. The neomedievalists never thoroughly ex-

ploded the myths about blue glass. In fact they tended to perpetuate them, and hence there was much good blue glass made, and rather too much of it used, while red was neglected.[13])

Except for their misunderstandings about blue, the twentieth-century medievalists had a mastery of the technical devices used by the craftsmen of Chartres, and one can see a gamut of venerable techniques used in the aisle windows of churches like St. John the Divine.

The mixing of bits of clear or white glass among primary colors makes those colors appear richer and more lively than if no white were used. (There is usually a good deal of white in most windows that seem at first glance to be an attractive mixture of deep primary colors.) Enamels appeared mainly as simple lines of sepia to evoke faces and other details, or to create diaper-work backgrounds (see figs. 1 and 2, p. 2). Leads helped to strengthen designs and give texture to windows, and the use of blues and reds was mastered so that they resonated against one another rather than merging into heavy purple. The grime and corrosion in medieval glass often enhances the luminous quality of old windows, and the twentieth-century glasswrights attempted to imitate the effects of time with films and splatterings of sepia enamels. Although the technique, sometimes called *antiquing,* has been known for centuries, it is treacherous. Applied carelessly, the matt paint will dull a window, and it is no substitute for artful diaper work. Occasionally one sees

an antiqued window with the same clumsy effect that Charles Winston denounced in 1847:

> In all English and French glass that I have seen *antiqued,* the process has been to bedaub the whole individual piece, and then to rub away some of the dirt in the center of the piece; whereas nature bedaubs the center of the piece, leaving, in general, the edges comparatively clear. The effect in the former case is, when the pieces of glass are very small, to make the whole design look as if it were *greasy*—as if it were made up of lumps of different-coloured fats, . . . like the little dumplings one sees swimming about in mutton broth.[14]

Most antiquing done by twentieth-century craftsmen was, however, substantially more subtle, as one can see by looking, again, at the aisle windows at St. John. Indeed, to all but the most practiced eye, the aisle windows at St. John equal the technical brilliance of the finest medieval windows. The images in the aisle windows, the busy little scenes so liked in the Middle Ages, are, however, more difficult to accept.

There are many small windows that creditably imitate medieval drawing. The most successful are often those that frankly re-create medieval subject matter along with the medieval style of the drawing.[15]

Little martyrs, virgins, saints, tradespeople journeying hither and yon through stylized twelfth-century towns and landscapes, all have been delightfully re-created as pastiches of medieval windows. Less successful, even when done by the same studios, are the attempts to transcend the medieval setting while retaining a distinctly medieval style. We squirm in a time warp, seeing a Gothic Abraham Lincoln deliver the Gettysburg Address.[16] Some artists took a freer approach to the imagery in detailed windows. One of the most successful was William Willet, mentioned earlier, who painted (and trained his assistants to paint) with energetic brush-strokes over pot-metal glass. His *Return of the Prodigal Son* (fig. 143, p. 122) at Green-Wood Cemetery in Brooklyn is full of fluid drama, which when viewed from a little distance merges into a medieval-looking window in harmony with its Gothic mullions. The costumes and settings of Willet's windows are neither medieval nor modern. Following the example but not the style of twelfth-century window makers, Willet, whenever possible, clothes his characters and places them in surroundings that are vaguely Biblical without summoning up any particular historical era.[17]

There was other work in small windows that offered an alternative to Gothic stiffness yet retained an otherworldliness deemed appropriate to stained glass. These windows are related to the illustrators' work of the early twentieth century. The nineteenth century saw an enormous increase in the number of books published. Illus-

trated works were popular, thus creating a vast new demand for artwork. We have already seen in the Renaissance the first appearance of art shaped by the processes of printing. Engravings, etchings, and woodcuts tended to emphasize drawing rather than painting for the creation of images. Despite the progress made with the photographic halftone and color processes, the technology of nineteenth- and early twentieth-century printing still encouraged linear work. The vitality of the 400-year-old illustrator's traditions interacted with some nineteenth-century devotees of fantasy and flat surfaces, such as the Pre-Raphaelites. All the Pre-Raphaelite artists discussed in chapter 2 did illustration work and thereby helped keep that field lively and innovative. Through their illustration work, and that of some of their successors like Walter Crane and Aubrey Beardsley, they popularized the exotic in style and subject matter. By the end of the nineteenth century illustrators like John Tenniel (*Alice in Wonderland,* 1865) seemed quite dated. Their nervous essays into the fantastic were superseded by artists like Arthur Rackham and Kay Nielsen, who used swift lyrical lines, or ones as strongly grotesque as the most bizarre fairy tale might suggest. Their sense of ornament made the surface of their pages as much an exercise in fantasy as the ideas being illustrated[18] (fig. 145, p. 123).

It has been suggested that whatever genius Edwardian easel painters lacked was balanced by the work of the most gifted generation of illustrators since Rembrandt. Many illustrators' styles were suitable for themes in stained glass, although only a few glass artists and churches had the imagination to make the connection. However, by the 1920s windows that echoed illustrators' styles began to appear in New York. These new windows were consonant with twentieth-century Gothic, yet were rich in humor, character, and line. In large windows the style sometimes lacked architectural scale. However, in the forty-four-foot-high window in figure 140 (p. 121) one can see a marriage of the style with strong, flat color passages to produce for the nave at St. John the Divine the splendid window depicting *Luke the Beloved Physician and Hippocrates.*

Despite such successes, small windows were usually more appropriate for the nuances associated with the illustrator's style. The beautifully drawn windows designed by J. Gordon Guthrie in collaboration with Henry Wynd Young are often such seemingly casual little panels that they are not noticed. In them line rather than color predominates. At St. Vincent Ferrer, Lexington Avenue and 66th Street, Manhattan, for instance, Charles Connick's vast blue windows overwhelm the visitor. Only after adjusting to Connick's icy power is one likely to notice two little narthex windows, only twelve inches wide and thirty-four inches high, signed "Henry Wynd Young, Glass painter." One window portrays *St. Augustine* (fig. 69), the other *St. Louis.* Combining seri-

69. Church of St. Vincent Ferrer, Lexington Avenue and 66th Street, Manhattan. *St. Augustine,* J. Gordon Guthrie (1874–1961) and Henry Wynd Young (d. 1923). c. 1925. W. 12″. Guthrie and Young brought a wry and sophisticated sense of character to many of the figures they created on glass. More than just painters, they used exquisite etching, antiquing, and leading to complement the refinement of their images.

70. The Riverside Church, Riverside Drive and 122nd Street, Manhattan. Baptistry windows, Wright Goodhue (1905–1931). c. 1929. W. approx. 144″. Goodhue was a splendid colorist, as these windows attest. The spotlight playing on the cross weakens the colors of the glass, which nevertheless assert themselves even under these unfavorable conditions.

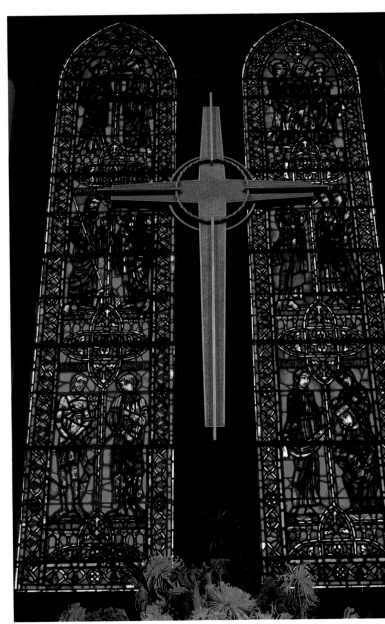

ousness and irony, Guthrie and Young manage with a few deft lines to portray those two exemplars of medieval wisdom as complicated human beings, undeniably saintly and patient but also more than a little fatigued at this world's unending folly.

Another glass artist who combined the illustrator's sense of imagination and line with twentieth-century medievalism was Wright Goodhue (1905–1931). One learns with some surprise that the pious Ralph Adams Cram admired Aubrey Beardsley. Cram said of young Goodhue, "I think his line came next to that of . . . Beardsley in keenness and distinction."[19] Goodhue was the nephew of Cram's colleague, Bertram Grosvenor Goodhue, so perhaps Cram was less than impartial, but one can immediately see in Wright Goodhue's windows an original talent. He was an eccentric and brilliant child. As an eight-year-old student at the Boston Museum of Fine Arts School he did not want to draw the prescribed apples and bananas; he preferred Crucifixions and Ascensions. In his tragically short life (he committed suicide) he designed windows for more than thirty churches. Within very strong, almost sculptured, lead lines Goodhue would create personages with exotic features that were more Romanesque than Gothic. Building committees were taken aback by young Goodhue's cartoons for windows, but his finished glass had immediate appeal, both for its extraordinary imagery and because Goodhue was a fine colorist.[20] His window behind the baptistry at The Riverside Church (fig. 70) is full of droll and grotesque figures. One sees in them how the illustrator's sense of the fantastic could make a seemingly medieval window that was inspired by the imaginative genius of the Middle Ages and yet not imitative of any historical window.

ROSE WINDOWS

Of the contributions of the twentieth-century medievalists, none was more important than the revival of the rose window as a major form of glass art. Rose windows were not common in nineteenth-century American churches, even those built in various Gothic styles. American ecclesiastical architecture was strongly English in feeling, and rose windows were not much used in English Gothic work, particularly in the modest parish churches that were the antecedents for so many American houses of worship. Even relatively large Gothic Revival churches, such as Trinity Church on Wall Street, usually had but a single bell tower built over the entrance, and this tower complicated the construction of a rose window in the place most appropriate for it—the rear gable of the church. Not many early American churches had the French style with large free gables that would lend themselves to the placement of a rose window. St. Patrick's Cathedral was an early exception—a large, French Gothic church. (In addition to the space between the paired bell towers of St. Patrick's, there are

71. Fifth Avenue Presbyterian Church, Fifth Avenue and 55th Street, Manhattan. Rose window. Studio of John C. Spence, Montreal. 1875, perhaps somewhat modified by Tiffany Studios in the 1890s. W. 14′2″. Sepia enamels on machine-rolled pot metal are combined in this exuberantly Victorian window.

of course the ends of the large transepts, whose gables display rose windows.[21])

Nonritualistic Protestant denominations began in the mid-nineteenth century to build auditorium-type churches, that is, preaching halls with the seating arranged in a semicircle facing the pulpit. Some of these churches were very large, and complicated roofs with big gables were needed to vault the auditoriums. Large circular windows offered a way of exploiting the gables by providing both light and decoration in such auditoriums. By the 1880s some Protestant denominations that had long resisted stained glass were able to accept the image-free geometry of a rose window. (Medieval rose windows usually had figures woven among their floral or abstract patterns, but sometimes no imagery was used, and the window simply expressed its geometry, which is the principal impression all rose windows make from the floor of a great cathedral. *Occhio* windows, popular in Italy, are also sometimes called rose windows, but they do not contain radiating imagery and elaborate stone tracery. They are simply scenes in glass set in a circular frame.) The windows for auditorium churches were usually made, as one might expect, from the enameled or opalescent glass popular in the nineteenth century. Enamel glass does not usually exploit the full potential of a rose

72. Cathedral of St. John the Divine, Amsterdam Avenue and 112th Street, Manhattan. Rosette above clerestory lancets, Reynolds, Francis, & Rohnstock. 1935. Diam. approx. 144″.

window, and opalescent materials may be even less radiant. The rose window, because of its abstract form, can suggest more to the imagination than a conventional window full of explicit imagery. The various concentric and radiating mullions imply movement to and from the center of the window, at the same time that the restful nature of the circle—a completed, perfect form—unifies the entire window. The tension between these static and dynamic characteristics has provoked comment from many observers, and a good deal of ink has been spilled in attempts to explore the symbolism and portentous energy that seems to be inherent in rose windows.[22] The dynamic aspects of rose windows are stepped up by pot-metal glass, which changes constantly with moving sun and clouds, or whatever else may alter the light falling on a window. Most enamel and opalescent glass is less sensitive than pot-metal glass to light changes. Furthermore, and perhaps most important, pot-metal glass is transparent, or nearly so, and only with some difficulty can our eyes find the true plane of such glass. We focus and refocus, trying to adjust to the blaze of light in the glass and to find its surface. The inherently dynamic design of most rose windows—blooming circles—is thus amplified by the inability of our eyes to pin down their exact distance (and hence their exact size). The window can be further dematerialized through the artful use of white or clear pot-metal glass around the spokes and circles of masonry. The light pouring through the clear glass produces *halation:* the spreading of light from its source (automobile headlights, or a flashlight, seen head on at night provide examples of the effect). Strong halation makes a piece of glass seem bigger at the expense of whatever adjoins it. Bordering the mullions of a rose window with very bright glass makes the masonry more delicate looking. The effect is a powerful one; from outdoors the Great West Rose of St. John the Divine reveals massive spokes of masonry; from inside the cathedral the same stonework (much of it bordered with white glass) looks like a fragile armature, half-lost in light. To return now to opalescent and enamel rose windows, their lustrous but solid-looking surfaces do not lend themselves to ethereal effects like halation. The substantial, stony appearance of opalescent glass is particularly unlike the impression made by pot-metal glass, and our eyes focus easily on the relatively dim surfaces of an opalescent window, leaving us undeceived about its immediate, physical nature. This is not to say, however, that all rose windows of opalescent glass are heavy-looking or incapable of being animated by the sun. Some of them are made of delicate glass, set with the vitreous chips and glass jewels commonly mixed into opalescent compositions. When the sun shines directly into such a rose, it blazes with energy (figs. 150 and 151, pp. 126 and 127). Enameled windows also tend to require direct, bright sunlight to bring out their most dynamic aspects. The rose in the south transept of St. Patrick's is an interesting example of nineteenth-century enamelwork, and although it looks static on dark days, noontime sunlight brings it alive.

When the twentieth-century Gothic style with its

French traditions came to dominate church construction in New York, the city began to receive the great roses that are today among its most beautiful windows. The Great West Rose of St. John the Divine is probably the most famous stained glass window in America, and it is very fine indeed (see figs. 64 and 65, p. 67). The crowds disgorged from tourist buses at the cathedral always seem to be awed by the Great West Rose, although part of their respect seems to be fed by the guides' deluge of statistics: there are 10,000 pieces of glass in the window, the tiny-seeming figure of Christ at the center is actually life-size, and so on. Less easy for a guide to explain, and impossible for a hurrying tourist to appreciate, is the iconographic and sensual vitality of the window. From Christ at the center radiate figures of angels, seraphim, and cherubim. Other heavenly beings and virtues are symbolized in the interstices of the tracery. With field glasses the arrayed figures can be picked out. Thus seen, one realizes how rich a rose window is in its potential for adding, through positioning within expanding circles, an additional layer of meaning to symbolic or metaphorical figures. However, without field glasses, none of the images, even that of Christ, has much force when seen from the faraway floor of the cathedral. More powerful than theological subtleties is the impact of the window as an emotional contrast to the rest of the cathedral, which is all a vast upward striving. The reaching for height that distinguishes Gothic architecture from most other building forms also reveals in the supposedly pious Gothic spirit evidence of human pride, even hubris. The rose window contrasts all that striving with a symbol of completion and wholeness, an invitation to introspection, to open oneself to an inner light.

There were a number of rose windows designed for New York churches in the 1920s and 1930s that broke with medieval models of kaleidoscopic symmetry (figs. 153 to 155, pp. 128–131). The West Rose at St. Thomas's Church on Fifth Avenue and 53rd Street was denounced in 1931 as "a mass of Antwerp blue glass with . . . red spots . . . spattered indiscriminately over its surface. . . ." A critic asked, "Having got what we could of inspiration from the Goths, are we now turning to the Vandals?"[23] That window is obscured partly by the reredos screen, and time has tempered both the colors and our notions of what a rose window should be. A similarly untraditional arrangement of glass (but set within formal traceries) was set in the east end of the Church of the Heavenly Rest on Fifth Avenue and 90th Street, Manhattan (not illustrated). This and other innovative rose windows continue the tradition of light and color focused toward the center of the window, but without traditional imagery or symmetrical designs. The abstraction associated with all rose windows, and slightly earlier essays at places like St. Thomas's, allowed J. Gordon Guthrie[24] to design the Heavenly Rest window without any imagery. Despite its relatively free form the concentration of blue glass in Guthrie's window draws our eye into the very dark area where it is placed and speaks as provocatively as John, "And the light shineth in darkness; and the darkness comprehended it not" (1:5).

Modern Glass

Modern is not a very useful word in itself; Abbot Suger was, after all, building an "opus modernum" in the twelfth century. The term is convenient in this chapter as a rubric for the disparate body of stained glass that rejects medieval and Renaissance models and reflects artistic and architectural trends of the last half century. *Modern* glass does not possess an era to itself. For many years it lay in the shadow of opalescent styles and then of neomedievalism. The work of Frank Lloyd Wright is thoroughly modern in its rejection of historic styles. He is mentioned in the last chapter because the roots of his style are in the nineteenth-century Arts and Crafts movement, and his own work belongs entirely to the late nineteenth and early twentieth century. His windows were an attempt to deal with some of the problems that caused homeowners to abandon stained glass in favor of simple clear windows. Giving him his due as the first great modernist, one must then admit that his work in glass, and that of other members of the Prairie School, had no meaningful influence for the next fifty years. By the time Wright began to have a national and international practice he had stopped designing glass, and never resumed.

As the preceding chapter suggests, the neomedieval school that developed around the turn of the century became the only American school of stained glass. The

elimination of ornamental windows from commercial and domestic architecture left church work as the sole concern of American studios. Stained glass became an ecclesiastical art. Furthermore, as church preferences in art and architecture were highly traditional, there was little demand for glass that reflected the changing tastes of the secular world of the 1920s and 1930s. The few innovations in church glass were almost all variations compatible with the rather strict medieval format; an artist like Emil Frei (1896–1967), who designed in a modified Byzantine style, was considered daring by the medievalists.[1]

The situation in the church-oriented studios of the 1920s influenced the development of American stained glass for the next forty years. The studios depended on their ability to create within the medieval idiom, and they seem to have been sincerely inspired to make great windows in ancient formats. Consequently both economics and aesthetic preferences encouraged the perpetuation of the medieval style. This situation had serious consequences for the future of stained glass because the Great Depression and then World War II left little opportunity for innovation. After 1929 commissions became very scarce; poverty-stricken painters and even sculptors might eke out the money for their materials during the Depression, but the cost of a substantial stained-glass

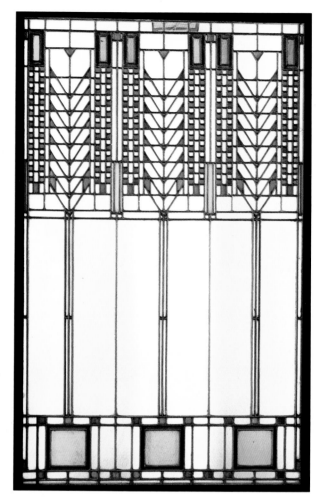

73. The Grey Art Gallery and Study Center, New York University, 33 Washington Place, Manhattan. Untitled panel (originally designed for the Darwin D. Martin House, Buffalo, New York), Frank Lloyd Wright (1869–1959). 1904. W. 26¼". The window is a highly stylized version of wheat plants. (Grey Art Gallery and Study Center, New York University Art Collection)

window amounted to thousands of dollars. Consequently, even well-established studios failed during the Depression (Tiffany Studios filed for bankruptcy in 1932), and with well-known artists looking for work, there were pitifully few opportunities for new designers. The *Journal* of the American Stained Glass Association was the only means of communication within a field mostly ignored by other art and architectural journals. The Stained Glass Association was held together during the Depression by a few respected masters of neomedievalism, and their views dominated the *Journal* as well as the association's exhibits and apprentice programs.

One could therefore hardly imagine that American stained-glass studios would produce from among their ranks a strong new generation of artists. Because archi-

tects had no interest in stained glass except as required for churches, there was also little impetus for new glass from the architectural profession. There were some exceptions to this dreary situation. New York saw a large part of what innovation and new life appeared in American glass during the 1930s and early 1940s.

The severe International Style did not have a direct impact on American architecture during the interwar years; it was too advanced for popular taste. However, the notion began to be accepted that it was boring to go on building endlessly in historical styles. Domestic architecture muddled along with various historical pastiches, although they began to be simplified and purified of some of their ornament. Historicism seemed even less appropriate in commercial and industrial buildings, and Art Deco emerged as a jazzed-up, popular interpretation of avant-garde architectural thought. For new industrial and commercial buildings, and especially for skyscrapers, people liked decoration evocative of the "modern age," ornament suggestive of fast-moving or powerful machines. In theory, glass like that of Wright would complement the appearance of many Art Deco buildings, but in fact nothing emerged except some heavy grillwork combined with glass. There is a functional resemblance between grillwork panels and stained glass, but the connection is tenuous. Typical examples of such grillwork with yellow and white glass appear in the entrance arches of the Chrysler Building (1930), but its architect, William Van Alen, would have been horrified by the suggestion that his slick new building contained any stained glass. Although similar panels set with pale-toned glass appear in a number of the city's buildings, they contain no strong colors or leadwork evocative of conventional stained glass. To have done so would have interfered with the feeling of the building as a great efficient machine, a cousin of the *Normandie,* or some streamlined locomotive.

As Art Deco was a popular style that was respectable enough to be used by businessmen for their office buildings, some churches could perceive it as acceptably modern but not obscenely different. A few church windows were commissioned to combine the feeling of modern structural grillwork with images and colors more reminiscent of conventional stained glass. Such work was rare, and as one might suspect, few such "modern" windows were made by the established studios. The most important Art Deco windows in the city came from New York's Rambusch Studios, which only began designing glass in 1922. For the nave of the new St. Bartholomew's on Park Avenue and 50th Street Rambusch executed clerestory windows (fig. 77), designed by Hildreth Meière (1893?–1961), that seem partly derived from Egyptian wall paintings—a style consonant with a zigzagging Art Deco motif—and they are set in heavy, geometrical leads that evoke structural grillwork. Although the figures are deeply colored, they are sur-

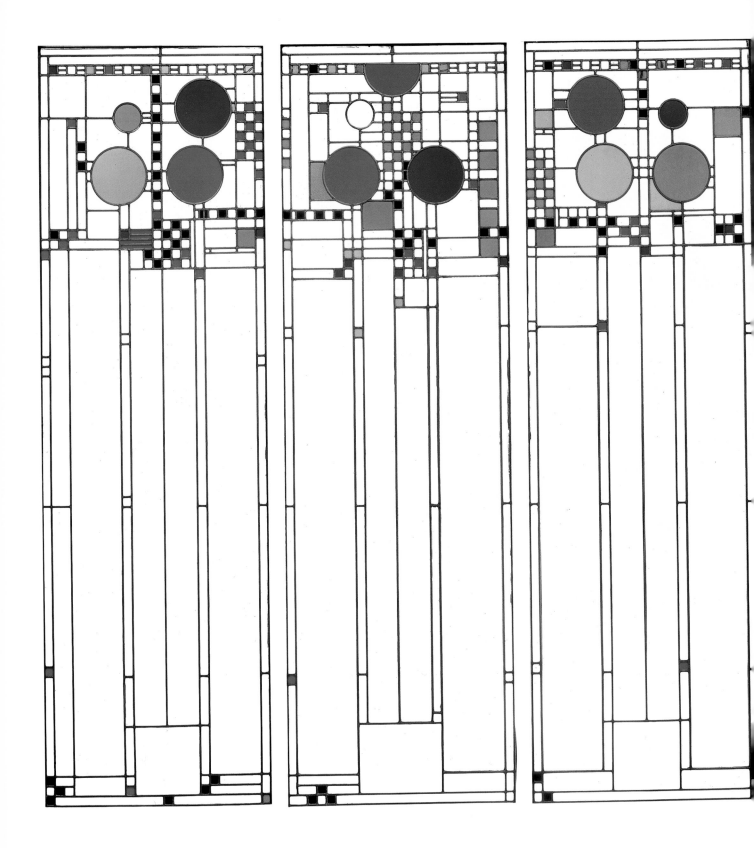

74. The Metropolitan Museum of Art, Fifth Avenue and 82nd Street, Manhattan. Triptych (originally in the Avery Coonley House, Riverside, Illinois), Frank Lloyd Wright. 1912. W. of each panel 28″. These windows come from the children's playroom of the Coonley House. The designs are contemporary with early European abstractions and anticipate the work of Piet Mondrian. (Photograph courtesy The Metropolitan Museum of Art)

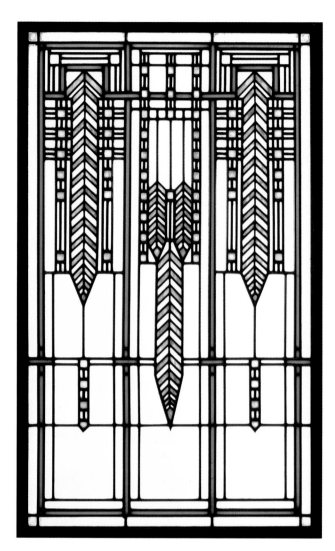

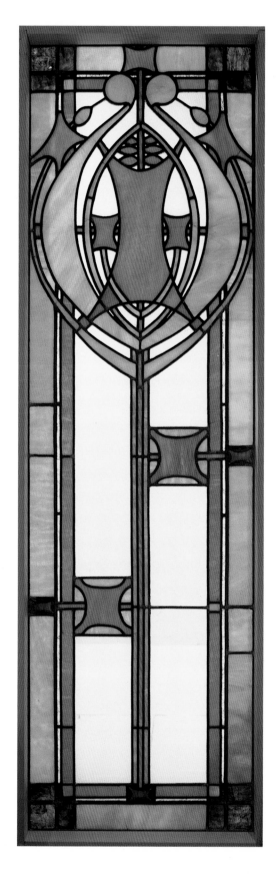

75. The Metropolitan Museum of Art. Panel (originally in the Sedgwick Brinsmaid House, Des Moines, Iowa), Arthur Heun, glass executed by Giannini & Hilgart. 1901-1902. W. 28″. Very similar to Wright's work of this period, the design of this panel is based on the leaves of the weeping willow. (Photograph courtesy The Metropolitan Museum of Art)

76. The Metropolitan Museum of Art. Untitled panel (designed for the J. J. Cross House, Minneapolis, Minnesota), George Grant Elmslie (1871-1952). c. 1911. W. 15″. Elmslie came to this country from Scotland in 1884 and worked as a designer-draftsman for several midwestern architects. He is probably responsible for much of the decorative richness that distinguishes buildings by Louis Sullivan. (Photograph courtesy The Metropolitan Museum of Art)

77. St. Bartholomew's Church, Park Avenue and 50th Street, Manhattan. Clerestory panel, original design Hildreth Meière (1893?–1961), execution Rambusch and other firms. c. 1930–1950. W. of panel 32".

rounded by so much clear glass that they appear almost as silhouettes. The substantial passages of clear glass thus mellow the bright figures, and let in enough light to show off the opulent Byzantine interior. Although the windows were completed in the mid-1950s, their artistic origins are in the prewar years.

Another Rambusch commission was for the windows of Our Lady of Angels Church, 7320 Fourth Avenue (figs. 78 and 147, p. 124), Bay Ridge, Brooklyn. The figures in the windows are simplified, straight-line versions of neomedieval work. Executed with pale glass and scattered spots of deeper color, they resemble grisaille work. The rose window is bolder and exploits the traditional freedom to be abstract in a rose window. Bright colors zigzag around this window. The colors as well as the forms recall Southwest Indian art rather than medieval windows.[2] There are a few other such windows in the city, but with the coming of World War II, almost all work in stained glass ceased and the Art Deco window became a rare curiosity, an example of a style practiced for a few years by a few artists.[3]

World War II brought most of the great functionalist, or International School, architects to the United States. Their presence gave additional impetus to the ascendancy of nonhistorical styles. As they came to have a major voice in architectural schools and offices, they further assisted in the demise of Art Deco, which was decried as a corruption of the chaste forms of a "truly" modern architecture. Ornament of course is also expensive, so the International School served to make respectable what was already expedient: buildings stripped to their barest essentials of walls, windows, and roofs.

Eclecticism, or any sort of romanticism, seemed utterly bankrupt. Most American home builders clung to watered-down versions of Colonial styles, but serious architects no longer designed anything, even churches, without attempting to declare at least some independence from historical formulas. Although there were many churches built in the 1950s that embodied reminiscences of Georgian or Tudor parish churches, the style was almost always freely interpreted. Of all the embar-

79. Church of the Redeemer, Fourth Avenue and Pacific Street, Brooklyn. Untitled panel, unidentified artist. Window c. 1920–1935. W. 8". The flow of the lines in this figure anticipates streamlined forms.

78. Our Lady of Angels Church, 7320 Fourth Avenue, Bay Ridge, Brooklyn. Rose window, Rambusch Studios. c. 1940. Diam. approx. 17'. This splendid rose window reflects the dynamism of Art Deco and recalls both the palette and geometry of Navajo designs.

80. New York Hall of Science, Flushing Meadow Park, Queens. *Dalle-de-verre* walls, Willet Studios in collaboration with the architectural firm of Harrison and Abramovitz. 1964. H. 80′. The thousands of inch-thick slabs of glass were hand-faceted by Willet for what was then the largest installation of *dalle de verre* in the world.

rassments suffered by architects designing such projects, the windows were particularly troublesome. Most congregations still felt that a church, even one derived from Georgian models, should have some stained glass in it. At the same time there was a desire for bright and cheerful interiors that would dispel any lingering notions for suburban America that religion was a gloomy business. Amid such doubts and lacking any strong alternatives from American glass studios, most churches installed weak derivations of neomedieval work. The glass was much lighter toned, quite unlike the work of the great neomedievalists of the prewar years, and the figures had all the static qualities of clerestory images, with little of their looming powers.

In some windows a Cubist feeling appears as a modification of the medieval style. One assumes that artists were trying to find a contemporary voice and also seeking relief from the stasis of monumental medieval figures. Cubism was more attractive to Americans than most avant-garde European art movements. Some historians believe the mechanical overtones of some Cubist work appealed to machine-loving Americans. One might also suspect that the luminous air of some Cubist work was attractive to American sensibilities nourished on light-filled landscapes. Whatever the causes of its fairly wide acceptance, or at least toleration in American art, one begins to see aspects of Cubism in American stained glass from around 1940. Glass designers began to experi-

ment with illusions of crystalline planes in images, reiterating through the style the notion that stained glass is about light and facets and jeweled colors. By the time Americans began to toy with Cubism as a popular style, the artists who pioneered it had discovered the limitations of its vocabulary and had left its geometry to facile imitators. Although Cubism was abandoned by most serious painters, it continues to influence stained-glass design, probably because it can be blended with rather traditional-looking windows and because it echoes the metaphors associated with stained glass since at least the twelfth century.

The last two clerestory windows in St. John the Divine were not installed until the mid-1960s and 1970s. Although they maintain the neomedievalism of the other clerestory windows (many of which were made in the 1930s), they reveal hints of the Cubism one finds more boldly expressed in other churches, which wished to have neither purely medieval nor definitely contemporary imagery in their glass.[4]

Another attempt to find a contemporary form of expression in glass was *dalle de verre*. The term means "glass flagstone," and as one might guess, the technique was invented in France. The *dalles* are glass slabs about one-inch thick that cannot be cut or assembled with ordinary equipment. The shaping of the *dalles* requires diamond saws and chisels. After being shaped, the pieces are arranged in a design with spaces between each piece of

81. New York Hall of Science. Detail showing some of the *dalles* set in the walls. W. approx. 20".

glass. Workmen then pour concrete into the interstices between the glass. In recent years epoxy cements have replaced concrete. When the poured matrix hardens, the window is finished. The technique is relatively simple and cheap and it produces a strong panel, even a large, sturdy wall if one desires. The finished window wall clearly suggests how and of what it was made.

The first appearance of *dalle* glass in the United States was in 1939, at the New York World's Fair. A window depicting *One of the Magi* was erected in the French Pavilion, and attracted comment for its depth of color and the fiery light produced by the chipped edges of the *dalles*. (The matrix is usually poured to a thickness less than that of the *dalles*, so their faceted edges protrude slightly and catch light.) *Dalle-de-verre* glass gained rapid acceptance after World War II, particularly for nontraditional churches. The thickness of the glass produces its rich color, but it also gives a rather coarse look to compositions. That look is heightened by the concrete-filled interstices in the windows; these concrete lines are harsher than even the thickest leads, so *dalle* compositions must be executed in some relatively bold "primitive" style. Some *dalle* windows are wonderfully effective, particularly when executed on a large scale, so the clumsy pieces of glass become relatively smaller, more subtle components of compositions. Because *dalle de verre* is less expensive than conventional stained glass, large expanses of wall can be devoted to it, thus presenting as in Gothic cathedrals an interior composed largely of luminous walls.

82. St. Mary Mother of Jesus Church, 2326 84th Street, Bay Ridge, Brooklyn. *Dalle-de-verre* panels, unidentified artist. c. 1960.

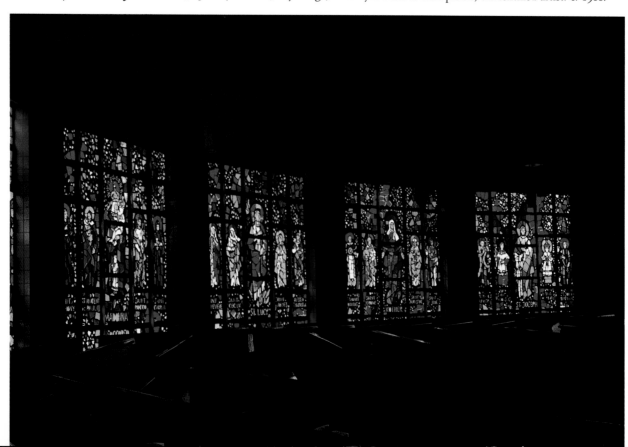

Rather than attempting to disguise the rough components of *dalle* windows, most designers, even of very large windows, choose to work in blocky abstract patterns or in forms reminiscent of Byzantine mosaic work. In either case the windows are instantly recognizable as different from traditional glass, and they have helped move glass toward acceptance as a contemporary medium.[5]

Dalle-de-verre glass seemed sufficiently modern that a few architects installed it in secular buildings. For the New York World's Fair of 1964 a large hall was built for a multimedia simulation of space flight. The hall consists of great undulating walls of *dalle-de-verre* glass. The building is one of the few structures preserved from the fair, and today it houses the New York Hall of Science (figs. 80 and 81). Its connections with flight are preserved in that the main hall is used to exhibit aircraft and space vehicles.[6]

THE NEW GLASS

Partly because of its very success in freeing stained glass from its image as an archaic art form, the popularity of *dalle de verre* has waned. Today artists feel free to use stained glass without apology and they usually prefer conventional glass because it allows a greater variety of artistic expression.

An early exponent of the free use of glass was Robert Sowers. He was responsible, with the architectural firm of Kahn and Jacobs, for the American Airlines Terminal (1960) at Kennedy Airport. The terminal facade is a great stained-glass mural a block long and twenty-two-feet high. As in the case of the Hall of Science at Flushing Meadow (which actually followed this window by four years) the romance of flight seemed to call for something more dramatic than the usual prescription from the International Style of architecture; indeed the novelty and daring of the other terminals at Kennedy indicate the ambiance in which Sowers's great window was conceived. From outside it is colorful both day and night: the panes of glass were coated with a vitreous enamel that can be read with reflected as well as refracted light. Consequently the mural looks like a mosaic by daylight. At night it is animated by the light passing out from the illuminated interior. That the window reads from outside in daylight probably had something to do with its inspiration. Kahn said that he was impressed by the mural walls he saw at the University of Mexico, and from those murals eventually grew Sowers's unusual opportunity to create something for a large secular building.[7] The window wall at the American Airlines Terminal faces south, and one enters the ticket concourse expecting a vast panorama of colored glass. Unfortunately, the architects chose to situate a set of offices across large sections of the south wall, so the interior is far from what it might be.

The search for a modern and yet freer architecture produced some other interesting stained glass at Kennedy (figs. 156 and 157, p. 131). The chapels there are determinedly modern-romantic. Floor-to-ceiling panels of glass make up the walls of the Roman Catholic chapel (fig. 156). In its composition and palette this glass echoes much of the glass of the 1950s and early 1960s: starburst patterns, semicubist forms, and pastel colors. The effect of the glass is more interesting than the imagery. The glass, along with panels of white marble, creates a very light interior suffused with delicate pale color. The figure of *Our Lady of the Skies* stands on an airplane propeller, making what now seems like an awkward attempt to be contemporary. Of course in fifty or one hundred years the figure will not suffer from our condescending distinctions between the symbolism of one decade and another.

Next door at the Protestant chapel (fig. 157) there appears the more provocative glass of the French artist Robert Pinart (b. 1927). The chapel was designed by Edgar Tafel, who was a student of Frank Lloyd Wright. Pinart's glass, which is dated 1968, obviously was designed to echo the forms of the chapel. Asymmetrical but strongly defined forms float up through the clear glass behind the altar, while the very low aisle windows provide a rich, earthbound illumination to contrast with the ascending forms of the altar window. Tafel was one of the first American architects to be aware of, and make use of, the brilliant glass designers who emerged in Europe during the years after World War II.

European glass before World War II was already more lively than that of America,[8] and the thousands of windows destroyed during the war gave European designers the opportunity to develop their talents further. By the 1960s European glass, especially that of Germany, had developed an imaginative and self-assured idiom that European architects eagerly exploited to add dimension to their structures. This European work was scarcely noticed by American architects, with exceptions like Tafel.

Artists like Robert Sowers, or the Europe-oriented Albinus Elskus (b. 1926), had little success in attracting commissions. Their isolation from the new architecture was exacerbated by the tendency of liberal churches to reject the entire concept of expensive liturgical art, no matter how richly contemporary it might seem. These were the very groups one would have expected to be most receptive to new ideas in glass, but the social distress of the 1960s and early 1970s caused many churchmen and congregations to direct their energies toward social causes rather than liturgical art. During this era the Episcopal Bishop of New York, Horace W. B. Donegan, declared that St. John the Divine would remain unfinished as a symbol of the church's commitment to human needs. A survey of American clerics revealed that they preferred neither modern nor traditional glass, but

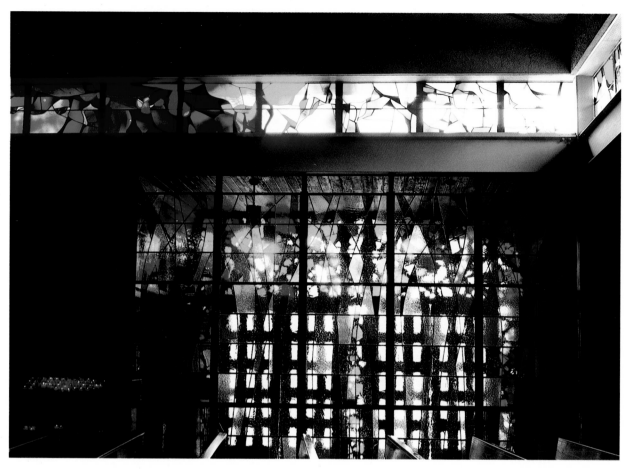

83. St. Charles's Church, Hylan Boulevard and Peter Avenue, New Dorp, Staten Island. Clerestory panels and entrance screen, Albinus Elskus (b. 1926). 1973. Germany has provided the most brilliant of the contemporary European glass designers, and Elskus is one German-influenced artist willing to brave the American indifference to the new European glass. He was educated in Freiburg and also studied in France, then completed an apprenticeship at New York's Durhan Studios, where he is now a partner. The glass he designed for St. Charles's varies greatly in texture and colors, yet the ensemble creates a serene radiance in the church. The panels shown here extend around the perimeter of the sanctuary. Elskus has said that stained-glass design can be judged first by looking at a window from the outside, where the lead designs are evident but no colors can be seen.

simply less stained glass of any kind in their churches. The churches, the last main support of stained glass in America, were beginning to see the medium as anachronistic, a symbol of outworn religious forms.

As often happens, ecclesiastical tastes are a cycle or two behind secular taste. While the churches saw new virtues in modernist severity, secular society began to seek alternative architectural expressions, and one of the alternatives turned out to be stained glass.[9]

Revolutions in taste can be overexplained. People simply get tired of looking at the same things. One may therefore suggest without being entirely frivolous that the reaction against Bauhaus functionalism was merely another turn of fashion's wheel. However true that may be, historians still seek reasons for the direction and tim-

ing of such changes, and there are seemingly evident causes for the substantial reordering of American aesthetic values in the 1960s and 1970s. Furthermore, and most interesting for the appreciation of what is happening today, these causes are still actively at work, transforming the environment we inhabit.

The tensions and disaffection that characterized the 1960s were all to some degree associated with the loss of control of human institutions. Amid the uproar of social protest and political crisis many people sought humanistic solutions to public and private distress. Life-styles and environments began to reflect a revulsion against the impersonal and mechanical. There was a return to notions explicitly like the Arts and Crafts movement of William Morris and many other nineteenth-century figures who had similarly found the then-modern industrial world dehumanizing. Things made by hand and manifesting a

84. Location unknown. Independent panel (intended as a fire screen), Gilly. 1978. W. 22″. Gilly has been active in New York for fifteen years.

85. Chapel of the Little Sisters of the Assumption, Lexington Avenue and 81st Street, Manhattan. Narthex window, David Wilson (b. 1941). 1966. W. approx. 96″. Wilson combined contemporary industrial glass with a rose window that was probably painted in Munich in the late nineteenth century.

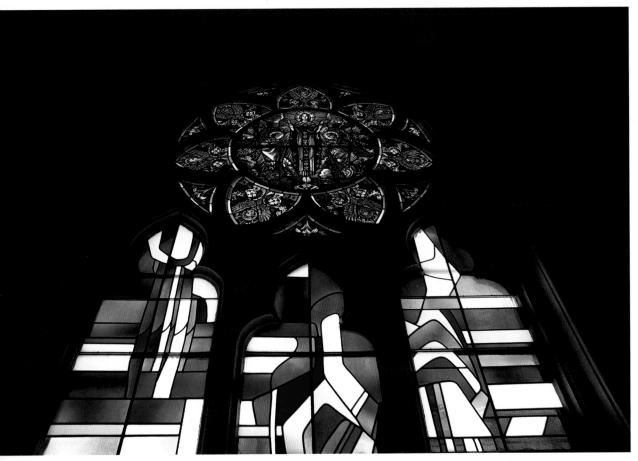

86. United Nations Secretariat Building, UN Plaza, Manhattan. Dag Hammarskjold memorial window, Marc Chagall (b. 1899). 1964. W. 15′. The glass was executed by Charles Marq, including deciding on the placement of the lead lines. At the dedication of the window Chagall spoke, "with all my soul, I wanted to convey the extent of my inspiration and the inspiration of Dag Hammarskjold and of all those who died for peace . . . These colors and these forms must show, in the end, our dreams of human happiness."

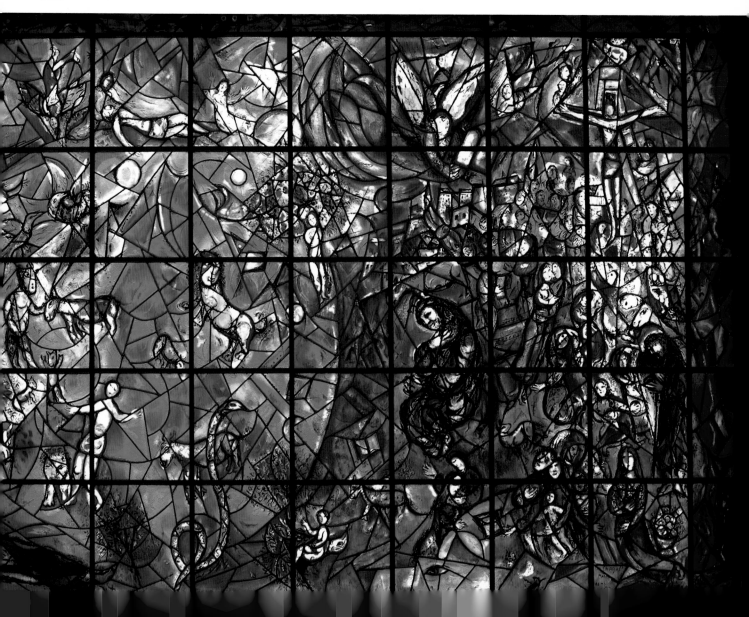

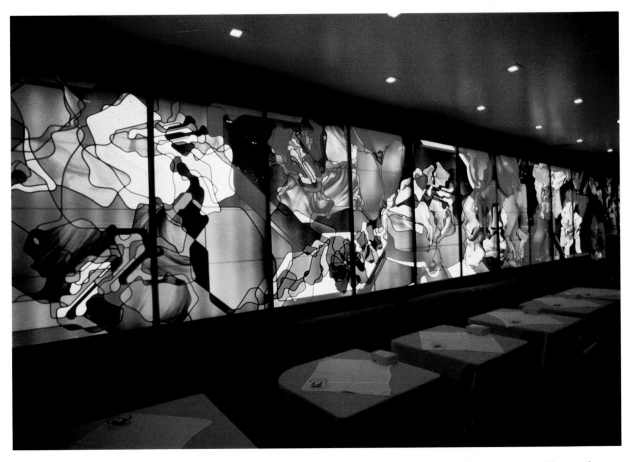

87. La Folie Restaurant, Madison Avenue and 61st Street, Manhattan. Untitled panels, Richard Avidon. 1976. L. 35′. The panels were executed at The Greenland Studio, Manhattan. Avidon is a New York glass artist who admires contemporary German windows, but for this work, based on a free interpretation of the eroticism of flower blossoms, pistils, and stamens, he abandoned the massive leading and cool palette of the Germans in favor of more exuberant work, such as one finds in France and on the American West Coast. Avidon has done restoration work at The Cloisters and has the highest admiration for medieval windows. Avidon says he "wants colored lights, not pictures. The light has content. The medievals knew that. Abbot Suger saw God in light. I want to keep that light in my windows. The purpose of a window is not to hide the light, but to shape it, to make us more aware of it."

personal effort were then as now preferred by many to machine-made products. The already established tendency in the fine arts to emphasize the artist's personality and the physical act of painting became popularized in the form of everyday handicrafts. Antiques from the Arts and Crafts era, particularly Art Nouveau with all its flamboyant eccentricity, became extremely popular. Tiffany enjoyed a revival of extraordinary proportions, which continues today as his windows and lamps fetch six-figure prices at auctions.

The very point that the Bauhaus wished to make, that architecture should reflect the building materials and social needs of an era, was well understood by the late 1960s, and that understanding turned toward artistic expression of more relaxed and humanistic environments.[10] This movement was strongest on the West Coast, and its strength there encouraged artists in the East who were working in a similar vein. As American glass gained creative strength and popularity, it also drew on contemporary European work, and in the resulting ferment one sees extraordinarily vital stained glass. The architecture of today is evolving into postmodernism, and in that architecture stained glass resumes its ancient role of bringing light and color to people's daily lives.

A Gallery of
Stained Glass

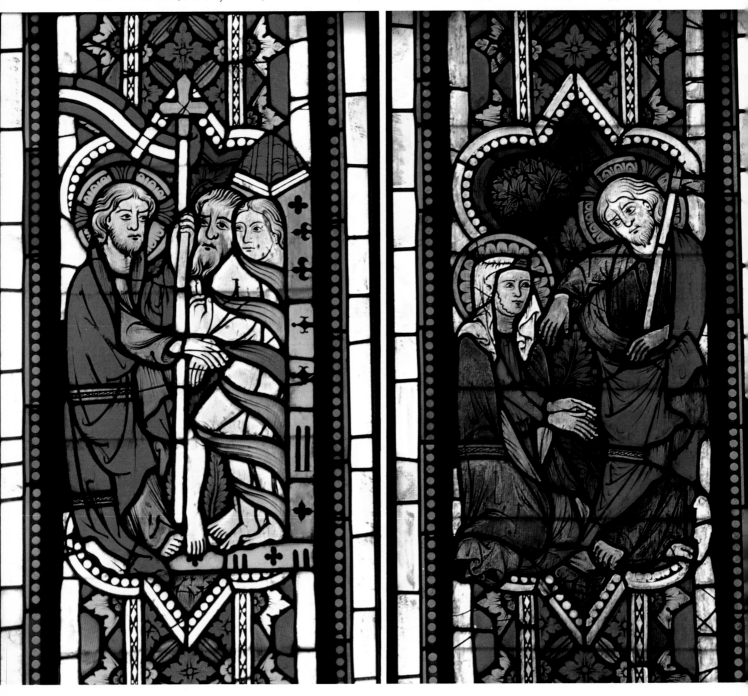

88. The Cloisters, Fort Tryon Park, Manhattan. Panel from St. Leonhard's Church, Lavantthal, Austria. c. 1340. W. 14″.

89. St. Ann's Episcopal Church, St. Ann's Avenue and 140th Street, Mott Haven, The Bronx. Memorial window. c. 1872. W. 32″. This window's provenance is unknown, but its colors and designs are typical of the glass that was produced by mid-nineteenth-century American firms such as Lamb Studios, founded in New York in 1857 and the oldest continuing American firm making stained glass.

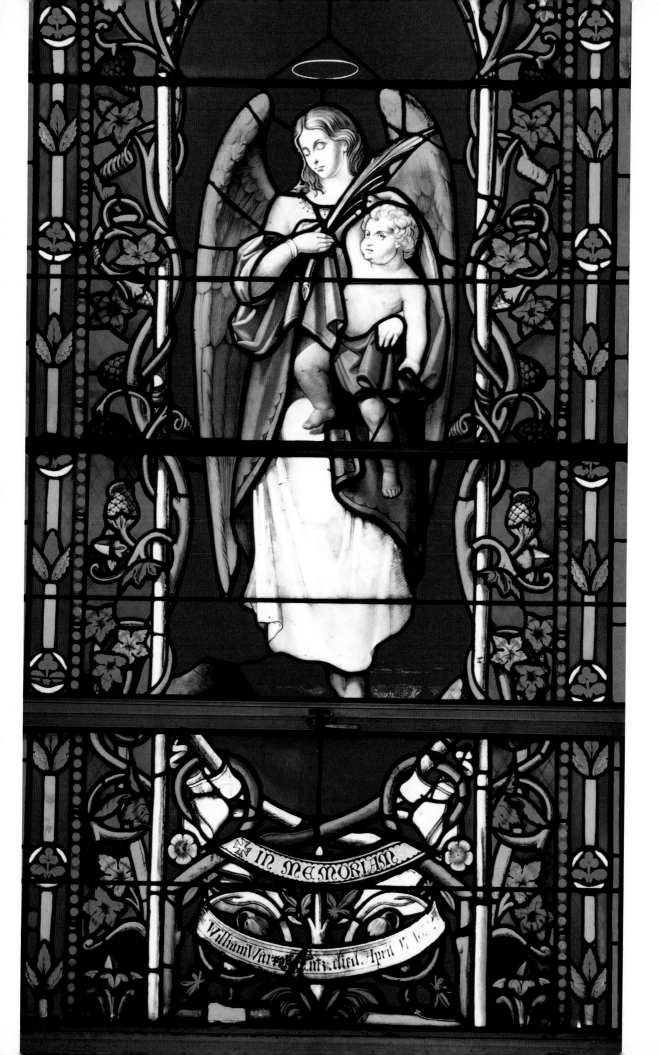

IN MEMORIAM

William Warren ... died April ...

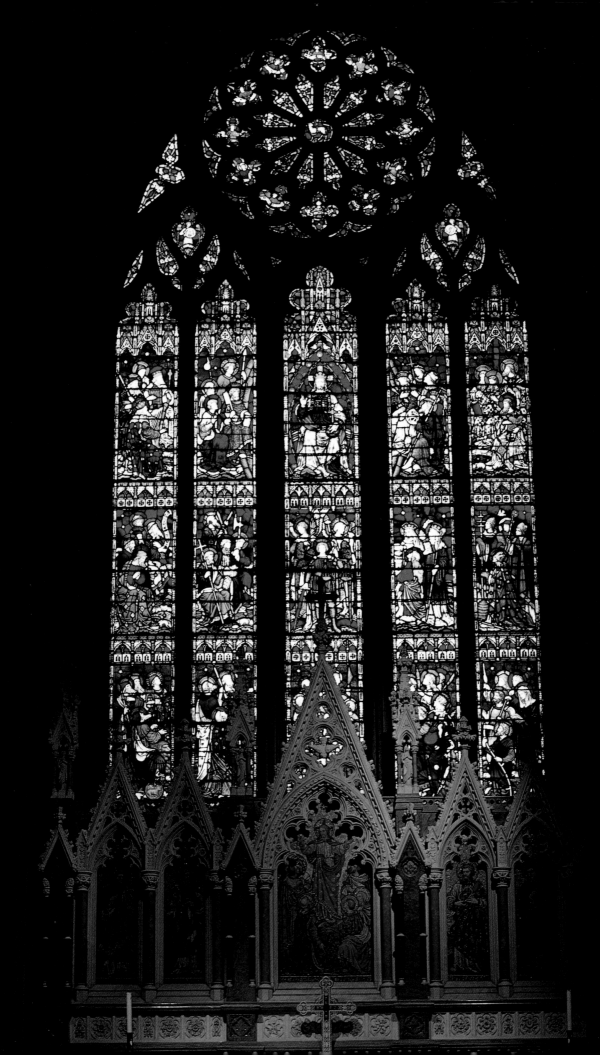

90. Snug Harbor Cultural Center (formerly Sailors' Snug Harbor), Richmond Terrace, Staten Island. Transom with nautical scenes, unidentified artist. W. 60″. The building this enameled transom is in was built in 1831 as a home for "aged, decrepit and worn-out sailors." The worn-out sailors are gone now to more modern facilities in North Carolina, but the windows remain. Nothing is known about their provenance, but the vessels depicted and the opalescent border glass suggest the late nineteenth century.

91. Grace Church, Broadway and Tenth Street, Manhattan. *Te Deum* window, also described as *The Church Triumphant,* Clayton and Bell. 1879. W. approx. 16′.

92. St. Augustine's Roman Catholic Church, Sixth Avenue and Park Place, Park Slope, Brooklyn. Rose window, unidentified artist. After 1888. W. approx. 96″.

SAINT·MARK·

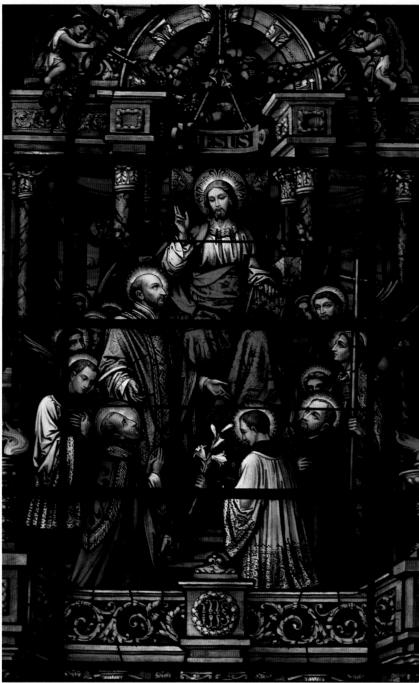

94. St. Raphael's Roman Catholic Church, Greenpoint Avenue, Long Island City, Queens. Untitled window, unidentified artist. Probably French or German. Late nineteenth century. W. 36″.

95. St. Ignatius Loyola Church, Park Avenue and 84th Street, Manhattan. St. Ignatius and other saints of the Jesuit Order with Christ, John Hardman and Co., London. After 1898. W. 71″.

93. St. Patrick's Cathedral, Fifth Avenue and 50th Street, Manhattan. Detail of figure 21 showing the window on the right.

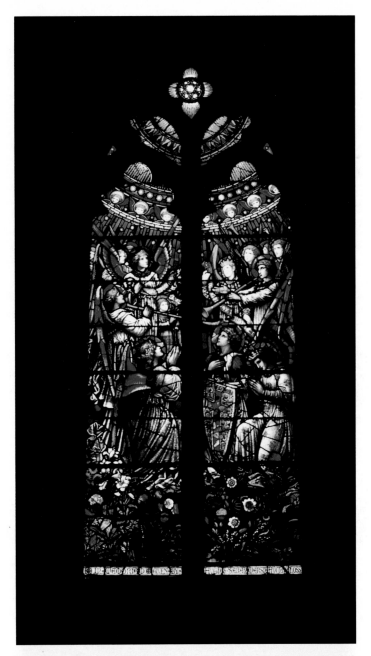

96. Grace Church, Broadway and Tenth Street, Manhattan. *The Heavenly Hosts,* Charles Booth, New York. c. 1880. W. 72″.

97. Grace Church. Detail of figure 96, *The Heavenly Hosts.* Booth's New York studio attracted the respect of Grace Church, which commissioned most of its glass from British firms.

98. St. James's Episcopal Church, Madison Avenue and 71st Street, Manhattan. *At the Morn Those Angel Faces . . . ,* Tiffany Studios. After 1895. W. of each lancet 22″.

99

101

99. Memorial Presbyterian Church, Seventh Avenue and St. John's Place, Park Slope, Brooklyn. *Suffer Little Children,* Tiffany Studios. Undated, but after 1890. W. approx. 24″. "Trailing clouds of glory," children came into the world, and Tiffany suggested the thin veil between them and heaven with a plate of frosted glass over the angel heads behind the child.

100. Church of St. Luke and St. Matthew, 520 Clinton Avenue, Fort Greene, Brooklyn. Rose window, unidentified artist. After 1891. Diam. 17′. The eclecticism of the opalescent age used baby angel faces in an unusual rose window whose classical rays begin with an egg-and-dart border and conclude with foliage and more angel faces.

101. West End Collegiate Church, West End Avenue and 77th Street, Manhattan. Untitled (but derived from Heinrich Hofmann's [1824–1902] popular and variously titled painting urging little children "to come unto me, for of such is the kingdom of heaven"), attributed to Tiffany Studios, although not claimed by them in their 1910 list of windows. Window made after 1899. W. 54″.

102. The Riverside Church, Riverside Drive and 122nd Street, Manhattan. Rosette copied from the south clerestory wall of Chartres Cathedral. c. 1930. Diam. approx. 108″.

100

102

104. St. Nicholas Carpatho-Russian Orthodox Greek Catholic Church, 288 East Tenth Street, Manhattan. Lancets, unidentified artist. After 1880. These extraordinarily rich windows were not installed when the church was built as a chapel of St. Mark's in the Bowery in 1880. The windows are unusual in style and material, being composed almost entirely of pressed-glass jewels.

103. West End Collegiate Church, West End Avenue and 77th Street, Manhattan. Lyons Memorial, Frances White with Walter Jones Studio. c. 1907. W. 10′.

105. Church of the Ascension, Fifth Avenue and Tenth Street, Manhattan. *Visit of Christ to Nicodemus,* John La Farge. 1884–1885. W. 66″.

106. Flatbush Dutch Reformed Church, Flatbush Avenue, Brooklyn. *Samson,* Tiffany Studios. Undated. W. 56″.

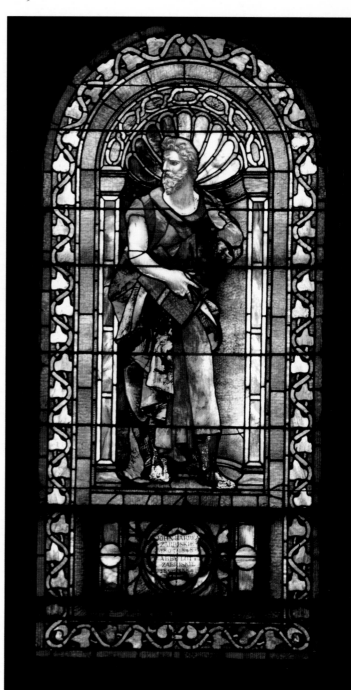

108. First Presbyterian Church, 124 Henry Street, Brooklyn Heights, Brooklyn. *River of Life,* Tiffany Studios. 1921. W. 83″. Reflecting his own interest in landscape, as well as the general American enthusiasm for the subject, Tiffany invented the landscape window, a form never before seen in stained glass. Tiffany himself signed this window, indicating that he took a personal hand in its creation.

109. Church of St. Luke and St. Matthew, 520 Clinton Avenue, Fort Greene, Brooklyn. Henry P. Martin memorial windows, unidentified artist. After 1906. W. 30″. These angels offer another example of the combination of medieval and classical trappings.

107. Riverdale Presbyterian Church, 4765 Henry Hudson Parkway West, The Bronx. Detail of *Hollyhocks,* Tiffany Studios. Undated. W. 22″.

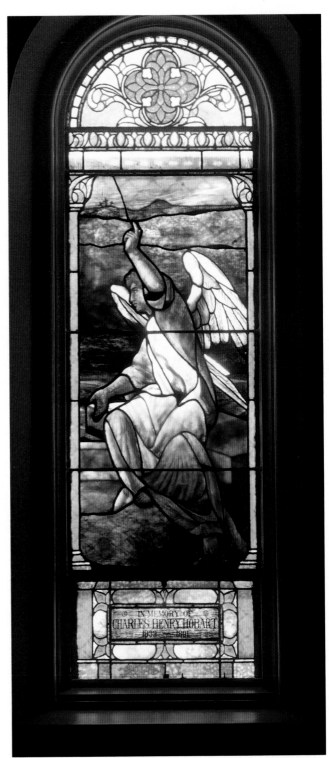

110. All Saints Episcopal Church, Seventh Avenue and Seventh Street, Brooklyn. *And Thou Shalt Call His Name Jesus,* unidentified artist. 1915. W. 42".

111. Lafayette Avenue Presbyterian Church, Lafayette Avenue and Oxford Street, Fort Greene/Clinton Hill, Brooklyn. Untitled angel (perhaps derived from Michelangelo), Frank Lauber. Undated. W. 40".

112. Church of St. Luke and St. Matthew, 520 Clinton Avenue, Fort Greene, Brooklyn. Untitled double lancets, unidentified artist. After 1891. W. of each lancet 30″.

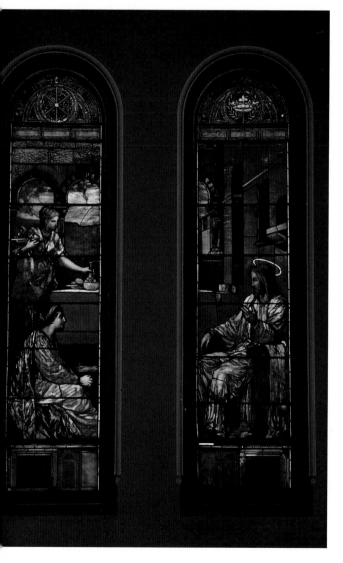

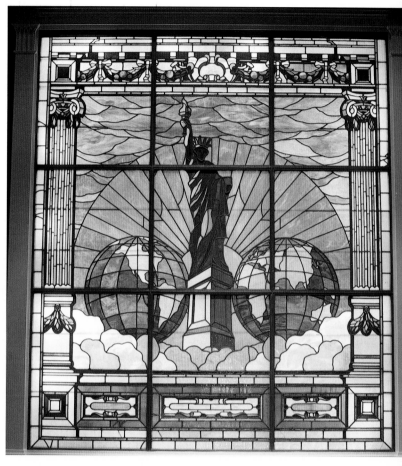

113. Columbia University, School of Journalism Building, Broadway and 116th Street, Manhattan. *Statue of Liberty,* Otto Heinigke (1850–1915) and Oliver Phelps Smith. c. 1915. W. 144″. The Statue of Liberty was one of the first great manifestations of enthusiasm for classical allegory in late nineteenth-century America. France's gift to the American Renaissance appears here in stained glass at Columbia University, but the window was formerly located in the old *New York World* building.

114. Woolworth Building, Broadway at Park Place, Manhattan. Lobby ceiling, Oliver Phelps Smith with Otto Heinigke. 1913. W. 20′. After designing this splendid skylight, Smith was promoted from an assistant to a partner in Heinigke's studio.

115. Holy Trinity Lutheran Church, Central Park West and 65th Street, Manhattan. *Second Advent,* Tiffany Studios. c. 1903. W. 72″.

116. Plymouth Church of the Pilgrims, Orange and Hicks streets, Brooklyn Heights, Brooklyn. Untitled window, Otto Heinigke. c. 1900. W. 102″. This window seems at first glance to be made entirely of opalescent glass, but closer examination reveals many pieces of thick pot metal worked into the composition. Heinigke would eventually become one of the craftsmen who led the return to the use of pot metal and the twentieth-century revival of Gothic glass.

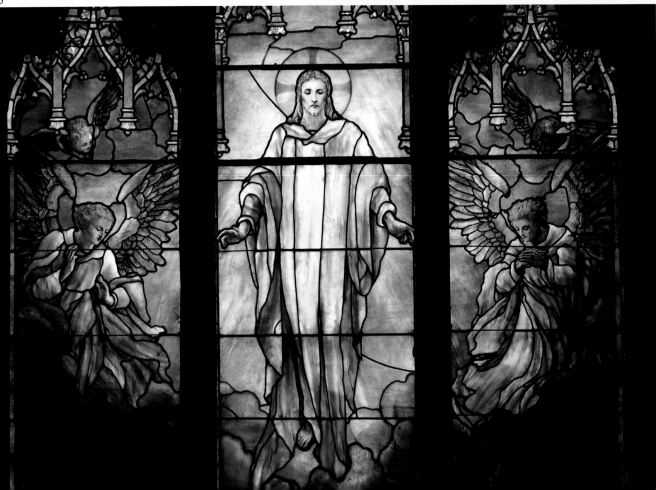

HIM THAT COMETH VNTO ME
I WILL IN NO WISE CAST OVT

117. Plymouth Church of the Pilgrims. c. 1900. W. of detail 30″. The robe is a typical example of heavily folded opalescent glass, but sections of the wings are a kind of barely transparent pot-metal glass.

118. Old First Dutch Reformed Church, Seventh Avenue and Carroll Street, Park Slope, Brooklyn. *The Sower, the Good Shepherd, and the Laborer in the Vineyard*, Otto Heinigke and Owen J. Bowen. c. 1893. W. 18′.

119. Packer Collegiate Institute, 170 Joralemon Street, Brooklyn Heights, Brooklyn. *Dawn on the Edge of Night* (originally in the Frank L. Babbot Home, Brooklyn), John La Farge. c. 1903. W. 52″. By the turn of the century the term *American Renaissance* frequently meant static, pale, and formal images. La Farge, despite his respect for the Renaissance, often preferred the fantastic visions associated with the Symbolist movement.

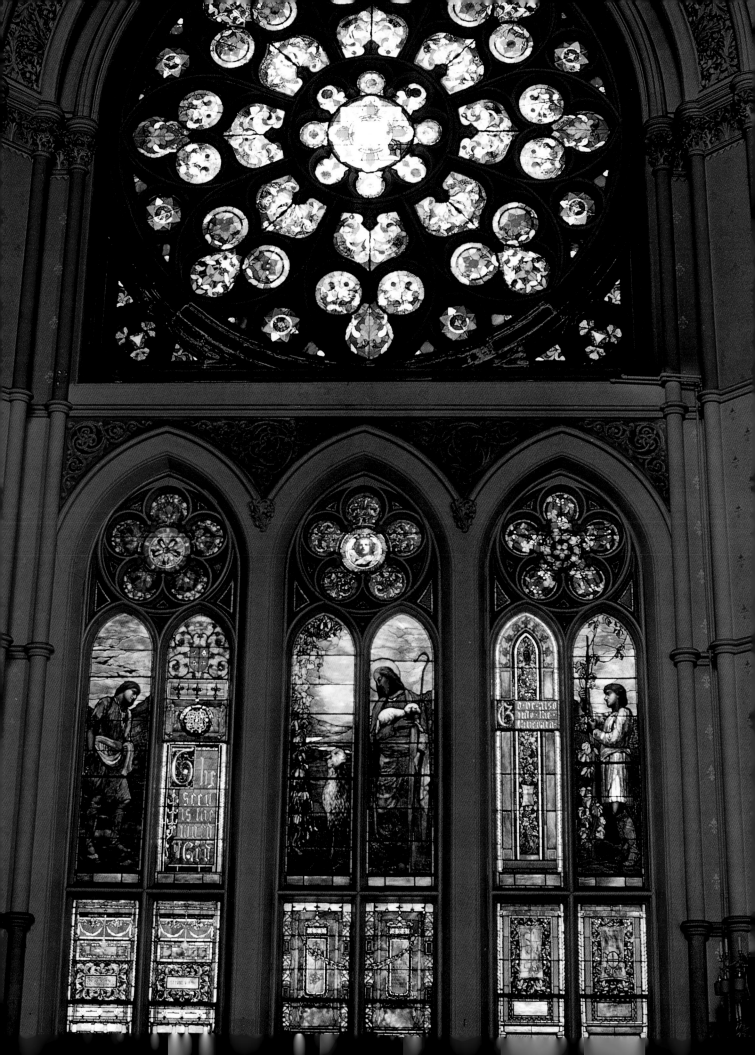

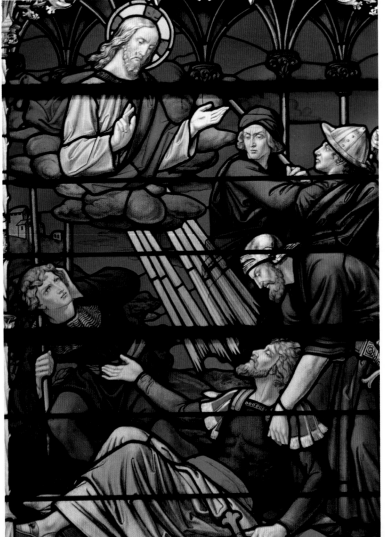

120. Old First Dutch Reformed Church, Seventh Avenue and Carroll Street, Park Slope, Brooklyn. Detail of rose window, unidentified artist. c. 1892. W. of detail 120″. The entire window is almost 20 feet in diameter.

121. St. Paul's Roman Catholic Church, Hicks and Warren streets, Cobble Hill, Brooklyn. *Conversion of St. Paul,* unidentified artist. Undated, but probably late nineteenth-century European. W. 72″. Enamel on pot metal.

122. St. Michael's Episcopal Church, Amsterdam Avenue and 99th Street, Manhattan. Lancet, Tiffany Studios. 1894 (glass installed 1895). W. 60″. This lancet is one of seven depicting the joyous uproar in heaven after St. Michael's victory over the forces of darkness.

123. Plymouth Church of the Pilgrims, Orange and Hicks streets, Brooklyn Heights, Brooklyn. *The Jewel Window,* Tiffany Studios. 1890. W. approx. 66″. Thick chunks of pot metal give this window in Hillis Hall its popular title, although Tiffany called it the Chittenden Memorial Window in his records.

124. St. Mark's in the Bowery, Second Avenue and Tenth Street, Manhattan. *Peter Stuyvesant,* unidentified artist. Probably early twentieth century. W. approx. 48″. Peter Stuyvesant's grave lies just outside this window, which combines opalescent glass with a well-done enamel portrait.

125. 115 Broadway, Manhattan. This window, in the former Lawyers' Club, was designed by J. Gordon Guthrie. 1913. W. approx. 14′. The style of this window is very different from the work that Guthrie developed in the 1920s and 1930s. As is appropriate in a window designed for lawyers, some of the details make interesting reading: "Usufruct is the right to enjoy the use and product of another man's property without the encroachment on the substance thereof."

126. First Presbyterian Church, 124 Henry Street, Brooklyn Heights, Brooklyn. *Angel of Victory,* Tiffany Studios. 1907. W. 83″.

127. Horace Mann School, Broadway and 120th Street, Manhattan. Opalescent glass panel over entrance, unidentified artist. Undated. W. 88″.

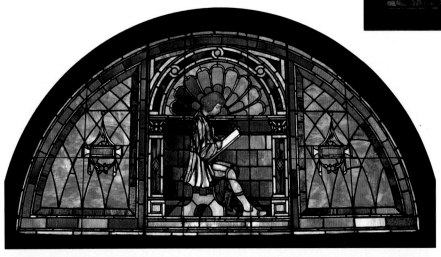

128. New York Yacht Club, 37 West 44th Street, Manhattan. Ceiling panel in Model Room, unidentified artist. c. 1899. W. 20′.

129. First Unitarian Church, Pierrepont Street and Monroe Place, Brooklyn Heights, Brooklyn. Two lancets, Tiffany Studios. Undated. W. of both lancets approx. 54″. Angels dressed in the dignified robes of late nineteenth-century American classicism.

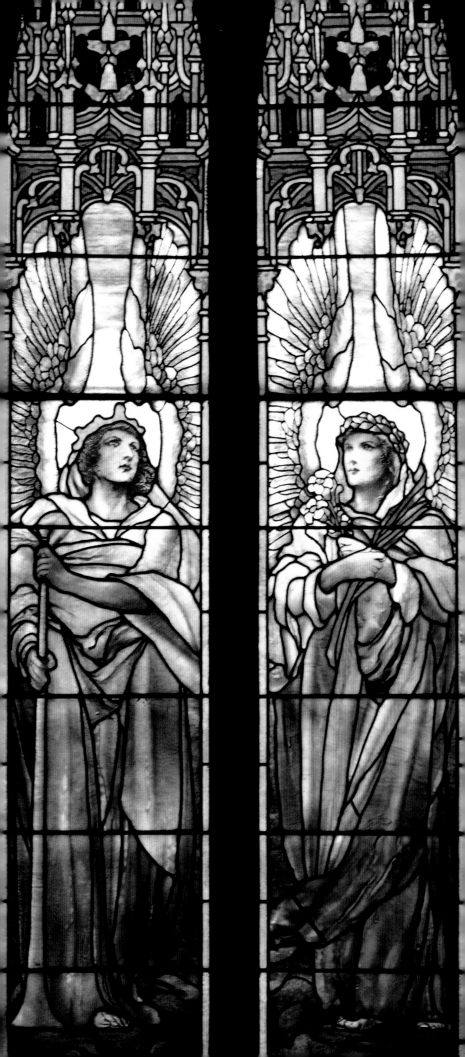

130. Marble Collegiate Church, Fifth Avenue and 29th Street, Manhattan. *Joshua Commanding the Sun to Stand Still,* Tiffany Studios. Before 1910. W. 60".

131. St. James's Episcopal Church, Madison Avenue and 71st Street, Manhattan. Untitled panel, unidentified artist. c. 1902. W. 24". Afternoon sunlight slants across a corner of this opalescent lancet. The blossoms in the bottom panel probably are derived from the Scottish master of Art Nouveau, Charles Rennie Mackintosh.

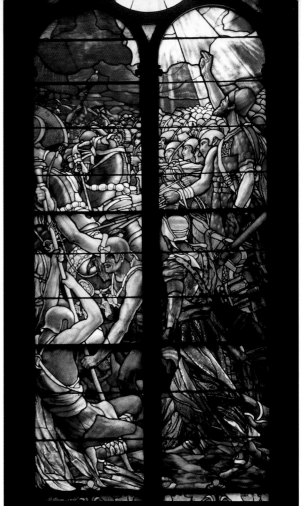

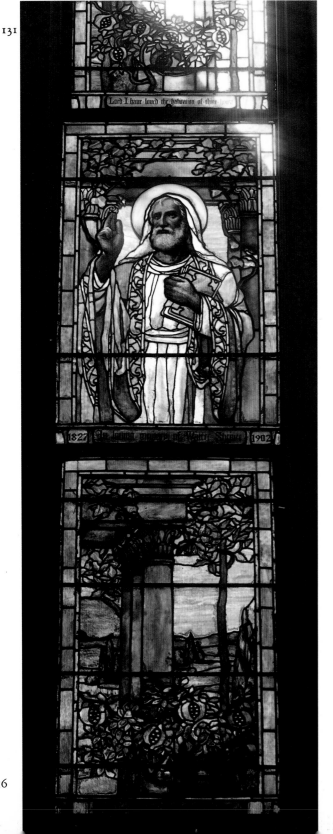

132. First Presbyterian Church, Fifth Avenue and 12th Street, Manhattan. *St. Paul,* D. Maitland Armstrong. Installed between 1893 and 1915. W. 76". Although not specified in the title or any document, one assumes that the Acropolis in the background refers to St. Paul's preaching in Athens.

133. St. Michael's Episcopal Church, Amsterdam Avenue and 99th Street, Manhattan. *I Was Thirsty and Ye Gave Me Drink,* designed by F. L. Stoddard, executed by R. Geisler. 1912. W. 44½". One wonders what connections there may have been between the obscure but obviously very accomplished artists who created this window and Maxfield Parrish. Such colors as these and back-lit scenes were well-known Parrish devices in 1912.

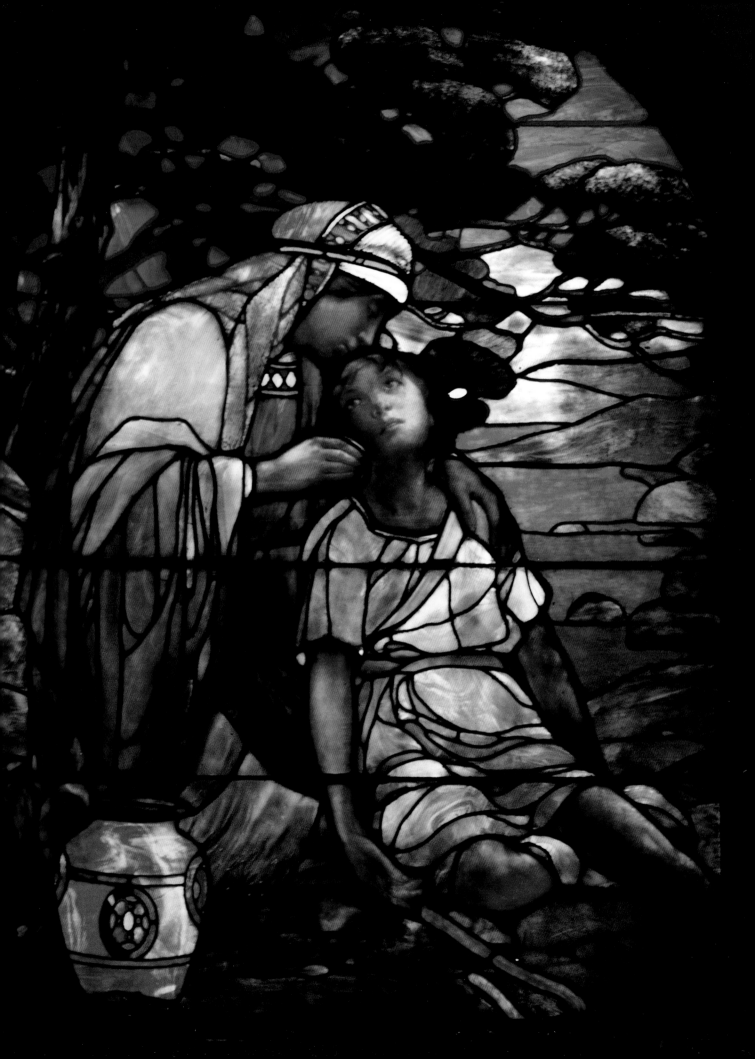

134. St. Michael's Episcopal Church. *St. Faith,* Frederick Wilson. 1916. W. 44½″. It was the gruesome misfortune of St. Faith to be burned alive on a gridiron because she would not renounce Christianity.

135. Greek Orthodox Church of the Annunciation, West End Avenue and 91st Street, Manhattan. *Christ in Gethsemane* (derived from a popular painting of the same subject), unidentified artist. Undated, but after 1885. W. approx. 60″.

136. St. Augustine's Roman Catholic Church, Sixth Avenue and Park Place, Park Slope, Brooklyn. Ascension window, unidentified artist. After 1892. W. approx. 21'. Nearly 1,000 square feet of opalescent glass create an eerie blue-green light in this church.

137. Plymouth Church of the Pilgrims, Orange and Hicks streets, Brooklyn Heights, Brooklyn. *The Ascension* (derived from Raphael's painting of the same title), Tiffany Studios. Undated. W. approx. 72".

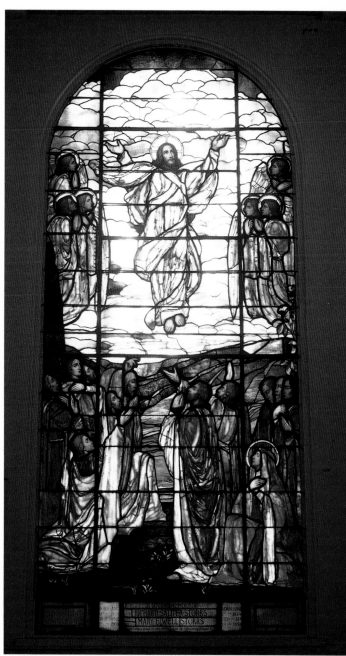

139. Church of the Evangel, Bedford Avenue and Hawthorne Street, Flatbush, Brooklyn. Tiffany Studios. 1927. W. 10'. The contract for this window is dated June 12, 1927, very late in the career of Louis Comfort Tiffany, and the style of the glass suggests an era quite different from the great period of this master designer.

138. All Saints Roman Catholic Church, Madison Avenue and 129th Street, Manhattan. Window. After 1894. W. approx. 96". A cherub surmounts the lancets of this window in All Saints in Harlem; like the rest of the glass in this church, the window is opalescent work by unknown studios.

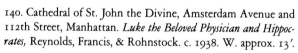

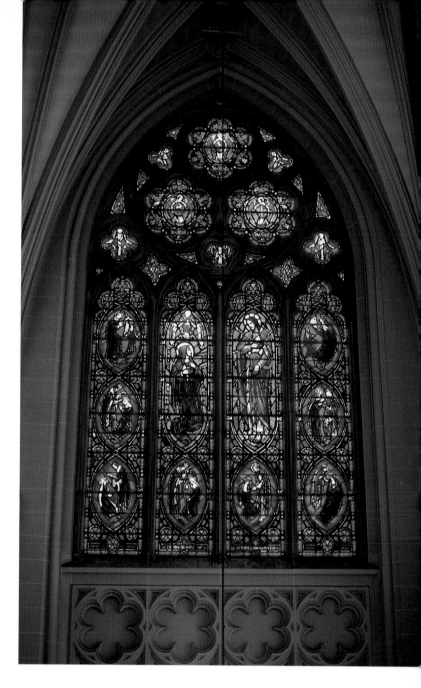

140. Cathedral of St. John the Divine, Amsterdam Avenue and 112th Street, Manhattan. *Luke the Beloved Physician and Hippocrates,* Reynolds, Francis, & Rohnstock. c. 1938. W. approx. 13′.

141. St. Patrick's Cathedral, Fifth Avenue and 50th Street, Manhattan. Clerestory window, Charles Connick. c. 1940. W. approx. 114″. Connick's pot-metal glass offers a clear contrast to the cathedral's French enamel windows of the 1870s.

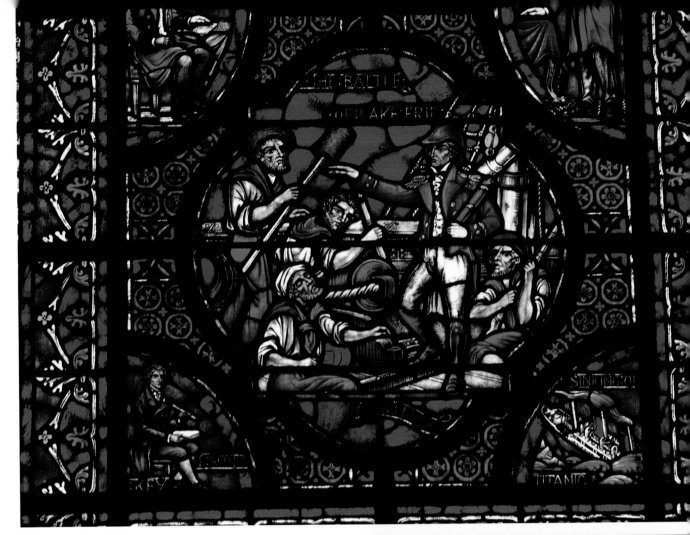

142. Cathedral of St. John the Divine, Amsterdam Avenue and 112th Street, Manhattan. Detail of aisle window, Ernest R. Lakeman (1883–1948). c. 1935. W. 40″. Lakeman managed to commemorate the Battle of Lake Erie without doing violence to the medieval mood that Ralph Adams Cram wished to re-create in the cathedral. The window is dedicated to the memory of John Jacob Astor, who was lost on the *Titanic.* The ship in the lower right-hand corner of the window symbolizes the disaster.

143. Green-Wood Cemetery chapel, Fifth Avenue and 25th Street, Brooklyn. *The Return of the Prodigal Son,* William Willet (1867–1921). Before 1921. W. 15″. Although Willet (or one of his assistants) was obviously a virtuoso with a brush and enamel paint, he seldom overpainted his windows and was among the twentieth-century artists who helped revive medieval clarity and vibrant color in glass.

144. St. Thomas's Church, Fifth Avenue and 53rd Street, Manhattan. Detail of *Joy and Love,* attributed to James Hogan (1883–1948) of Whitefriars, London. c. 1935. W. 11″.

145. St. Bartholomew's Church, Park Avenue and 50th Street, Manhattan. Aisle window, designed by J. Gordon Guthrie, painted by Ernest R. Lakeman in Henry Wynd Young's studio. c. 1925. W. 30″. Edith Sitwell in one of her medieval daydreams might have imagined herself transformed into one of these elegant angels. The foliage in the grisaille suggests part of the origin for windows like this: the exquisite lines peculiar to turn-of-the-century fantasy illustration.

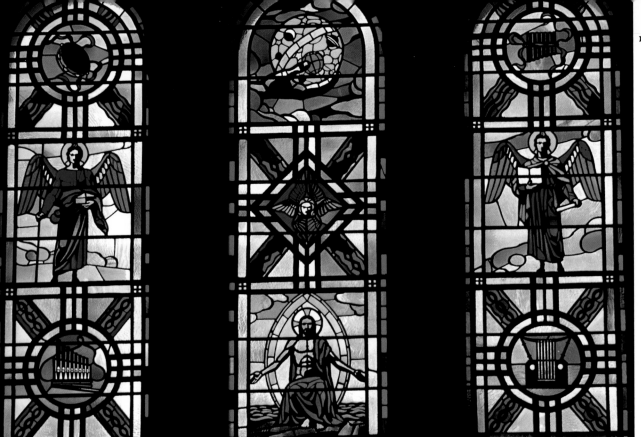

146. St. Batholomew's Church. Detail of clerestory panel, original designs by Hildreth Meière, executed by Rambusch and other firms. c. 1930–1950. W. of panel 32″.

147. Our Lady of Angels Church, 7320 Fourth Avenue, Bay Ridge, Brooklyn. Nave window, Rambusch Studios. c. 1940. W. approx. 72″. The figures in this window are transitions from the twentieth-century Gothic style that flourished in the 1920s.

148. Church of the Heavenly Rest, Fifth Avenue and 90th Street, Manhattan. Clerestory windows, James Hogan. c. 1929. W. 144″. Hogan used Norman slab, a now-uncommon type of glass about one fourth of an inch thick, to give a deep, quiet radiance to these splendid windows. The Church of the Heavenly Rest is one of the places where one can see forms and colors undergo substantial changes as the eyes adjust to the dark interior of the church.

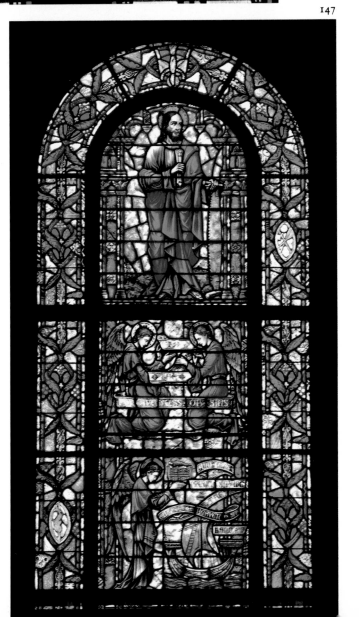

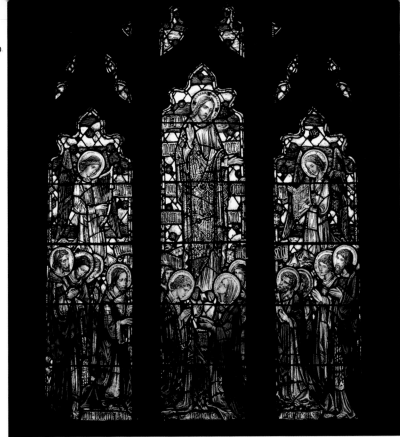

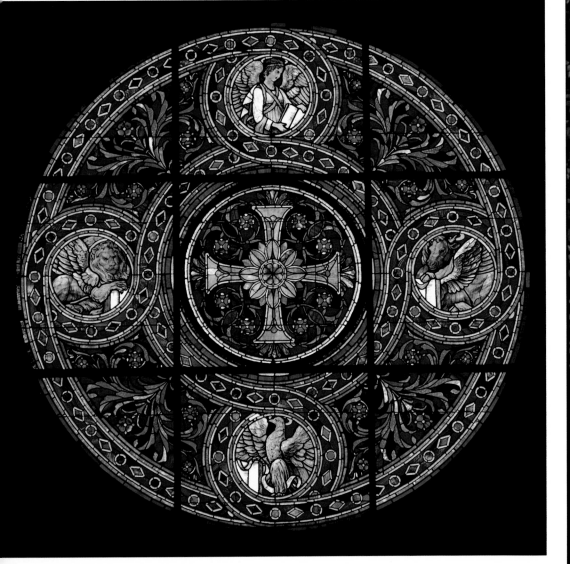

149. St. George's Episcopal Church, 135–32 38th Avenue, Flushing, Queens. *The Ascension,* designed by J. Gordon Guthrie, executed by Henry Wynd Young. Probably 1920s. W. approx. 108″. One wonders if Guthrie was influenced by the suspended vertical figures of such Symbolist paintings as Ferdinand Hodler's *Chosen One* (1893).

150. Judson Memorial Church, 55 Washington Square South, Manhattan. Rose window, John La Farge. After 1892. Diam. approx. 120″. This design is adapted from stonework designs around Romanesque window openings. Each of the small circles contains one of the attributes of the Evangelists (for example, the lion of St. Mark) and an ornamental cross fills the space that in the original Romanesque scheme would have been left open to serve as a window.

151. Odyssey Institute (formerly Church of the Holy Communion), Sixth Avenue and 20th Street, Manhattan. Rose window of the *occhio* type, D. Maitland Armstrong. Before 1896. Diam. approx. 120″. When the morning sun strikes the vitreous jewels scattered through this opalescent glass, the window declares the genius of its maker.

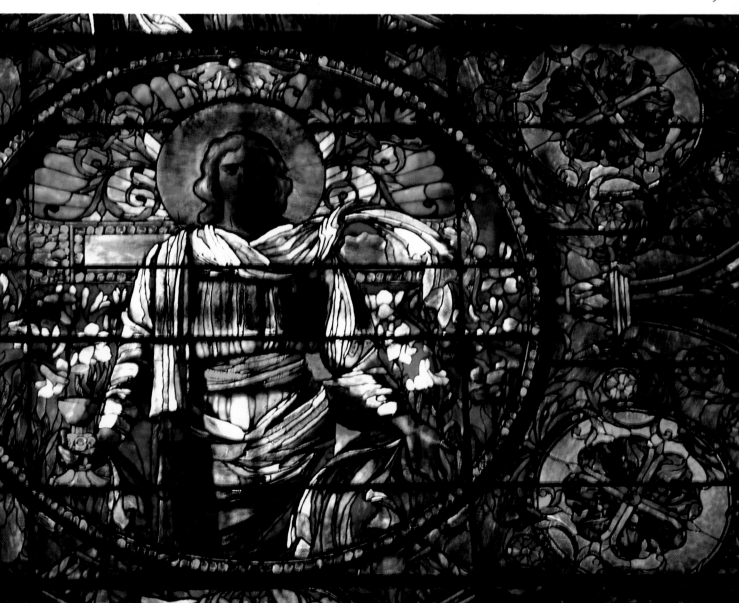

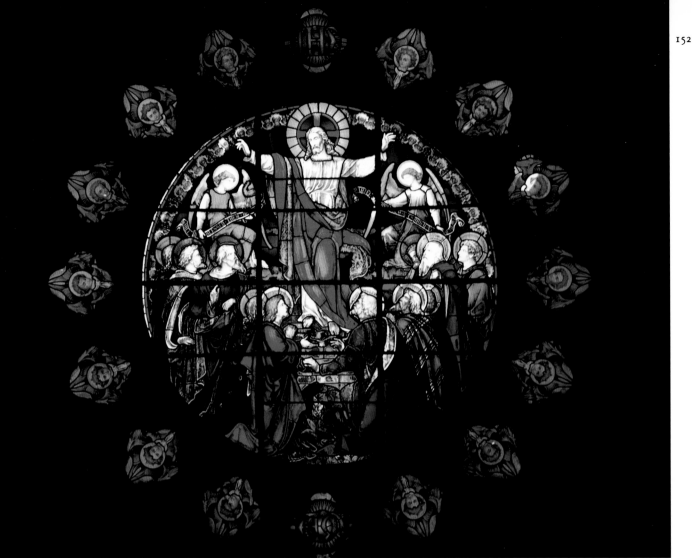

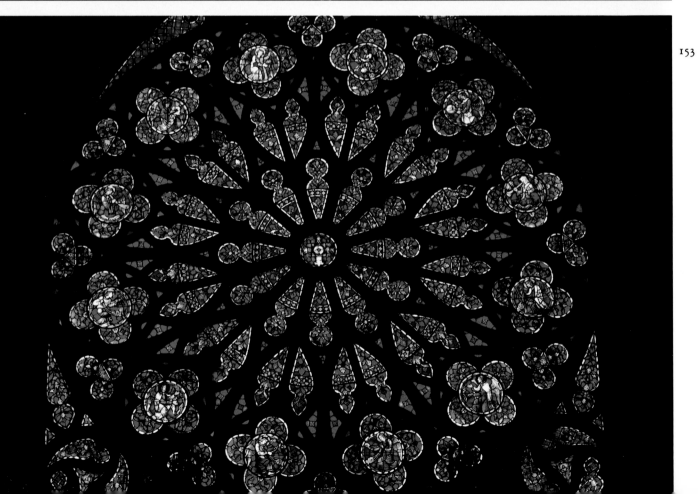

152. Packer Collegiate Institute, 170 Joralemon Street, Brooklyn Heights, Brooklyn. Another version of an *occhio* window, modified by the symmetry of angel faces surrounding the central image. The maker and date are unknown, but one suspects the glass was painted and assembled sometime between 1870 and 1880. Diam. 132".

153. Blessed Sacrament Church, 152 West 71st Street, Manhattan. Rose window, Clement Heaton (1861–1940). Diam. approx. 31'. The splendor of this window from the 1920s or 1930s appears fully only when reflected sunlight displaces the shadows of 71st Street.

154. St. Thomas's Church, Fifth Avenue and 53rd Street, Manhattan. East rose window, attributed to Whitefriars. Early 1930s. Diam. 23'. This lovely window transforms itself continuously as the sun moves across the sky.

154

155. St. Bartholomew's Church, Park Avenue and 50th Street, Manhattan. Rose window called the *Sanctus Window,* Reynolds, Francis, & Rohnstock. After 1918, but before c. 1930. Diam. 24′. An infinitely vital form, the medieval rose in St. Bartholomew's south transept blooms anew with Art Deco forms.

156. Our Lady of the Skies, Kennedy Airport, Queens. Narthex window, J. Bonet and L. Hofman, Montreal. 1968. W. 144″. Most of the glass consists of abstract patterns in shattered crystalline forms. The abstractions are sufficiently organized to evoke images of radiant, bursting light—a concept natural to stained glass and appropriate to theological metaphors equating God and light.

157. Protestant Chapel, Kennedy Airport, Queens. Robert Pinart (b. 1927). 1968. By the late 1960s bold forms were well established in the vocabulary of European stained-glass artists like Pinart, who maintains studios in Paris and New York.

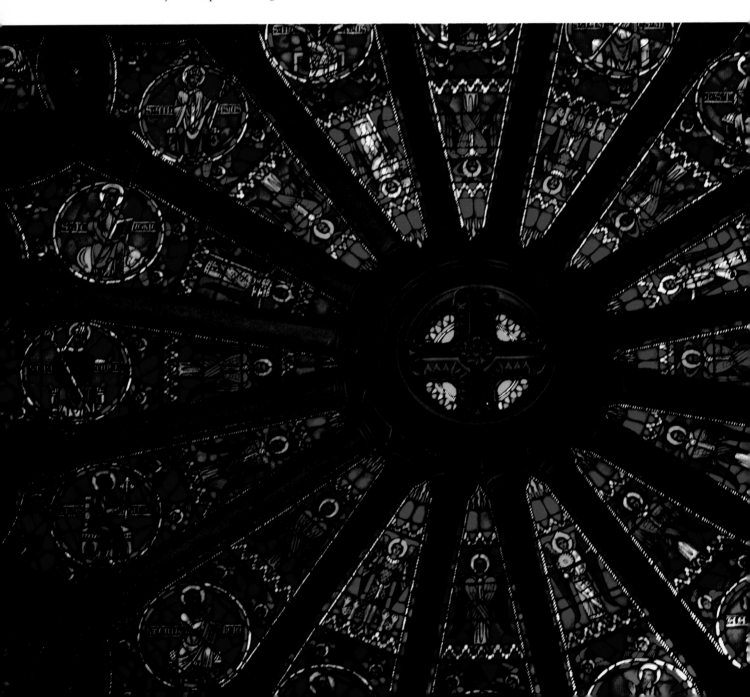

155

156

157

158. Tavern-on-the-Green Restaurant, Central Park at West 67th Street, Manhattan. Untitled panel in the Elm Room. Designed and executed by Warner Leroy Studios. 1981. W. 66″.

Appendix:
A Selected List
of Stained-Glass
Windows
in New York City

The following list comprises notable windows in public or semipublic buildings in the city. As there are literally thousands of stained-glass windows in New York and neither I nor anyone else has seen them all, this list must necessarily be subjective and partial. I have further reduced its potential length by restricting it to windows about which something is known, or whose intrinsic qualities seem to merit attention. Little is known about many windows that were obviously made by superb craftsmen. Our ignorance stems partly from the loss of records, partly from the privacy in which many records are still maintained, and partly from the lack of scholarly attention that has been given to stained glass. The task of a comprehensive survey and documentation of American stained glass is just beginning under the aegis of the Census of American Stained Glass, 1840–1940, which Willene Clark has done most to launch. This census will undoubtedly recover an enormous amount of documentation as well as discover hundreds of unknown works of glass art. In the meantime the list below may serve as a selective guide to windows that are already known in the city and stimulate further scholarship.

The technical descriptions of the windows are cursory, not only for reasons of economy but because in many cases the glass is in inaccessible locations and one can only approximate its constituents. *Pot metal* is used in its broadest sense to include any glass, except opalescent and *dalle de verre,* which is colored while molten. *Opalescent* includes flashed opals (a thin layer of opalescent glass on a clear base). *Enamel* refers to glass

that is predominantly or wholly colored with various vitreous paints. *Enamel and pot metal* implies that the majority of the coloring involves vitreous paints, whether applied to sections of colorless glass or used to modify the color of pot metal. *Pot metal and enamel* means a window made mainly of pot metal but with some colored enamels either on colorless glass or on the pot metal itself. Mention of the style I call *twentieth-century Gothic,* or its synonymous term, *twentieth-century medieval,* refers not only to that style but to a technique based on pot metal with the details painted in blackish-brown enamels and perhaps silver stain, as was done in the Middle Ages. Occasionally some colored enamels may appear in twentieth-century Gothic work.

The names of buildings, especially churches, vary. I have tried to cross-reference some of the rubrics most likely to cause confusion, but the variety of terminology makes a thorough system of cross-references impossible. For example, Advent Lutheran Church is also known as the Lutheran Church of the Advent, the Church of the Advent, and so on. Whenever possible I have relied on the American Institute of Architects' *Guide to New York City,* revised edition, by Norval White and Elliot Willensky (New York: The Macmillan Company, 1978), for the names of buildings and neighborhoods.

MANHATTAN SOUTH OF 42ND STREET

Appellate Division, New York State Supreme Court, Madison Ave. and 25th St. Charles Connick attributes work in this

building to Otto Heinigke (*Adventures in Light,* p. 358). Other sources ascribe it to D. Maitland Armstrong, whose signature appears on some of this opalescent glass, all of which was made c. 1900.

Armenian Cathedral of New York, Second Ave. and 34th St. *Dalle-de-verre* windows by Lamb Studios, c. 1967.

Bowery Mission, 227 Bowery. Streetfront, *Return of the Prodigal,* opalescent glass, illuminated at night.

Calvary Episcopal Church, 61 Gramercy Park N. European and American glass of many styles, some of which seems to date from not long after the construction of the church in 1864.

Church Center of the United Nations, 777 United Nations Plaza. Sculptured wall and glass, by Willet Studios and Benoit Gilsoul, 1963.

Church of the Ascension, Fifth Ave. and Tenth St. D. M. Armstrong, in vestibule, 1911; tower windows of pot metal, G. Owen Bonawit, c. 1938; in the nave, important opalescent windows, including, in the north aisle, *Flight Into Egypt,* J. Alden Weir, after 1892; *The Women at the Sepulchre,* Frederick Wilson, 1894; *Christ's Admonition to Thomas,* Joseph Lauber, c. 1900; and *The Good Shepherd,* John La Farge, 1910. In the south aisle, from the chancel, *Nicodemus Coming to Jesus by Night,* La Farge, 1886; *The Annunciation,* D. M. Armstrong, 1886; *The Presentation of Christ in the Temple,* La Farge, c. 1888; *The Child Jesus . . . in the Temple,* D. M. Armstrong, 1895; and *The Three Marys,* La Farge, 1889. In the clerestory *dalle-de-verre* windows by Willet Studios, 1963, and two opalescent windows by John Humphreys Johnston, a pupil of La Farge.

Church of the Holy Apostles, Ninth Ave. and 28th St. Pot metal, silver stain, and enamels, William Jay Bolton, 1848.

Church of the Incarnation, Madison Ave. and 35th St. In the nave, south wall, from rear; *Now Is Christ Risen . . . ,* Henry Holiday, pot metal and enamels, probably c. 1885; *Old Testament Window,* pot metal and enamel, Clement Heaton, Butler & Bayne, London, after 1885; *New Testament Window,* pot metal and enamel, Clayton and Bell, London, after 1882; *The Calling of the Apostles,* opalescent glass, La Farge, 1884; window depicting Jacob and his children, Christ and St. Peter, pot metal and enamel, Holiday, after 1882; Grape vine and angels design, opalescent glass, La Farge, 1884; *Angels Ascending and Descending* (two lancets, one atop the other), Morris and Company, 1885; *The Pilgrim,* Tiffany Studios, before 1910. Chancel windows, pot metal by Young, c. 1920; chapel by unidentified English studio; west wall of north transept window by Heaton, Butler & Bayne. In the nave, north wall, window to faith and charity, Edward Burne-Jones, after 1882; *Christ Feeding the Multitudes,* Cottin & Co., London; *St. John and Christ at the Last Supper, St. John Comforting Mary,* unidentified studio; Cole Memorial Window, by (Frederick?) Wilson, Tiffany Studios; both Tiffany windows after c. 1892, before 1910; in the gallery, north window by Guthrie & Davis, adjoining opalescent window by Tiffany Studios, before 1910; Great West Window by C. E. Kempe, c. 1885.

Church of the Transfiguration, 1 E. 29th St. *St. Faith* window, said to be 14th century, from Belgium; a large 1863 rendition in enamel of Raphael's *Transfiguration;* in the same medium, a skylight with child angels, including yet another set of putti adapted from those in the *Sistine Madonna,* by Raphael; numerous other late 19th- and early 20th-century windows in various styles and techniques; Booth memorial window, La Farge, 1897; Drexel window similarly attributed but without documentation; *Christ as the True Vine,* Joseph Lauber, before 1916; *St. Ursula,* designed by Hogan and executed by Powell's of Whitefriars, 1930.

Epiphany Roman Catholic Church, Second Ave. and 22nd St. Contemporary pot-metal designs by Elskus, executed by Durhan Studios, 1967-1968. The Epiphany window incorporates sections of a Mayer Studios (Munich) window, which survived the fire that destroyed the previous building of this church.

First Presbyterian Church, Fifth Ave. and 12th St. In the narthex, zodiac and seasons, Van Brunt. Opalescent windows in the nave, from the rear, in the north aisle, *Moses,* D. M. Armstrong, before 1915; *David,* Lamb Studios, installed "some years" before 1915; *Isaiah,* Tiffany Studios, c. 1902; *St. John,* Francis Lathrop, 1892; *St. Paul,* D. M. Armstrong, installed 1893-1915; *Christ in the Garden of Gethsemane,* Tiffany Studios, 1919. In the south aisle, from chancel, *The Puritan,* D. M. Armstrong, c. 1893; *St. Columba,* Tiffany Studios, prior to 1915; *Admiral Gaspard de Coligny,* D. M. Armstrong, prior to 1915; *Martin Luther,* Lamb Studios, prior to 1915; *Peter Waldo,* D. M. Armstrong, prior to 1915.

General Theological Seminary, Chapel, 175 Ninth Ave. Pot metal and enamels, probably English, late 1880s.

Grace Church, Broadway and Tenth St. The church has an excellent guide to its glass, available in the vestry office. The chantry contains pot-metal and enamel windows, mostly from British studios, c. 1900-1932. The church proper has work by several distinguished British studios, particularly Clayton and Bell. *The Four Fishermen,* Willet Studios, 1966, is an interesting attempt to match the style of three much earlier windows by Henry Holiday.

Holy Trinity Chapel, Washington Sq. and Thompson St. *Dalle-de-verre* windows by Earl Neiman, 1965.

Jefferson Market Library, Sixth Ave. and Tenth St. Tinted factory-made glass, with some painted figures and other enameled decorative work, c. 1877.

Judson Memorial Church, 55 Washington Sq. S. All windows by La Farge, c. 1892-1909.

The Lawyers' Club, 115 Broadway. The earliest work ascribed to Guthrie in the city, opalescent glass, 1913.

Little Church Around the Corner, see Church of the Transfiguration.

Marble Collegiate Church, Fifth Ave. and 29th St. *Moses in [sic] the Burning Bush* and *Joshua,* Tiffany Studios, before 1910; *dalle-de-verre* windows in Poling Chapel, pot-metal panels by Bakst in adjoining Telephone Center.

Morgan Library, Madison Ave. and 36th St. German, Dutch, and Swiss glass, principally of the 16th century. Skylights of a thick blue glass brought from France, c. 1906.

National Arts Club, 15 Gramercy Park South. Entrance hallway window by La Farge, skylight said to be from MacDonald of Boston, c. 1884.

The Players' Club, 16 Gramercy Park South. In the third-floor library, small 17th-century German and perhaps Dutch

panels, sepia enamel and silver stain; in the lounge and reading room on main floor, armorial panels from Tiffany Studios, before 1910.

St. Cyril's Croatian Catholic Church, 502 W. 41st St. Enamel and pot metal in the Munich style, late nineteenth and early twentieth century.

St. George's Church, Stuyvesant Sq. at Rutherford Place. Chapel windows by Lamb Studios, after 1911.

St. Marks in the Bowery, Second Ave. and Tenth St. Opalescent windows by unknown but accomplished studio(s), c. 1890-1910.

St. Mary's Byzantine Rite Church, Second Ave. and 15th St. *Dalle-de-verre* walls from Schmitt Studios, Milwaukee, designed by Felix Senger, 1963.

St. Nicholas Carpatho-Russian Orthodox Greek Catholic Church, 288 E. Tenth St., at Tompkins Sq. Pressed pot-metal glass jewels, of unknown provenance. The church was built in 1884 as a mission of St. Marks in the Bowery, but fairly extensive records there make no mention of these windows.

St. Peter's Episcopal Church, 346 W. 20th St. Opalescent windows, many said to be from Tiffany Studios.

St. Peter's Roman Catholic Church, 22 Barclay St. Charles Connick, c. 1930.

St. Stephen's Church, 142 E. 28th St. Aisle windows of enamel and pot metal, perhaps from Munich. Interesting (and inaccessible) lancets high in the narthex wall, and a boldly designed rose in the west transept, all of unknown provenance.

St. Vartan's Cathedral, *see* Armenian Cathedral of New York.

Seamen's Church Institute, 25 South St. Lobby contains four fine panels inscribed *They that go down to the sea in ships . . .*, probably English, enamel and pot metal. These panels may have come from the institute's original building. The chapel windows by Rambusch Studios date from c. 1968.

Trinity Church, Broadway and Wall St. Chancel window, Upjohn, Hoppin, and Stephenson, 1845; chapel windows, Heinigke and Smith.

Washington Square United Methodist Church, 135 W. Fourth St. Opalescent and pot-metal glass in simple geometrical forms typical of Methodist and likeminded Protestant congregations, 1895.

Woolworth Building, Broadway at Park Place. Lobby ceiling by Heinigke and Bowen, designed by Oliver Smith, 1913.

MANHATTAN NORTH OF 42ND STREET

Advent Lutheran Church, Broadway and 93rd St. Opalescent windows, after 1901; the landscapes in the chancel and west windows are noteworthy.

Belasco Theatre, 111 W. 44th St. Tiffany supervised the decoration of the theatre, since remodeled, and of David Belasco's private apartment in the theatre, currently a shambles, but being restored with its stained glass.

Bible Deliverance Church, 205 W. 71st St. Several opalescent windows said to be by Tiffany Studios, after 1890; a large lancet of pot metal in 20th-century Gothic style, c. 1925.

Blessed Sacrament Church, 152 W. 71st St. Pot-metal clerestory windows and great rose, Clement Heaton, after 1921.

Central Presbyterian Church, Park Ave. and 64th St. West

window, Young, after 1922.

Church of Christ, Scientist, Central Park W. and 96th St. Opalescent windows to match the style and scale of this great English Baroque structure, c. 1903.

Church of St. Catherine of Siena, First Ave. and 68th St. Pot metal and enamel designed by Elskus for Durhan Studios, c. 1961-1965.

Church of St. Mary the Virgin, 145 W. 46th St. Simple geometric designs in the clerestory and rose, unknown provenance and dates; figured windows, Kempe of London, before 1915.

Church of the Annunciation, West End Ave. and 91st St. Opalescent windows, at least some of which are probably from Tiffany Studios or made by workers associated with Tiffany. (Note design similar to Wilson's "River of Life," First Presbyterian Church, Brooklyn Heights.)

Church of the Ascension, 221 W. 107th St. Interesting rose window of unknown provenance.

Church of the Heavenly Rest, Fifth Ave. and 90th St. In the nave, Norman slab windows, James Hogan, c. 1930; window over entrance, Powell of London, 1938; chancel rose and chapel windows, Guthrie, before 1939.

Church of the Intercession, Broadway and 155th St. Major windows are grisaille, D'Ascenzo, 1914; Lady Chapel and other small figured windows, Lakeman, before 1940.

Columbia University, St. Paul's Chapel. Chancel windows, La Farge, 1906; armorial windows below dome, Armstrong; transept windows, Young and Guthrie, c. 1925. In Kent Hall, windows by Lamb Studios. In School of Journalism, *Statue of Liberty,* Heinigke and Smith, c. 1915.

Congregation Habonim, 44 W. 66th St. Sowers, c. 1957.

Cooper-Hewitt Museum (former Andrew Carnegie House), Fifth Ave. and 91st St. Marquee and interior transoms probably by Tiffany Studios, glass by La Farge in collection but not on exhibit.

Fifth Avenue Presbyterian Church, Fifth Ave. and 55th St. Inexpensive, factory-made glass typical of the late nineteenth century, but capable of creating a fine effect, as the rose window demonstrates.

French Embassy Cultural Services (former Payne Whitney House), 972 Fifth Ave. La Farge's *Autumn Scattering Leaves* is currently covered with shelving, which the French plan to remove.

Holy Family Church, 315 E. 47th St. Contemporary pot metal, Rambusch Studios, c. 1960.

Holy Name Church, Amsterdam Ave. and 96th St. Enamel and pot metal, perhaps German, after 1891. The small windows in the entrance tympanums are noteworthy.

Holy Trinity Episcopal Church, 316 E. 88th St. Entire glazing program, Henry Holiday, after 1897; considered by some to be his best work, here or in Britain; contemporary glass in the cloister chapel, Robert Sowers.

Holy Trinity Lutheran Church, Central Park W. and 65th St. *Advent,* Tiffany Studios, before 1910; other opalescent windows, Lamb Studios; fine rose window by unknown studio.

Immanuel Evangelical Church, Lexington Ave. and 88th St. All the windows in this church were recently replaced with work by Benoit Gilsoul.

Incarnation Church, St. Nicholas Ave. and 175th St. The entire church, glazed between about 1930 and 1945, proves

that the Munich firm of F. X. Zettler mastered the 20th-century Gothic style. Much of the glass was apparently made in the firm's New Jersey studio.

La Folie Restaurant and Discothèque, Madison Ave. and 61st St. Richard Avidon, 1976. Pot metal and various types of opalescent glass, all sand-blasted on their rear surfaces to produce an even translucent effect.

Lincoln Square Synagogue, Amsterdam Ave. and 69th St. Pot metal, Shamir, c. 1971. These windows make a colorful gift to the street when they are illuminated on Sabbath evenings.

Little Sisters of the Assumption, Provincialate and Chapel, 1195 Lexington Ave. Undated enamel windows, probably late 19th century from Germany or France; contemporary designs by David Wilson in industrial glass (machine-rolled material for skylights, showers, and so forth) and pot metal, executed by Rambusch, 1963–1966.

Maxwell's Plum Restaurant, First Ave. and 64th St. Ceiling, Le Roy, c. 1965; panel over bar, La Farge, from Frederick Ames House, Boston; numerous other opalescent panels and light fixtures.

The Metropolitan Museum of Art, Fifth Ave. and 82nd St. Extensive collection of medieval and Renaissance glass, important works by Tiffany and La Farge, also Goodhue, Sullivan, Wright, and other early 20th-century artists.

Metropolitan Baptist Church, Seventh Ave. and 128th St. Noteworthy rose window, unknown studio, after 1884.

Milton Steinberg House, 50 E. 87th St. Stained-glass facade by Adolf Gottlieb, 1955.

Museum of the City of New York, Fifth Ave. and 103rd St. Second-floor (period rooms) window from Henry G. Marquand House on E. 68th Street, designed by Richard Morris Hunt, executed by E. S. Oudinot, 1884, with enamels on pot metal.

The New-York Historical Society, Central Park W. and 77th St. Early 17th-century Dutch panels attributed to Duyck-inck (in storage); in reading room, Hudson Memorial, Frank J. Ready, 1909; *Edict of Nantes,* Tillinghast, 1908; in Dexter Hall, *President Washington Taking the Oath, Federal Hall,* . . . *1789,* unknown artist, oil on linen, c. 1839. (This translucent painting, meant to be displayed in a window, is the same sort of work described in chapter 2 as a substitute for stained glass.)

New York Society for Ethical Culture, Central Park W. and 64th St. Auditorium windows, Louis D. Vaillant, 1910–1916; other opalescent glass in top-floor windows.

Park Avenue Christian Church, Park Ave. and 85th St. Figured scenes in narthex window, Tiffany, before 1893, remainder of window may also be Tiffany Studios, but after 1911.

The Riverside Church, Riverside Drive and 122nd St. In the lobby stairwell, two small panels, perhaps 14th century, pot metal with silver stain; above them, The Flemish Windows, 16th century; all the rest of the glass in the church is 20th-century Gothic, c. 1930–1935; in the ambulatory, triforium, and Men's Committee Room, Wright Goodhue; aisle windows, Reynolds, Francis, & Rohnstock; choir clerestory, Burnham; nave clerestory windows (copied from Chartres), Simon of Rheims and Lorin of Chartres; rose in kindergarten lobby, Guthrie, chapel, D'Ascenzo.

Rhinelander Memorial Church of the Holy Trinity, *see* Holy Trinity Episcopal Church.

Salem United Methodist Church, Seventh Ave. and 129th St. Rose windows, c. 1890, dominate what was, at the time of its construction, the largest Protestant church auditorium in this country.

St. Andrew's Church, Fifth Ave. and 127th St. Mostly opalescent work, after 1891. *St. Agnes,* Joseph Lauber, before 1916.

St. Bartholomew's Church, Park Ave. and 50th St. Four windows in north transept, six in south transept (under rose), Guthrie; north aisle windows designed by Guthrie, executed by Young, c. 1920–1930; south, or *Sanctus* rose, Reynolds, Francis, & Rohnstock, as are the chapel windows, c. 1940; clerestory designs, Hildreth Meière, executed by Rambusch and others, c. 1940–1950. The opalescent glass in the south choir wall may be by Francis Lathrop, who made most of the windows for the old St. Bartholomew's (now demolished) on Madison Avenue.

St. David's School, 12 E. 89th St. Pot-metal and enamel windows, probably 16th-century French.

St. Elizabeth's Roman Catholic Church, Wadsworth Ave. and 187th St. Interesting chancel lancets of unknown origin.

St. Ignatius Loyola Church, Park Ave. and 84th St. Clerestory and aisle windows in opalescent glass, c. 1900; enamel transept windows, a London firm, after 1898.

St. James's Episcopal Church, Madison Ave. and 71st St. North transept, enamel and pot-metal windows in north wall, perhaps from Europe; in west wall of same transept, opalescent *Angels of Victory,* Tiffany, adjoining lancet also probably Tiffany, as is definitely the set of windows in the narthex stairwell inscribed . . . *Those Angel Faces* . . . ; West Rose designed by Guthrie, made by Ernest Lakeman in Young's studio; chancel windows, Lakeman; south aisle and transept windows (in alternating placement), Connick and Young.

St. John the Divine, Cathedral Church of, Amsterdam Ave. and 113th St. Edward H. Hall, *A Guide to the Cathedral Church of St. John the Divine* (published by the Cathedral, 1965), provides an accurate guide to virtually all the glass in this enormous structure. The clerestory windows nearest the crossing on the south side of the nave were made by Lakeman.

St. Luke's Lutheran Church, 308 W. 46th St. Narthex windows, Zettler, Munich, probably 1920–1930. A north exposure and dense protective exterior glass makes these windows somber except on very sunny mornings.

St. Martin's Church, Lenox Ave. and 122nd St. Fire twice destroyed the interior and the original windows of this enormous Romanesque church. The opalescent windows in the rear of the sanctuary are probably ones that Tiffany designed for the old building of the Church of the Heavenly Rest.

St. Mary's Episcopal Church, Manhattanville, 521 W. 126th St. Several interesting late 19th- and early 20th-century windows, opalescent glass and enamel on pot metal, of unknown provenance.

St. Michael's Episcopal Church, Amsterdam Ave. and 99th St. Pot-metal windows, Connick, 1927; opalescent glass in chancel (1895) and two rear chapel windows, Tiffany Studios; two adjoining windows in chapel, D. M. Armstrong. Baptismal window over south door, unknown studio, 1907; in east transept aisle, from chancel, *Luke the Beloved Physician,* D. M. Armstrong; *St. Agnes,* unknown studio, 1896; *St. Faith,* Frederick Wilson, 1916; *I Was*

Thirsty, also known as the *Good Samaritan Window,* F. L. Stoddard, designer, made by R. Geisler, 1912.

St. Patrick's Cathedral, Fifth Ave. and 50th St. Enamel and pot-metal windows in the nave, Lorin of Chartres and Ely of Nantes, c. 1879; similar windows in the choir by the same firms; the transept roses are also by these firms or by Morgan Brothers of New York, the records are unclear; pot-metal clerestory windows and Great West Rose, Connick, c. 1942; pot-metal Lady Chapel windows, Paul Woodroffe, 1927–1931.

St. Paul the Apostle Church, Ninth Ave. and 59th St. Central apse window, Cox Sons, Buckley & Co., London, 1885; two flanking windows, Mayer of Munich, 1887. Blue nugget windows in the apse and all the remaining glass, La Farge, completed by 1889.

St. Phillip's Church, 214 W. 134th St. The *City Window,* Willet Studios, 1977, to celebrate the congregation's 167th anniversary.

St. Thomas's Church, Fifth Ave. and 53rd St. Clerestory windows, Powell of London (Whitefriars), except one south window by D'Ascenzo, and rear north window; most of the glass was placed in the church in the 1930s, but the Willet window dates from 1973.

St. Vincent Ferrer Church, Lexington Ave. and 66th St. Chancel windows, nave clerestories, and St. Patrick's chapel, Connick; small windows near entrance, Guthrie, painted in Young's studio; aisle and Friars' Chapel, Alexander Locke and Harry Goodhue.

Seventh Regiment Armory, Park Ave. and 67th St. Windows and decor of the Veterans' Room still as designed by Tiffany in 1879.

Temple Emanu-El, Fifth Ave. and 65th St. Documentation is confusing, but at least some of the aisle windows and the west rose window are by Oliver Smith; some of the clerestory windows are by Payne Studios; the red-toned south clerestory was designed by Guthrie. Rear chapel windows by D'Ascenzo; front chapel panels by Tiffany Studios, designed for the old Temple Emanu-El before 1910 (one of the first landscapes ever designed for a Jewish house of worship). Other windows by Bonawit and by Castle and Calvert.

United Nations Headquarters, Secretariat Building, UN Plaza, E. 46th St. Hammerskjold Memorial, Chagall and Charles Marq.

West End Collegiate Church, West End Ave. and 77th St. Early 20th-century opalescent windows, *Dawn . . .* Clara Burd; Christ and children, Tiffany before 1910; others attributed to Tiffany and to Frances White.

Y.W.C.A., 610 Lexington Ave. In main stairwell, landscape, Tiffany Studios, 1918.

BROOKLYN

All Saints' Episcopal Church, Seventh Ave. and Seventh St., Park Slope. Windows in pot metal and enamel from turn of the century, opalescent windows from various studios, including several said to be from Tiffany.

Bay Ridge United Methodist Church, 7002 Fourth Ave. *Dalle-de-verre* rose window in subdued grays and blues, c. 1965.

Bethlehem Lutheran Church, 490 Pacific St. (two blocks west of Long Island R.R. Terminal). Two large rose windows and several lancets, all distinguished examples of opalescent floral abstractions.

Brooklyn Museum, The, 200 Eastern Parkway. *Marine Mosaic* of seashells, stones, and glass, W. Cole Brigham, c. 1910; *Hospitalitas,* La Farge. The museum hopes to restore the long-lost and damaged window of Frederick Lamb, *Religion Enthroned,* which was honored at the Paris Exposition of 1910. Apparently in storage are Emmanuel Vigeland's *Angel and Old Woman,* and several other panels by the distinguished Norwegian artist.

Brooklyn Society for Ethical Culture (former Childs Mansion), 53 Prospect Park W. Numerous transoms and roundels from Tiffany Studios, c. 1900 and 1907.

Brooklyn Woman's Club (originally George Cornell House), 114 Pierrepont St., Brooklyn Heights. The house was built in 1840 but drastically remodeled in 1887, which would be a likely date for the filigree-pattern window on the main floor of this building. Similar windows using pieces of opalescent glass, pressed-glass jewels, and cut clear glass are common in many Brooklyn Heights buildings. The transoms at 84 Pierrepont Street (originally the Herman Behr Residence, built in 1890) are another good example of the kind of work that makes it a pleasure to walk in Brooklyn Heights (and also Park Slope) in the evening when the illuminated windows in these neighborhoods become visible from the street.

Christ Church, Ridge Blvd. and 73rd St., Bay Ridge. Much praised by Connick and others, these pot-metal windows from the 1930s by Otto Heinigke and his son Otto W. show how far the elder Heinigke traveled to become the doyen of 20th-century medievalism. Not everyone will agree that these windows are superior to his earlier opalescent work.

Christ Church and the Holy Family, Clinton and Kane Sts., Cobble Hill. Windows assembled from various unknown locations to replace ones lost in a fire. Some of the opalescent work now in place may be from Tiffany Studios or craftsmen associated with Tiffany, other windows may be European.

Church of St. Luke and St. Matthew, 520 Clinton Ave. near Atlantic Ave., Fort Greene. Opalescent glass, after 1891. At least two studios are probably represented here, one that produced handsomely naïve chancel windows, and another firm, probably Tiffany Studios, that made the rich glass of the nave.

Church of the Evangel, Bedford Ave. and Hawthorne St., Flatbush. A late (1927) Tiffany Studios' version of the first Easter morning.

Church of the Redeemer, Fourth Ave. and Pacific St. Opalescent windows, all undocumented, including an interestingly naïve *Transfiguration.* In the chapel, two miniature windows in enamel and pot metal.

First Presbyterian Church, 124 Henry St., Brooklyn Heights. An impressive assembly of Tiffany windows, including an unusual skylight. The window ascribed to "Cartier" in the brochure available at the church is perhaps by the London and New York firm of Cottier.

First Unitarian Church, formerly, Church of the Savior, Pierrepont St. and Monroe Pl., Brooklyn Heights. Low, Woodward, Frothingham, and Farley Memorials, Tiffany Studios, before 1910; other opalescent windows probably by the same studio.

Grace Church, Hicks St. and Grace Ct., Brooklyn Heights. Husted and Litchfield Memorials, Tiffany Studios, before 1910; other opalescent windows by unknown studios.

Green-Wood Cemetery, main entrance on Fifth Ave. and 25th St. The chapel windows are by Willett Studios. Many of the mausoleums contain stained-glass windows, few of which have any interest.

Hanson Place Central Methodist Church, Hanson Pl. near Times Plaza. Impressive but undocumented 20th-century Gothic glass, after 1930.

Holy Trinity Church, *see* St. Ann and the Holy Trinity.

Lafayette Avenue Presbyterian Church, Lafayette Ave. and Oxford St., Fort Greene/Clinton Hill. Opalescent windows by Alex S. Locke, Benjamin Sellers, Joseph Lauber, and Tiffany Studios, the last dating mostly from 1893 to 1895. In the chapel, *Creation* window, Tiffany Studios, 1917. The simple geometric glass in the tower dates from before the 1890s and may be contemporary with this 1862 structure.

Lutheran Church of the Good Shepherd, 7420 Fourth Ave., Bay Ridge. In the chapel, *Adoration of the King of Kings,* Tiffany Studios, originally in St. James's Lutheran Church (now demolished) on Madison Avenue in Manhattan.

Memorial Presbyterian Church, Seventh Ave. and St. John's Pl., Park Slope. All the windows are said to be from Tiffany Studios; some are signed by the Studios and the Woodford, Robertson, and Bayliss memorials are mentioned in Tiffany publications.

Mount Sinai Baptist Church, 241 Gates Ave., Bedford-Stuyvesant. Opalescent windows; particularly fine craftsmanship in the window on the right side of the nave and the version of *The Light of the World* in the chancel.

National Shrine Church of St. Bernadette, 8201 13th Ave., between 82nd and 83rd Sts. An interior dominated by light from pot-metal windows, c. 1937.

New Utrecht Dutch Reformed Church and Parish House, 18th Ave. and 83rd St., Bensonhurst. Several opalescent windows, including those in the Parish House, by Tiffany Studios, others undocumented or unsigned.

Old First Dutch Reformed Church, Seventh Ave. and Carroll St., Park Slope. North and south rose windows and lancets, Heinigke and Bowen; *Christ Healing the Sick,* Heuser and Hausleiter; *The Rest Window,* by a "Mr. Colgate"; *Christ and the Woman of Samaria,* Tiffany Studios, all c. 1893. No records seem to exist relating to the large east rose.

Our Lady of Angels Church, 7320 Fourth Ave., Bay Ridge. Pot metal, Rambusch Studios, c. 1940.

Our Lady of Guadalupe, 7201 15th Ave. Pot metal and enamel designed by Elskus for Durhan Studios, 1977.

Our Lady Queen of All Saints Church, Vanderbilt and Lafayette Aves., Fort Greene. Very unusual pot metal, c. 1913, molded like the convoluted surface of some opalescent windows.

Packer Collegiate Institute, 170 Joralemon St., Brooklyn Heights. There are a number of notable windows in this complex of 19th-century buildings. The former St. Ann's Episcopal Church, now part of the institute, retains its stained glass, much of which was probably installed within a decade or two of the construction of the 1869 structure. In the Assembly Hall of the institute are numerous windows from Tiffany Studios, and La Farge's *Dawn on the Edge of Night* (1903), which was originally in the home of Frank L. Babbot.

Plymouth Church of the Pilgrims, Orange and Hicks Sts.,

Brooklyn Heights. In the sanctuary, opalescent windows, Lamb Studios, c. 1917; in Hillis Hall, Chittenden memorial window, 1890, and *The Valiant Woman,* 1902, both Tiffany Studios, as is the window depicting Christ's Ascension. To the left and right of the *Ascension,* windows by Heinigke and Bowen; in the east wall, glass by Henry Holiday and Tiffany.

Pratt Institute, Caroline Ladd Pratt House, 229 Clinton Ave. near Willoughby, Clinton Hill. In the grand stairwell, five armorial windows, La Farge, c. 1898. In the rear East Room, a composite scene of mostly 16th-century glass, perhaps German. (Next door, at 241 Clinton Ave., is the former Charles Millard Pratt House, now the residence of the Roman Catholic Bishop of Brooklyn; not usually open to the public, but in the stairwell is a Tiffany landscape, c. 1893.)

St. Agnes Church, Sackett and Hoyt Sts., Gowanus. Zettler Studios, Munich, after 1905. Technically superb glass, but in both Europe and America work was apportioned among various craftsmen—some specialized in painting faces, others cut glass for lettering, etc. The practice was denounced by artists like La Farge, and its effect can be seen in these windows, where *St. Agnes* bears the same mechanical expression as she proceeds through all her travails. The rose window is a better example of German artistry.

St. Ann and the Holy Trinity (formerly Holy Trinity Church), Montague and Clinton Sts., Brooklyn Heights. Pot metal with enamels, William Jay Bolton with John Bolton, c. 1844–1847.

St. Augustine's Roman Catholic Church, Sixth Ave. and Park Pl., Park Slope. Opalescent glass after 1892. In the 1910 pamphlet published by Tiffany Studios, "ornamental windows" are listed in an otherwise unidentified St. Augustine's Church in Brooklyn. *Ornamental windows* in Tiffany's parlance usually refers to relatively simple designs not elaborate figured windows like those in the present church. The parish can find no records relating to these ambitious windows.

St. Ephrem's Church, 75th St. and Fort Hamilton Pkwy. Enamels on antique clear glass, Joep Nicolas, 1952. The distinguished European career of Nicolas was interrupted by World War II, when he fled Holland for New York. Before returning to Europe in the 1950s, he made many windows for American buildings but the St. Ephrem's glass and his work at Fort Totten Post Chapel, Queens, are his only windows in New York.

St. Gregory the Great Roman Catholic Church, 224 Brooklyn Ave., Crown Heights. Pot metal and enamel in the impressive narthex rose designed by Guthrie for Young and Bonawit, after 1915.

St. John the Baptist, 75 Lewis Ave., Bushwick. Opalescent windows by Tiffany, including some said to have been designed by Guthrie, c. 1896; and a colossal rose by Leon Dabo, executed in La Farge's studio.

St. Mary Mother of Jesus Church, 2326 84th St., Bay Ridge. *Dalle-de-verre* windows, Durhan Studios, c. 1960.

St. Paul's Roman Catholic Church, Hicks and Warren Sts., Cobble Hill. Nineteenth-century enamels on pot metal, probably German or French.

St. Thomas's Episcopal Church, 1405 Bushwick Ave. Large narthex and chancel windows in opalescent glass.

THE BRONX

Christ Episcopal Church, 5030 Riverdale Ave., Riverdale. Numerous enamel and pot-metal windows, probably English, dating to the 1880s or earlier; fine 20th-century Gothic windows, Len R. Howard, c. 1930; in north transept, Oudinot window, c. 1890.

First Presbyterian Church of Riverdale, *see* Riverdale Presbyterian Church.

Fordham University Chapel, near the center of Fordham's Rose Hill Campus. Windows in nave probably from Sevres, c. 1846.

Riverdale Presbyterian Church, 4765 Henry Hudson Parkway W. *Hollyhock* panels by Tiffany Studios; several interesting pot-metal windows of unknown provenance.

St. Ann's Episcopal Church, St. Ann's Ave. and 140th St., Mott Haven. *Nativity,* Tillinghast; early enamel and pot-metal windows in nave; substantial but undocumented opalescent windows in transepts.

St. Brendan's Roman Catholic Church, Perry Ave. and 206th St., Norwood. *Dalle-de-verre* windows in bold colors, c. 1966.

St. Francis de Chantal Church, Hollywood and Harding Aves., Throggs Neck. *Dalle-de-verre,* designed by Elskus, executed by Durhan Studios, c. 1971.

St. Nicholas of Tolentine Roman Catholic Church, 2345 University Ave. and Fordham Rd. Edward Heimer Studios considered this 20th-century Gothic work (c. 1928) their greatest accomplishment.

Union Reformed Church of Highbridge, 1272 Ogden Ave. Chancel and narthex windows, Tiffany Studios, c. 1888; other opalescent and 20th-century Gothic glass by unknown studios.

Woodlawn Cemetery, entrances at Jerome Ave. north of Bainbridge Ave. and at E. 233rd St., Norwood. In the Woodlawn mausoleum, *Immortality* in the fused-glass medium developed by Willet Studios in the 1950s; in the Daniel S. Lamont mausoleum, La Farge's *Resignation.*

QUEENS

American Airlines Terminal, Kennedy Airport. Sowers, 1960. Pot metal and unusual vitreous paints.

Cathedral College Chapel, 7200 Douglaston Pkwy., Douglaston. Pot metal and enamel designed by Elskus for Durhan Studios, c. 1968.

Church of the Immaculate Conception, 64-65 178th St., Jamaica. Pot metal and enamel designed by Elskus for Durhan Studios, 1962.

Church of the Most Precious Blood, 32-23 36th St., Long Island City. Pot metal and clear glass in designs that were innovative when they were created c. 1940.

The First Presbyterian Church of Far Rockaway (also known as Russell Sage Memorial Chapel), 13-24 Beach 12th St., Tiffany Studios, c. 1910.

Fort Totten Post Chapel, Willets Point. *Brotherhood of Man,* Joep Nicolas, c. 1945-1950.

Grace Episcopal Church, Jamaica Ave. and 153rd St., Jamaica. Late 19th- and early 20th-century glass, Mayer of Munich; one opalescent window said to be from Tiffany Studios.

Hall of Science, New York Museum of Science and Technology, Flushing Meadows Park at 111th St. *Dalle-de-verre*

walls designed by Harrison and Abramovitz and Willet Studios, 1964.

Our Lady of the Skies Chapel, Kennedy Airport. J. Bonet and L. Hofman, Montreal, pot metal, 1968.

Protestant Chapel, Kennedy Airport. Robert Pinart, pot metal, 1968.

St. George's Episcopal Church, Main and 38th Sts., Flushing. *Ascension* designed by Guthrie, made in Young's studio; also fine opalescent windows, some by Tiffany Studios.

St. Mark's Episcopal Church, 33-50 82nd St., Jackson Heights. Pot metal, Connick.

St. Raphael's Roman Catholic Church, 35-20 Greenpoint Ave., Long Island City. European enamels on pot metal, late 19th century.

St. Thomas the Apostle Church, 87-19 88th Ave., Woodhaven. Pot metal, Heaton.

STATEN ISLAND

Brighton Heights Reformed Church, 320 St. Marks Pl., St. George. Opalescent windows from some highly professional studio, mostly c. 1900-1910.

Calvary Presbyterian Church, Bement and Castleton Aves., West New Brighton. Opalescent glass from the chapel of Sailors' Snug Harbor, probably designed by Helen Armstrong (daughter of Maitland Armstrong), 1914.

Oakwood Heights Community Church, 345 Guyon Ave. During World War I T. W. Harland gathered fragments of glass in war-wrecked European churches, and in World War II friends gathered more such remnants. In 1950 Harland assembled them in a matrix of blue pot metal. Most of the fragments appear to date from the Renaissance or later, and one piece of opalescent glass is probably from the John Harvard Memorial Window by La Farge, which was severely damaged in the London blitz.

Snug Harbor Cultural Center (formerly Sailors' Snug Harbor), Richmond Terrace and Snug Harbor Rd., West New Brighton. The windows with nautical scenes in enamel probably date from the 1880s, as does the window proclaiming the Harbor to be a refuge for "aged, decrepit, and worn-out sailors." Etched flashed glass probably 1930-1940.

St. Andrew's Episcopal Church, 4 Arthur Kill Rd., Richmondtown. Modest but handsome examples of many styles of glass: Victorian enamels, 20th-century Gothic, contemporary pot-metal work.

St. Charles's Church, Hylan Blvd. and Peter Ave., New Dorp. Pot metal, Elskus, c. 1965.

St. John's Episcopal Church, 1331 Bay St., Fort Wadsworth. Several fine enamel and pot-metal windows, probably English, from the 1870s and 1880s; two lancets, Percy Bacon & Bros., London, c. 1908, with excellent silver stain work; *Cornelius and Angel,* Tiffany Studios, before 1910.

Trinity Lutheran Church, 309 St. Paul's Ave., Stapleton. Very late examples of the Munich style. Mayer & Co. with studios in New York as well as in Germany (to escape tariffs) made these windows between around 1920 and 1940. Although handsome as an ensemble, the heavy enamel matting used to antique the glass makes these windows less radiant than the Munich glass at Grace Church in Jamaica, Queens.

Notes

1: NEW YORK'S MEDIEVAL AND RENAISSANCE GLASS

1. This chapter omits specific scholarship on the glass of The Cloisters because scholarly readers have available Jane Hayward's splendid essay, "Stained Glass Windows—An Exhibition of Glass in the Metropolitan Museum's Collection," *Metropolitan Museum of Art Bulletin* 30, no. 3 (December 1971-January 1972). Any information desired beyond Dr. Hayward's essay is readily available in the acquisition files of The Metropolitan Museum of Art. Since Dr. Hayward's essay was written, Linda Papanicolaou has identified the previously unknown origin and iconography of the Early Gothic Hall windows. Her research will be forthcoming in a year or two in the *Journal of The Metropolitan Museum of Art*. I wish to thank Dr. Hayward and Dr. Papanicolaou for making available to me the new information on the Early Gothic Hall windows. In addition to Dr. Hayward's essay, chapter 1 also owes a substantial debt to Erwin Panofsky, "Abbot Suger of St.-Denis," *Meaning in the Visual Arts* (New York: Doubleday Anchor Books, 1955). James R. Johnson, *The Radiance of Chartres* (New York: Random House, 1965), provided an approach to stained glass informed by both aesthetic and physiological knowledge. A valuable essay on recent studies of early glass, and particularly the controversies surrounding the effects of restoration, appears in *Les Vitraux: Les Monuments Historiques de la France, Sommaire* (Paris: Édition de la Caisse Nationale des

Monuments Historiques, 1977). The author assumes responsibility for assumptions about the techniques used in the *Barbara von Zimmern* window. See Lawrence Lee *et al., Stained Glass* (New York: Crown Publishers, 1976), p. 49, for a summary of the methods likely to have been used in the von Zimmern window. The window can be enjoyed and examined at very close range, and one can see the physical evidence of the artisans' techniques, such as abraded flashed glass. I assume that abrasion was the technique used for removing flashing because that technique, as opposed to the more common modern use of acid, is the only method mentioned as late as 1813 when John Sidney Hawkins wrote *An History of the Origin and Establishment of Gothic Architecture . . . and an Inquiry into the Mode of Painting and Staining on Glass* (London: J. Taylor, 1813).

2. See *The Flemish Stained Glass Windows* (New York: Park Avenue Baptist Church, 1925). The archives of the Park Avenue Baptist Church (now The Riverside Church) were not available to the author to corroborate or further investigate the provenance of the Flemish Windows. However, the above pamphlet appears to be the work of a knowledgeable scholar. A copy of the pamphlet is available in the Avery Library, Columbia University.

3. Documentation on the St. David's windows seems to be limited to the fact that they came from a warehouse of the William Randolph Hearst collection (interview with David Hume, headmaster of St. David's School, June 5, 1979). The author's assumptions about the dates and origins of the win-

dows can obviously be only tentative, with the added warning that cartoons for windows might be used over and over again, and be taken to different countries, so a window does not necessarily reflect fashions and other social characteristics of the immediate era and region in which it was made.

4. Like much distinguished glass, the windows of The Pierpont Morgan Library are ill documented. The specific provenance of none of the Morgan glass seems to have been firmly established.

5. See acquisition files at The Metropolitan Museum, acquisition no. 52.77.46; Duyckinck's career is summarized in R. W. G. Vail, "Storied Windows Richly Dight," *The New-York Historical Society Quarterly* 36, no. 2 (April 1952), pp. 149-159.

2: THE GOTHIC REVIVAL

1. Wayne Andrews, *American Gothic* (New York: Random House, 1975), pp. 19-24, offers a lively retelling of the history of Fonthill Abbey. Numerous contemporary accounts of Fonthill mention various stained-glass windows, often with approval, but the descriptions and illustrations are too sketchy to give a clear idea of what the windows looked like or how they were made. One of the glaziers of Fonthill was Francis Edginton, who also made a window for Salisbury Cathedral. This window, unlike the glass of Fonthill, has survived, but only to be called "a wretched thing, despite the fact that the design was by Sir Joshua Reynolds," Maurice Drake, *A History of English Glass-Painting* . . . (New York: McBride, 1913), pp. 99-100. For a contemporary account of the Abbey, see James Storer, *A Description of Fonthill Abbey, Wiltshire, Illustrated by Views* (London: W. Clarke, 1812), esp. pp. 8, 12, 17.

2. Compare the figure of *St. James* (fig. 67) from the clerestory of The Riverside Church with plate XII (unpaged) of Marcel Aubert, *French Cathedral Windows of the Twelfth and Thirteenth Centuries* (New York: Oxford University Press, 1947), which shows the original St. James window at Chartres as it appeared around 1946.

3. Lee, *Stained Glass,* pp. 148-149.

4. *History of Architecture and the Building Trades of Greater New York* (New York: Union History Company, 1899), vol. 2, pp. 17-19. The Preface lists Russell Sturgis and Frederic Crowninshield among the several contributors to the volume, but the exact contribution of these well-informed writers cannot be determined in this unannotated volume.

5. *Ibid.,* p. 19.

6. Willene B. Clark, "America's First Stained Glass: William Jay Bolton's Windows at Holy Trinity Church, Brooklyn, New York," *The American Art Journal* (October 1979), p. 32. Professor Clark generously gave me a manuscript copy of her article before it was published.

7. *Ibid.,* pp. 32-36.

8. No documentation for the Fordham windows could be found in the archives of Fordham University or the Archdiocese of New York. The traditional provenance of the windows appears in Robert I. Gannon, S.J., *Up to the Present: The Story of Fordham* (New York: Doubleday & Co., 1967), p. 36. Father Gannon's otherwise carefully documented book offers no citation for the paragraph devoted to the windows.

9. *New York Ecclesiologist* 2, no. 1 (October 1849), p. 29.

10. Archives of Trinity Church, "Invoice of 11 boxes colored window glass for Trinity Church . . . , Bremen, April 15, 1844." Obviously raw material, not finished windows, the materials described in this invoice dispel the notion that the Trinity window may have been made abroad; see also a document labeled "Colors of Drapery of Apostles, Mr. Hoppin's [*sic*]," which gives in detail the pot-metal and enamel schemata of the robed figures' colors. A letter from Hoppins dated "Providence, May 8, 1846," offers evidence that Hoppins was responsible for the execution of the visages: "I have already been to New York twice [to make alterations] . . . I cannot alter the head of the Saviour without altering the whole figure."

11. Margaret Tuft, The Stained Glass Windows of Trinity Church, New York, manuscript dated 1967, Avery Library, Columbia University.

12. I am indebted to the rector of the Church of St. Ann and the Holy Trinity, The Reverend Franklin E. Vilas, Jr., for allowing me to examine fragments of glass from the windows of Holy Trinity, or as it is now known, St. Ann and the Holy Trinity. The glass, being out of its lead, revealed some pieces to be painted on both sides.

13. Clark, "America's First Stained Glass," pp. 38-39, citing "Architecture and Its Connection with Religion," *Christian Advocate and Review,* ser. 2, 6 (November 1872), pp. 838-839.

14. My entire discussion of Bolton's windows rests on Professor Clark's article, but I am particularly grateful for the clarity with which she analyzed the variety of styles and influences that Bolton assimilated into his work.

15. Otto Heinigke, "The Windows of Holy Trinity Church, Brooklyn, New York," *The Architectural Review* 13 (January 1906), pp. 1-2.

16. Gail T. Guillet, "Historical Sketch of the Church of the Holy Trinity" (n.p., n.d.); Guillet prepared the brochure with the assistance of Professor Clark. The brochure was published by St. Ann and the Holy Trinity.

17. Clark, "America's First Stained Glass," pp. 52-53. The qualitative judgments about the windows at Holy Apostles are mine, not those of Professor Clark.

18. Paul Goldberger, *The City Observed—New York: A Guide to the Architecture of Manhattan* (New York: Random House, 1979), pp. 80-81. All the comments on the glass are my responsibility, except that Goldberger also observed the unfortunate effect produced by plate glass in this building.

19. John Gilbert Lloyd, *Stained Glass in America* (Jenkintown, Pa.: Foundation Books, 1963), p. 51; Lloyd's undocumented volume is supported by an undated typescript in the archives of the Lamb Studios (currently located in Northvale, New Jersey). The typescript is in an envelope marked "Frederick" and was apparently written around 1920. It is presumably the work of Frederick Lamb and confirms the general history of the Lamb Studios as told by Lloyd. Also in the Lamb archives, a *Catalogue* of 1893 lists works by the firm but none could be located that seems to date from the mid-nineteenth century.

20. St. Patrick's Cathedral, *Solemn Blessing and Opening of the New Cathedral* (New York: Archdiocese of New York, 1879), pp. 12, 13, 20, *et passim;* the rose windows in the north and south transepts are not French, but the work of "Morgan Brothers, New York," p. 21. Morgan Brothers also made

twelve clerestory windows, all since replaced by work from Connick Studios.

21. Information on French enamel and glass has been drawn principally from *The Second Empire, 1852 to 1870: Art in France Under Napoleon III* (catalogue of an exhibition sponsored by the Louvre, the Philadelphia Museum of Art, and The Detroit Institute of Arts) (Detroit, Mich.: Wayne State University Press for the Philadelphia Museum of Art, and The Detroit Institute of Arts, 1978), pp. 169–204. Comparative light-meter readings taken by the author at Chartres Cathedral and at St. Patrick's Cathedral in April 1979; account of St. Patrick's during the blackout from an interview with Teddy Patroff, June 10, 1979.

22. Information from Christ Church records given to the author by Robert R. Rodie, Jr., rector of the church. Information on Eugène Oudinot from Olivier Merson, *Les Vitraux* (Paris: Librairie-Imprimeries Réunies, 1895), pp. 301, 305, and Pierre Larousse, *Grand Dictionnaire Universel du XIX Siècle* (Paris: Larousse, 1872), vol. II, p. 156. Other sources declare that no Pre-Raphaelite influences were felt in French glass, which may be perfectly true in that Pre-Raphaelite *windows* seem little known in France, but the window in question here certainly suggests the influence of Pre-Raphaelite *painting*. See Marcel Aubert *et al.*, *Le Vitrail Français* (Paris: Editions des deux mondes, 1958), p. 278.

23. Timothy Hilton, *The Pre-Raphaelites* (New York: Praeger Publishers, 1974), p. 11.

24. The best general discussion of nineteenth-century British glass is in Lewis F. Day, *Windows, A Book About Stained and Painted Glass* (London: Bradbury, Agnew, 1894). Provenance of the windows at the Church of the Incarnation from an anonymous pamphlet published by the Church of the Incarnation, *Descriptive Pamphlet of the Church of the Incarnation* (n.p., n.d.); copy in The New York Public Library accessioned in 1919. Also, J. Newton Perkins, *History of the Parish of the Incarnation in New York City, 1852–1912* (Poughkeepsie, N.Y., 1912), *passim*. Willene Clark told the author that the Clayton and Bell figures resemble those of the German Nazarene School of painting, an early 19th-century movement strongly related to German Renaissance painting.

25. Anonymous typescript, Windows of Grace Church, three-page mimeograph work revised 1979 by Edyth McKitrick, archivist of Grace Church. I wish to thank Mrs. McKitrick for a copy of her manuscript revisions of this work.

26. A. Charles Sewter, *The Stained Glass of William Morris and His Circle* (New Haven, Conn.: Yale University Press, 1975), vol. 2, p. 225.

27. Quentin Bell, *Victorian Artists* (London: Routledge & Kegan Paul, 1967), p. 68. On the same page Bell added an appropriate bit of praise: "this vision of things . . . is humane, tender and delicate . . . and in every sense of the word, gentle." Burne-Jones's relation to the Pre-Raphaelites and the later history of British painting is discussed with original intelligence in Allen Staley's Introduction and "Post-Pre-Raphaelitism" in *Victorian High Renaissance* (catalogue of an exhibition organized by City Art Gallery, Manchester; The Minneapolis Institute of Arts; and The Brooklyn Museum) (Minneapolis, Minn.: The Minneapolis Institute of Arts, 1978), pp. 15–30.

28. Henry Holiday, *Stained Glass as an Art* (London: Macmillan & Co., 1896). See particularly the figure on page 156 showing Holiday's nude studies for the window he designed for St. Luke's Hospital at Amsterdam Avenue and 114th Street in Manhattan: the painter in Holiday was so strong that he could only approach a window in the approved academic style, beginning with nude studies, then clothing them. This approach is likely to result in anatomically correct figures, but is also likely to subordinate the needs of a window for vitality of design and color to the needs of figure drawing, as one can see when looking at the overpainted window that is still in place at St. Luke's Hospital.

29. Michael Petzet, "Ludwig and the Arts," in *The Dream King, Ludwig II of Bavaria,* by Wilfrid Blunt (New York: Studio Publications, 1970), pp. 229–254. Many of the windows at Grace Episcopal Church are signed by Munich firms, mostly Mayer, and although the window in question is not signed, both the author and Dorothy Kling, historian of Grace Church, believe that the style of the window confirms the belief that it too is from Munich (letter to the author from Dorothy Kling, December 2, 1979).

3: THE OPALESCENT ERA: TIFFANY AND LA FARGE

1. The wrangle over who did what first has been substantially clarified by Barbara Weinberg, "A Note on the Chronology of La Farge's Early Windows," *Stained Glass* 67, no. 4 (Winter 1972–1973), pp. 13–15. I still tend to believe, however, that the similarity between La Farge's cartoons of 1878 for the Harvard memorial window and the finished window indicate that he was working in opalescent glass in the late 1870s, and that one should therefore accept his date of 1878–1879 for *Peonies* until it is firmly disproved. I obtained much help in this matter from Henry La Farge in the correspondence we carried on during 1979. Mason Hammond (see note 4, below) was also most helpful.

2. John K. Howat *et al.*, *Nineteenth-Century America: Paintings and Sculpture: An Exhibition in Celebration of the Hundredth Anniversary of The Metropolitan Museum of Art* (New York: The Metropolitan Museum of Art, 1970), text accompanying figure 112.

3. Russell Lynes, *The Art-Makers of Nineteenth-Century America* (New York: Atheneum Publishers, 1970), p. 418.

4. Mason Hammond, The Stained Glass Windows in Memorial Hall, Harvard University (Cambridge, Mass., 1978), pp. 60, 72; mimeograph manuscript available from Professor Hammond; copy on deposit at Widener Library, pp. 60, 72.

5. Helene Barbara Weinberg, "The Decorative Work of John La Farge" (Ph.D. diss., Columbia University, 1972), p. 359. Professor Weinberg's dissertation provides a thorough and sophisticated analysis of La Farge's work as an artist. For an appealing portrait of the artist himself, see Royal Cortissoz, *John La Farge, A Memoir and A Study* (New York: Houghton Mifflin, 1911).

6. Louis C. Tiffany, *The Art Work of Louis C. Tiffany* (Garden City, N.Y.: Doubleday & Co., 1914). There is no indication in this book that anyone but Tiffany made a substantial contribution to the invention of American glass; see esp. pp. 14–19.

7. Gary A. Reynolds, *Louis Comfort Tiffany: The Paintings* (catalogue of an exhibition at The Grey Art Gallery, New York University) (New York: New York University Press, 1979). The discussion of Tiffany's career owes much to pp. 8–22; the quotation is from p. 21. Also valuable to my discussion of Tiffany's career was Robert Koch, *Louis C. Tiffany, Rebel in Glass,* 2d ed. (New York: Crown Publishers, 1966), esp. pp. 87–118.

8. Reynolds, *Tiffany: The Paintings,* p. 20.

9. Koch, *Rebel in Glass,* p. 79.

10. *Ibid.,* p. 90, gives a black-and-white illustration of one of the windows at the Church of the Sacred Heart, and also of the *St. Mark* window, Islip, Long Island.

11. Roger Riordan, "American Stained Glass," *The American Art Review* 2, div. 2 (1881), pp. 63–64.

12. Ann Douglas, *The Feminization of American Culture* (New York: Alfred A. Knopf, 1977), offers a fine summary of the liberalization of American religion, as well as her own fascinating interpretation of the phenomenon.

13. C. R. Leslie, *Memoirs of the Life of John Constable, Composed Chiefly of His Letters* (London: Phaidon, 1951), p. 85.

14. Weinberg, "Decorative Work of John La Farge," pp. 382–383; see also obituary of Mary E. Tillinghast in *The New York Times,* December 16, 1916. (Birth dates are often unavailable for women artists like Tillinghast, or Clara Burd, the designer of the window shown in fig. 35.)

4: OPALESCENT GLASS AND THE ARCHITECTURE OF THE "AMERICAN RENAISSANCE"

1. A valuable survey of the architecture of the era discussed in this chapter and the following one is in Walter C. Kidney, *The Architecture of Choice: Eclecticism in America, 1880–1930* (New York: George Braziller, 1974). Richer as a source for the present chapter is *The American Renaissance, 1876–1917* (New York: The Brooklyn Museum, 1979). See pp. 12 and 19 of this exhibition catalogue for an indication of the closeness and mutual admiration of the artists and architects of the era. (No specific attention is paid to stained glass in either of the above works; all comments on the medium thus far in the present chapter are my responsibility.)

2. Weinberg, "Decorative Work of John La Farge," p. 410.

3. Tiffany Glass and Decorating Company, *A Partial List of Windows and Extracts from Letters and Newspapers* (New York, 1910; reprint ed., Watertown, Mass.: Tiffany Press, 1973), p. 7, claims the windows of the church as products of the Tiffany Studios. Tiffany Studios operated under several different names. For convenience I refer to the firm only as "Tiffany Studios." For the titles used at various periods see Koch, *Rebel in Glass, passim.*

4. Letter from Joan Morcerf, historian of the Church of the Good Shepherd, July 26, 1978, stating that handwritten notes compiled by her predecessor in 1943 refer to the windows as being by Tiffany and coming from St. James's Lutheran Church. Tiffany, *A List of Windows,* p. 7, lists a work titled *Christ and Mary and Martha* at St. James's, which may refer to the set of three windows now in Brooklyn. No other documentation seems to exist.

5. Attribution of the window at New York Society for Ethical Culture based on photograph and caption in *Brochure of the Mural Painters* (New York: Mural Painters' Press, Kalkolf Co., 1916), p. 41. A copy of the brochure was found among the archives of Lamb Studios.

6. "New York's New Palace of Justice," *New York Herald,* March 12, 1899, sec. 5, p. 4; also, *Brochure of the Mural Painters,* p. 54.

7. See Tiffany, *A List of Windows,* p. 9, for attribution of *The Second Advent.*

8. August Belmont papers, manuscript room, The New York Public Library, Percy S. Grant (rector of the Church of the Ascension) to August Belmont, March 13, 1899. A "Miss Schnell" is referred to in this letter; she had apparently "bespoken" a casement and promised to pay for a window for it five years previously, but thus far she had not "seen anything she likes," although "she intends to place the window as soon as she can decide on a maker."

9. Koch, *Rebel in Glass,* p. 83.

10. La Farge wrote to Henry Adams that the window had lost part of its intended "late graeco Roman Alexandrine" character and a simpler base substituted to satisfy the Players' committee. Weinberg, "Decorative Work of John La Farge," pp. 414–416.

5: TWENTIETH-CENTURY GOTHIC

1. Koch, *Rebel in Glass,* p. 21; Edith Wharton and Ogden Codman, Jr., *The Decoration of Houses* (New York: Charles Scribner's Sons, 1894), pp. 13–16, 64–73.

2. Kidney, *Architecture of Choice,* pp. 43–44. For a fascinating account of how the events described by Kidney wrecked the hopes for a new architecture in the Midwest, see H. Allen Brooks, *The Prairie School* (Buffalo, N.Y.: University of Toronto Press, 1972), esp. pp. 337–339.

3. David A. Hanks, *The Decorative Designs of Frank Lloyd Wright* (New York: Dutton Paperbacks, 1979), esp. pp. 50, 53–60. Also Robert Judson Clark, *The Arts and Crafts Movement in America, 1876–1916* (catalogue of an exhibition sponsored by The Art Museum, Princeton University, and The Art Institute of Chicago) (Princeton, N.J.: Princeton University Press, 1972), pp. 58–63; and Isabelle Anscombe and Charlotte Gere, *Arts and Crafts in Britain and America* (New York: Rizzoli International Publications, 1978), *passim.*

4. Kidney, *Architecture of Choice,* summarizes Cram's career and his relationship with St. John the Divine on pp. 36–42. Also Ralph Adams Cram, *My Life in Architecture* (Boston: Little, Brown, 1936). The relationship between Cram and stained-glass artists emerges in multitudinous bits and pieces in the pages of *Stained Glass,* the journal of the Stained Glass Association of America, all through the late 1920s and the 1930s, when frequent articles about, by, or mentioning Cram appeared. See, for example, Ralph Adams Cram, "Stained Glass in Church Architecture," *Stained Glass* 26, no. 7 (July 1931), pp. 225–228; also the obituary of Cram in *Stained Glass* 37, no. 4 (Winter 1942), pp. 103–104; 106–107; 118.

5. Andrews, *American Gothic,* p. 123.

6. Edward Hagaman Hall, *A Guide to the Cathedral Church of St. John the Divine* (New York: The Dean and Chapter of St. John the Divine, 1965), *passim.*

7. Charles Connick, "Otto Heinigke," *Stained Glass* 30, no. 3 (Winter 1935–1936), pp. 67–70, and in the same issue, Otto Heinigke, "Rambling Thoughts of a Stained Glass Man," pp. 75–90. See also, Otto Heinigke, "Architectural Sympathy in Leaded Glass," *Architectural Review* 4 (1896), pp. 60–64.

8. Virginia Lewis, "Some Aspects of Stained Glass," *Stained Glass* 56, no. 1 (Spring 1961), p. 14; interview with Helene Weis, librarian of Willet Studios, May 14, 1979.

9. Charles Connick, *Adventures in Light and Color* (New York: Random House, 1937); Orin E. Skinner, "Connick in Retrospect," *Stained Glass* 70, no. 1 (Spring 1975), esp. pp. 17–19. Henry Lee Willet recounts some of the difficulties of

working with Connick in "Henry Lee Willet, Troublesome Fellow," *Stained Glass* 73, no. 1 (Spring 1978), p. 24.

10. Willet Studios in Philadelphia inherited some of Lakeman's papers; many of them are filed with material on the Cathedral of St. John the Divine. See also "Ernest W. Lakeman, 1883–1948," *Stained Glass* 43, no. 4 (Winter 1948), p. 129; for the career of Guthrie, see Albin Elskus, "The Purist, John Gordon Guthrie, 1874–1961," *Stained Glass* 69, no. 3 (Autumn 1974), pp. 40–43; I wish to thank Mark Liebowitz of Lamb Studios for pointing out to me the preponderant creative role Guthrie probably played in the various collaborations he undertook. A memorial window to Young, given by other glassmakers, is in the St. James Chapel at the Cathedral of St. John the Divine, and Young's firm was at the very center of some of the most creative work done in the 1920s and 1930s, yet Young's life and activities seem to be unchronicled. See Connick, *Adventures in Light and Color,* p. 32, for a brief discussion of Young.

11. For one example of the many careful studies of Chartres and other cathedrals undertaken by the twentieth-century medievalists, see Connick, *Adventures in Light and Color,* pp. 287 ff.

12. Frank E. Cleveland, "Remembered Friendship," *Stained Glass* 41, no. 1 (Spring 1946), p. 14.

13. Lawrence Saint recounts his attempts to re-create medieval ruby glass in his delightful memoir, which deserves publication. A mimeographed copy of his story, The Romance of Stained Glass, is in the rare books room of the Bancroft Library, University of California, Berkeley. The obsession with blue manifests itself not only in the work of several artists of the period but in the unquestioning acceptance of the theories of Viollet-le-Duc as expressed in the section titled "Vitrail" of his *Dictionnaire Raisonné,* vol. 9 (Paris: Librairie des Imprimeries Réunies, 1889). "Vitrail" was translated in the 1920s and printed in English for the first time in the pages of *Stained Glass.* See Charles Connick, "The Tree of Jesse Window," *Stained Glass* 27, no. 1 (January 1932), p. 39. Not until James R. Johnson published *The Radiance of Chartres* was Viollet-le-Duc's theory about blue shown to be dubious, and further doubt was cast on Viollet-le-Duc by Richard B. Beaman, " 'Vitrail' Reconsidered," *Stained Glass* 62, no. 3 (Autumn 1967).

14. Robert Sowers, *Stained Glass: An Architectural Art* (New York: Universe Books, 1965), p. 54, citing Charles Winston, *An Inquiry into the Differences of Style Observable in Ancient Glass* (Oxford, 1847), p. 250.

15. The Chapel at The Riverside Church contains a series of beautiful windows done in this fashion.

16. See the aisle window in the Historic and Patriotic Societies' Bay, Cathedral of St. John the Divine.

17. Letter from Helene Weis, librarian of the Willet Studios, to the author, November 20, 1979. She is quite sure that an assistant did the painting of the Green-Wood windows and she kindly provided me with copies of William Willet's original cartoons. These already possess energetic line and indications of texture that were captured by whoever executed the enameling.

18. A great deal of literature, much of it beautifully illustrated, has been printed in the last ten years on the illustrators of the late nineteenth and early twentieth century. One excellent and comprehensive volume is Brigid Peppin, *Fantasy: The Golden Age of Fantastic Illustration* (New York: Watson-Guptill, 1975).

19. Anonymous article, "An Exhibition of the Work of the Late Wright Goodhue," *Stained Glass* 27, no. 3 (March 1932), p. 91. The source of the quotation attributed to Cram is not given.

20. Lewis, "Some Aspects of Stained Glass," pp. 16–17.

21. See note 20, chapter 2, for the provenance of this window.

22. Much of the preceding discussion owes a debt to Painton Cowen, *Rose Windows* (San Francisco: Chronicle Books, 1979). Cowen's book is a broad treatment of his subject, but he has ignored American and nineteenth-century glass while being more than generous with Jungian metaphors.

23. J. Monroe Hewlett, letter dated August 19, 1931, from *Architecture Magazine,* reprinted in *Stained Glass* 26, no. 12 (December 1931), pp. 437–438.

24. E. Liddall Armitage, *Stained Glass: History, Technology, and Practice* (Newton Centre, Mass.: Charles T. Branford, 1959), p. 68, attributes the glass at Heavenly Rest to Hogan, but church records show that Guthrie made the rose window.

6: MODERN GLASS

1. "Emil Frei," *Stained Glass* 62, no. 2 (Summer 1967), pp. 20–23.

2. Interview with Viggo Rambusch, Jr., of Rambusch Studios, June 11, 1979; Harold Rambusch, "An Autobiography," *Stained Glass* 72, no. 2 (Summer 1977), p. 88.

3. The interesting windows of the Church of the Most Precious Blood in Astoria, Queens, are discussed by Maurice Lavanoux, "Here and There," *Stained Glass* 27, no. 10 (October 1932), pp. 292–293.

4. Examples include the principal sanctuary windows at the Church of the Good Shepherd, Bay Ridge, Brooklyn, and the windows of Our Lady of the Skies at Kennedy Airport (fig. 156); also note the hints of Cubism in the clerestory window dedicated to *St. Alban* in the Cathedral of St. John the Divine.

5. Sowers, *Stained Glass: Architectural Art,* p. 39.

6. Interview with Helene Weis, May 15, 1979; also "A Modern Museum for the Space Age," *Stained Glass* 60, no. 1 (Spring 1965), pp. 9–12.

7. "The World's Largest Stained Glass Window," *Stained Glass* 56, no. 3 (Autumn 1961), p. 17.

8. See, for example, Robert Mallet-Stevens, *Vitraux Modernes (Exposition Internationale de 1937)* (Paris: Moreau, 1937); even tradition-laden studios like Charles Lorin were making innovative windows, as plate 27 of *Vitraux Modernes* demonstrates.

9. Lee, *Stained Glass,* pp. 158–175; the founding of a new journal, *Glass,* in 1972, with an emphasis on nonecclesiastic work is significant. Several recent books have appeared on "The New Glass"; the most thoughtful is the second volume of Peter Mollica's *Stained Glass Primer,* rev. ed. (Oakland, Calif.: Mollica Stained Glass Press, 1978). Worth seeking out is the issue of *Glass* (7, no. 1 [May 1979]) that was prepared specifically for the 1979 meeting of the American Institute of Architects.

10. Worth quoting in this connection is an extreme but insightful remark by Kenneth Frederick von Roehn, Jr., in "Resurrect Stained Glass as an Architectural Art?," *Glass* 7, no. 1 (May 1979), "Modern architecture . . . could not communicate those qualities we recognize as essential to a humanistic possession of architectural environments."

ARCHIVAL MATERIAL AND PRIVATELY PUBLISHED LITERATURE

The following abbreviations are used in this bibliography: NYPL: work can be located in The New York Public Library through the general catalogue; *Avery:* Avery Library, Columbia University, New York; *Bancroft:* Bancroft Library, University of California, Berkeley California.

Archdiocese of New York (Roman Catholic), Archives. St. Joseph's Seminary, Dunwoodie, New York.

Belmont, August. Papers. Manuscript Division, NYPL. Belmont was for many years an active member and officer of The Church of the Ascension; numerous documents concerning that church are preserved in Belmont's papers.

Cathedral Church of St. John the Divine, Archives.

Church of the Incarnation (Madison and 35th). *Descriptive Pamphlet of the Church of the Incarnation.* n.p. n.d. The pamphlet was accessioned in 1919. NYPL.

Eccleston, Rev. John. *Jubilee Sermon Preached at St. John's Church, Clifton, December 31, 1893.* Published for the church, 1893. Includes comments on the glass of this Staten Island church. NYPL.

The Flemish Stained Glass Windows. New York: Park Avenue Baptist Church, 1925. Pamphlet. Avery.

Fordham University, Archives.

Grace Church. Windows of Grace Church. Anonymous typescript, revised by Edyth McKitrick, 1979.

Guillet, Gail T., "Historical Sketch of the Church of the Holy Trinity." n.p. n.d. Brochure published by St. Ann and the Holy Trinity, Brooklyn, in late 1970s.

Hammond, Mason. The Stained Glass Windows in Memorial Hall, Harvard University. Mimeographed. Cambridge, Mass.: Harvard University, 1978. Professor Hammond's careful research provides important information on the early career of La Farge.

History of the First Reformed Protestant Dutch Church of Breuckelen. Compiled by order of the Consistory, 1896. Jean Smida (see below) drew on this book after finding that it was congruent with extant documents in the church archives. Copy owned by Old First Reformed Church, Park Slope, Brooklyn.

Kennedy, James W. *The Unknown Worshipper.* New York: Published for The Church of The Ascension, 1964. NYPL.

Lamb Studios, Archives. Northvale, New Jersey.

Maitland Armstrong & Co. *Maitland Armstrong & Co., Some Examples of Their Work.* New York, 1896. This brochure includes twelve plates that identify several otherwise unascribed windows of importance. Avery.

Metropolitan Museum of Art, The. Catalogue Department Files. These files, which are available to scholars, are supposed to contain the museum's most recent information on provenance, restorations, literature, and so forth, pertaining to each work of art owned by the museum. Not all the records are up to date.

Perkins, J. Newton. *History of the Parish of the Incarnation in New York City, 1852-1912.* Published by the Senior Warden and printed by Frank B. Howard. Poughkeepsie, N.Y., 1912. NYPL.

Saint, Lawrence. The Romance of Stained Glass, by Lawrence Saint, A Story of His Experiences and Experiments. Mimeographed. Huntingdon Valley, Pa., 1959. Bancroft.

St. Mark's in the Bowery, Archives.

Smida, Jean. *Old First Reformed Church; 325th Anniversary, 1654-1979.* Published by the church, 1979.

Tiffany Glass and Decorating Company. *A List of Windows and Extracts from Letters and Newspapers.* New York, 1897. Avery.

Tiffany Studios. "Three Portfolios of Photos of Their Works." c. 1900. Avery.

Trinity Church, Archives. 74 Trinity Place, Manhattan.

Tuft, Margaret H. The Stained Glass Windows of Trinity Church, New York. Manuscript dated 1967. Avery.

Union Reformed Church, Archives. Highbridge, The Bronx.

Weinberg, Helene Barbara Kallman. "The Decorative Work of John La Farge." Ph.D. dissertation, Columbia University, 1972. Avery.

Willet Studios. Archives. Philadelphia.

BOOKS, CATALOGUES, AND PERIODICALS

The American Renaissance, 1876-1917 (catalogue). New York: The Brooklyn Museum, 1979. Destined to be a classic.

Andrews, Wayne. *American Gothic.* New York: Random House, 1975.

"An Exhibition of the Work of the Late Wright Goodhue." *Stained Glass* 27, no. 3 (March 1932), p. 91.

Anscombe, Isabelle, and Gere, Charlotte. *Arts and Crafts in Britain and America.* New York: Rizzoli International Publications, 1978. Excellent study of the Arts and Crafts movement.

Armitage, E. Liddall. *Stained Glass: History, Technology, and Practice.* Foreword by Richard Coombs. Newton Centre, Mass.: Charles T. Branford, 1959.

Armstrong, David Maitland. *Day Before Yesterday.* Edited by Margaret Armstrong. New York: Charles Scribner's Sons, 1920. Good for the early careers of Armstrong and his friend John La Farge, disappointingly little about their later and more important involvement in painting and glass.

Aubert, Marcel. *French Cathedral Windows of the Twelfth and Thirteenth Centuries.* Introduction by G. G. Coulton. new ed. New York: Oxford University Press, 1947.

———. *Le Vitrail Français.* Paris: Editions des deux mondes, 1958. The best recent survey of French glass, including nineteenth-century work.

Baker, John. *English Stained Glass of the Medieval Period.* London: Thames & Hudson, 1978.

Beaman, Richard B. " 'Vitrail' Reconsidered." *Stained Glass* 62, no. 3 (Autumn 1967). (The reader will notice varieties of forms and a break in the continuity of the volume numbers of *Stained Glass;* these irregularities reflect changes in the magazine's title page.)

Bell, Quentin, *Victorian Artists.* London: Routledge & Kegan Paul, 1967. The apologies made for some of the paintings he discusses no longer seem necessary; Bell has carried the day perhaps better than he intended. The book remains an absolute delight.

Bing, Samuel. *Artistic America, Tiffany Glass, and Art Nouveau.* Translated by Benita Eisler, introduction by Robert Koch. Cambridge, Mass.: Massachusetts Institute of Technology Press, 1970. The first essay was originally published in 1895 as "La Culture Artistique en Amérique."

Brooks, H. Allen. *The Prairie School: Frank Lloyd Wright and His Midwest Contemporaries.* Buffalo, N.Y.: University of Toronto Press, 1972.

Clark, Kenneth. *Landscape into Art.* Boston: Beacon Press, 1961.

Clark, Robert Judson. *The Arts and Crafts Movement in America, 1876-1916* (catalogue). Princeton, N.J.: Princeton University Press, 1972. Encyclopedic.

Clark, Willene B. "America's First Stained Glass: William Jay Bolton's Windows at Holy Trinity Church, Brooklyn, New York." *The American Art Journal* (October 1979). A pioneering piece of scholarship.

Cleveland, Frank E. "Remembered Friendship." *Stained Glass* 41, no. 1 (Spring 1946), pp. 12-14. This issue of *Stained Glass* contains a number of other essays on Charles Connick.

Coleman, Caryl. "A Comparative Study of European and American Church Glass." *House Beautiful* (April 1898), pp. 42-48.

Connick, Charles. *Adventures in Light and Color: An Introduction to the Stained Glass Craft.* Foreword by Charles D. Maginnis. New York: Random House, 1937. The best source for the twentieth-century Gothic movement as well as a delightful introduction to medieval windows. The Gazetteer section, however, contains numerous errors and/or unverifiable statements as well as neglecting many important windows in favor of an extensive listing of twentieth-century Gothic work.

———. "Otto Heinigke." *Stained Glass* 30, no. 3 (Winter 1935-1936), pp. 67-70.

———. "The Tree of Jesse Window." *Stained Glass* 27, no. 1 (January 1932), p. 39.

Cortissoz, Royal. *John La Farge, A Memoir and A Study.* New York: Houghton Mifflin, 1911.

Cowen, Painton. *Rose Windows.* San Francisco: Chronicle Books, 1979.

Cram, Ralph Adams. *My Life in Architecture.* Boston: Little, Brown, 1936.

Day, Lewis F. *Windows: A Book About Stained and Painted Glass.* London: Bradbury, Agnew, 1894.

Dickason, D. H. "The American Pre-Raphaelites." *Art in America* 30 (July 1942), pp. 157-165.

Douglas, Ann. *The Feminization of American Culture.* New York: Alfred A. Knopf, 1977.

Drake, Maurice. *A History of English Glass-Painting, with Some Remarks upon the Swiss Glass Miniatures of the Sixteenth and Seventeenth Centuries.* New York: McBride, 1913.

Duncan, George Sang. *The Bibliography of Glass.* Edited by Violet Dimbleby, foreword by W. E. S. Turner. London: Wm. Dawson & Sons, 1960. Comprehensive, especially for European medieval glass, but not annotated.

Elskus, Albin. "The Purist, John Gordon Guthrie, 1874-1961." *Stained Glass* 69, no. 3 (Autumn 1974), pp. 40-43.

"Emil Frei." *Stained Glass* 62, no. 2 (Summer 1967), pp. 20-23.

Gannon, Robert I., S.J. *Up to the Present: The Story of Fordham.* New York: Doubleday & Co., 1967.

Gaudin, Félix. *Le Vitrail.* Paris: Flammarion, 1928.

Goldberger, Paul. *The City Observed—New York.* New York: Random House, 1979. Intelligent guide to the architecture of Manhattan (the other boroughs are omitted), but does not attempt to be encyclopedic or discuss interiors.

Hall, Edward Hagaman. *A Guide to the Cathedral Church of St. John the Divine in the City of New York.* New York: The Dean and Chapter of St. John the Divine, 1965. Thorough and much more scholarly than most such publications.

Hanks, David A. *The Decorative Designs of Frank Lloyd Wright.* New York: Dutton Paperbacks, 1979. Includes an excellent discussion of Wright's glass.

Hawkins, John Sidney. *An History of the Origin and Establishment of Gothic Architecture . . . and an Inquiry into the Mode of Painting and Staining on Glass.* London: J. Taylor, 1813.

Hayward, Jane. "Medieval Stained Glass from St. Leonhard in Lavantthal at The Cloisters." *The Metropolitan Museum of Art Bulletin* (February 1970), pp. 291-292.

———. "Stained Glass Windows—An Exhibition of Glass in The Metropolitan Museum's Collection." *The Metropolitan Museum of Art Bulletin* 30, no. 3 (December 1971-January 1972). Invaluable not only as the sole survey of The Metropolitan's extraordinary collection of glass (most of which is not on permanent exhibit) but also for the concise history of medieval and Renaissance glass accompanying the plates.

Heinigke, Otto. "Architectural Sympathy in Leaded Glass." *The Architectural Review* 4 (1896), pp. 60-64.

———. "The Windows of Holy Trinity Church, Brooklyn, New York." *The Architectural Review* 14 (January 1906), pp. 1-3.

Hilton, Timothy. *The Pre-Raphaelites.* New York: Praeger Publishers, 1974.

History of Architecture and the Building Trades of Greater New York. vol. 2. New York: Union History Company, 1899.

Holiday, Henry. *Stained Glass as an Art.* London: Macmillan & Co., 1896. Worth reading for itself in addition to the light it casts on Holiday's perception of his craft.

Howat, John K. *et al. Nineteenth-Century America: Paintings and Sculpture: An Exhibition in Celebration of the Hundredth Anniversary of The Metropolitan Museum of Art.* New York: The Metropolitan Museum of Art, 1970.

James, Henry. *The Painter's Eye, Notes and Essays on the Pictorial Arts.* Edited by John L. Sweeney. London: Hart-Davis, 1951.

Johnson, James R. "The Internal Structure of Medieval Ruby Glass." *Stained Glass* 59, no. 2 (Summer 1964), pp. 17-22.

———. *The Radiance of Chartres.* New York: Random House, 1965. One of the most valuable and exciting books ever written, not only on Chartres but on stained glass in general.

Kidney, Walter. *The Architecture of Choice: Eclecticism in America, 1880-1930.* New York: George Braziller, 1974.

King, Moses. *Handbook of New York City.* 2d ed. Boston: Moses King, 1893.

Koch, Robert. *Louis C. Tiffany, Rebel in Glass.* 2d ed. New York: Crown Publishers, 1966. Extensive bibliography,

particularly for contemporary journalism by and about Tiffany.

Lamb, Charles Rollinson. "The Romance of American Glass." *Brooklyn Museum Quarterly* 16 (October 1929), p. 109 ff.

Lamb, Frederick S. "The Making of a Modern Stained Glass Window—Its History and Process." *Craftsman* 10 (April 1906), pp. 18-31.

Larousse, Pierre. *Grand Dictionnaire Universel du XIX Siècle.* vol. 11. Paris: Larousse, 1872.

Lauber, Joseph. "European vs. American Color Windows." *Architectural Record* 31 (February 1912), pp. 139-151.

Lavanoux, Maurice. "Here and There." *Stained Glass* 27, no. 10 (October 1932), pp. 292-293. Essay on the Art Deco windows of the Church of the Most Precious Blood, Astoria, Queens.

Lee, Lawrence *et al. Stained Glass.* New York: Crown Publishers, 1976. Fully illustrated in color, the best popular survey of stained glass from medieval times to the present.

Leslie, C. R. *Memoirs of the Life of John Constable, Composed Chiefly of His Letters.* Introduction by Benedict Nicolson. London: Phaidon, 1951.

Les Vitraux: Les Monuments Historiques de la France, Sommaire. Paris: Édition de la Caisse Nationale des Monuments Historiques, 1977.

Lloyd, John Gilbert. *Stained Glass in America.* Jenkintown, Pa.: Foundation Books, 1963. The only monograph on the subject, unannotated and fervently pro-Connick, anti-Tiffany.

Loire, Gabriel. *Le Vitrail: Aperçus Historiques, Artistiques.* Angers: Librairie du Roi René, 1924. Although focused on earlier glass of Anjou, has a good section on nineteenth-century work.

Low, Will H. "Old Glass in New Windows." *Scribners Magazine* 4 (1888), pp. 675-686. Discusses work by various opalescent artists.

Lynes, Russell. *The Art-Makers of Nineteenth-Century America.* New York: Atheneum Publishers, 1970.

Mallet-Stevens, Robert. *Vitraux Modernes (Exposition Internationale de 1937).* Paris: Moreau, 1937. Good for French contemporary work.

Malraux, André. *The Voices of Silence.* Translated by Stuart Gilbert. New York: Doubleday & Co., 1953.

Marteau, Robert. *The Stained-Glass Windows of Marc Chagall, 1957-1970.* New York: Tudor Publishing, 1973.

McGrath, Raymond. *Glass in Architecture and Decoration.* Cheam, England: Architectural Press, 1937. Discusses then-contemporary work.

Merson, Olivier. *Les Vitraux.* Paris: Librairie-Imprimeries Réunies, 1895. Although flawed by the maddeningly inadequate annotation of nineteenth-century French scholarship, good for nineteenth-century artists.

Mollica, Peter. *Stained Glass Primer.* vol. 2. Oakland, Calif.: Mollica Stained Glass Press, 1978.

Morrison, Ellen E. "A New Approach to the Making of Medieval Stained Glass." *Stained Glass* 63, no. 1 (Spring 1968), pp. 20-32. A dubious foray into the continuing controversy over medieval glass technology; a prime artifact in Morrison's analysis is the splendid window from St. Germain des Prés, in The Metropolitan Museum of Art.

Mural Painters of America. Brochure of the Mural Painters. New York: Mural Painters' Press, Kalkolf Co., 1916. A slightly

revised version of this brochure appears as "Mural Paintings in Public Buildings in the United States," *American Art Annual* 19 (1922). Both articles illustrate a few, and list many, works in stained glass by members of the Mural Painters' Society.

New York Ecclesiologist, 1848-1853. A periodical published by the New York Ecclesiological Society in imitation of similar British journals devoted to the niceties of Episcopal ritual and Gothic architecture.

Panofsky, Erwin. "Abbot Suger of St.-Denis." In *Meaning in the Visual Arts*. New York: Doubleday Anchor Books, 1955.

Peppin, Brigid. *Fantasy: The Golden Age of Fantastic Illustration*. New York: Watson-Guptill, 1975.

Rackham, Bernard. *A Guide to the Collection of Stained Glass*. London: The Victoria and Albert Museum, 1936. This beautifully written guide to the glass in The Victoria and Albert Museum is also one of the best histories of British medieval and Renaissance glass.

Rambusch, Harold. "An Autobiography." *Stained Glass* 72, no. 2 (Summer 1977), pp. 88 *ff.*

Reynolds, Gary A. *Louis Comfort Tiffany: The Paintings* (catalogue). New York: New York University Press, 1979.

Reynolds, Joseph G. *Stained Glass*. Boston: Reynolds, Francis, & Rohnstock, 1928-1929. A reprint of a series of articles by the master artist in the firm of Reynolds, Francis, and Rohnstock. The articles, which originally appeared in *The Church Monthly* for September, October, and December 1928, and March 1929, contain a good account of the procedures used in major studios in the 1920s.

Rigan, Otto B. *New Glass: Environmental Stained-Glass Artists and Their Work*. San Francisco: S. F. Book Imports, 1976. Stresses West Coast American work.

Riordan, Roger. "American Stained Glass." *The American Art Review, Part One*. 1, pp. 229-234; *Part Two* and *Part Three* in 2, pp. 6-11; 63-64 (1881).

Roehn, Kenneth Frederick, von, Jr. "Resurrect Stained Glass as an Architectural Art?" *Glass* 7, no. 1 (May 1979), unpaged.

Saint Patrick's Cathedral. *St. Patrick's Cathedral*. New York: Published for the Archdiocese of New York, 1942.

———. *Solemn Blessing and Opening of the New Cathedral of St. Patrick, May 25, 1879*. New York: Archdiocese of New York, 1879. Includes numerous references to the glass.

Scheyer, Ernest. *The Circle of Henry Adams: Arts and Artists*. Detroit, Mich.: Wayne State University Press, 1970.

The Second Empire, 1852 to 1870: Art in France Under Napoleon III (catalogue). Detroit, Mich.: Wayne State University Press for the Philadelphia Museum of Art, and The Detroit Institute of Arts, 1978.

Sewter, A. Charles. *The Stained Glass of William Morris and His Circle*. 2 vols. New Haven, Conn.: Yale University Press, 1974-1975.

Skinner, Orin E. "Connick in Retrospect." *Stained Glass* 70, no. 1 (Spring 1975), pp. 16-19.

Smith, Minna C. "The St. Michael's Window and Decorations." *The International Studio* 33 (November 1907-February 1908), p. 97.

Sowers, Robert. *Stained Glass: An Architectural Art*. New York: Universe Books, 1965.

Stanton, Phoebe B. *The Gothic Revival and American Church Architecture: An Episode in Taste, 1840-1856*. Baltimore, Md.: Johns Hopkins University Press, 1968.

Storer, James. *A Description of Fonthill Abbey, Wiltshire, Illustrated by Views*. London: W. Clarke, 1812.

Tafel, Edgar. "Windows by Frank Lloyd Wright." *Stained Glass* 66, no. 2 (Summer 1971), pp. 20-21.

Tiffany Glass and Decorating Company. *A Partial List of Windows*. New York, 1910. Reprint. Introduction by John H. Sweeney. Watertown, Mass.: Tiffany Press, 1973.

Tiffany, Louis C. "American Art Supreme in Colored Glass." *The Forum* (1893).

———. *The Art Work of Louis C. Tiffany*. Garden City, N.Y.: Doubleday & Co., 1914. For an exhaustive bibliography of contemporary literature by and about Tiffany, see Koch, above.

Trees, Henry John. "Periodic Bands in Ruby Glasses." *Journal of the Society of Glass Technology* (June 1954).

Vail, R. W. G. "Storied Windows Richly Dight." *The New-York Historical Society Quarterly* 36, no. 2 (April 1952), pp. 149-159.

Victorian High Renaissance (catalogue). Minneapolis, Minn.: The Minneapolis Institute of Arts, 1978.

Viollet-le-Duc, Eugène. "Vitrail." *Dictionnaire Raisonné de l'Architecture Française*. vol. 9. Paris: Librairies des Imprimeries Réunies, 1889.

Waern, Cecilia. *John La Farge, Artist and Writer*. New York: The Macmillan Company, 1896.

Weinberg, Helene Barbara. "The Early Stained Glass Work of John La Farge." *Stained Glass* 67, no. 2 (Summer 1972), pp. 4-16.

———. "John La Farge and the Invention of American Opalescent Windows." *Stained Glass* 67, no. 3 (Autumn 1972), pp. 4-11.

———. "A Note on the Chronology of La Farge's Early Windows." *Stained Glass* 67, no. 4 (Winter 1972-1973), pp. 13-15.

Wharton, Edith, and Codman, Ogden, Jr. *The Decoration of Houses*. New York: Charles Scribner's Sons, 1894.

White, Norval, and Willensky, Elliot (for the American Institute of Architects). *AIA Guide to New York City*. New York, 1978. An encyclopedic guide to the city.

Willet, Henry Lee. "Henry Lee Willet, Troublesome Fellow." *Stained Glass* 73, no. 1 (Spring 1978), pp. 23-26.

Winston, Charles. *An Inquiry into the Differences of Style Observable in Ancient Glass*. Oxford, 1847.

Zettler, Franz Xavier. *Ausgewählte Kunstwerke aus dem Schätze der Reichenkapelle in der Königlichen Residenz zu München*. Munich, 1876. An insight into some of the work of a firm that supplied windows for New York and eventually established studios near the city.

Index

Page references for illustrations are in **boldface** *type.*

WITHDRAWN